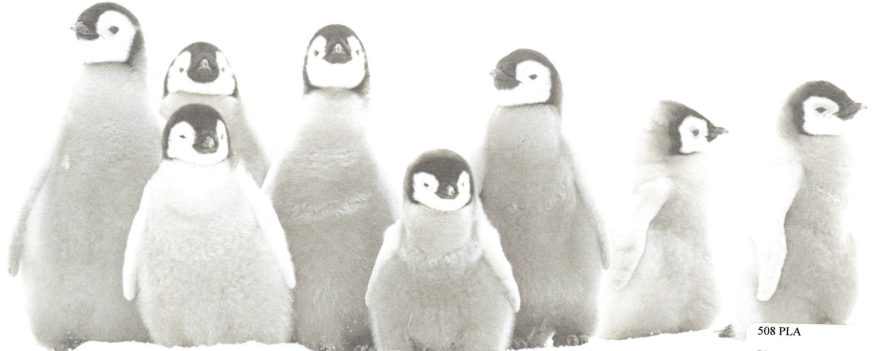

TIME

Planet Earth
AN ILLUSTRATED HISTORY

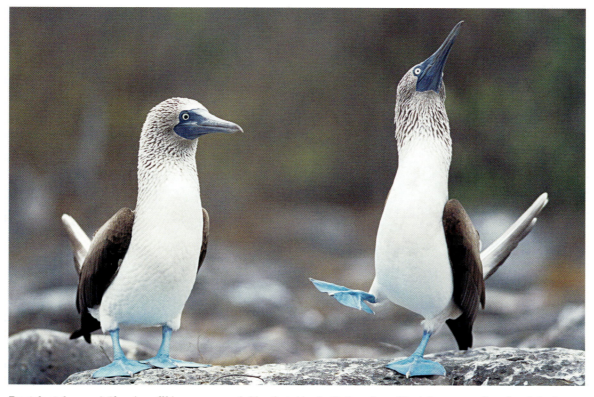

Best foot forward *Showing off his moves, a male blue-footed booby* (Sula nebouxii), *right, prances for a female in the Galápagos Islands. A booby's courting dance often includes a high-stepping strut to show off his feet*

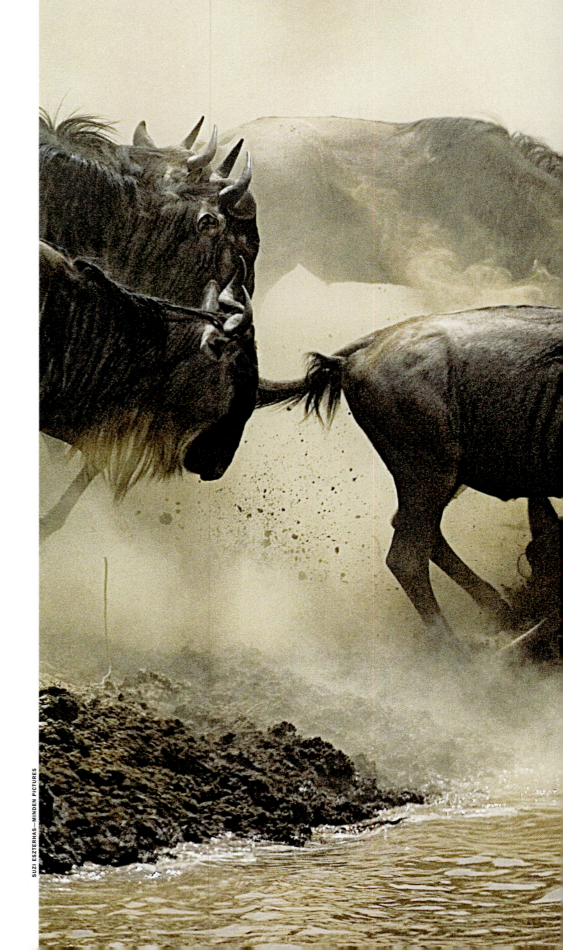

TIME

MANAGING EDITOR Richard Stengel
DEPUTY MANAGING EDITOR Adi Ignatius
ART DIRECTOR Arthur Hochstein

Planet Earth

EDITOR Kelly Knauer
DESIGNER Ellen Fanning
PICTURE EDITOR Patricia Cadley
RESEARCHER/WRITER Matthew McCann Fenton
RESEARCH Matt Wagner
COPY EDITOR Bruce Christopher Carr

TIME INC. HOME ENTERTAINMENT
PUBLISHER Richard Fraiman
GENERAL MANAGER Steven Sandonato
EXECUTIVE DIRECTOR, MARKETING SERVICES Carol Pittard
DIRECTOR, RETAIL & SPECIAL SALES Tom Mifsud
DIRECTOR, NEW PRODUCT DEVELOPMENT Peter Harper
ASSISTANT DIRECTOR, NEWSSTAND MARKETING Laura Adam
ASSISTANT DIRECTOR, BRAND MARKETING Joy Butts
ASSOCIATE COUNSEL Helen Wan
SENIOR BRAND MANAGER, TWRS/M Holly Oakes
BOOK PRODUCTION MANAGER Suzanne Janso
DESIGN AND PREPRESS MANAGER Anne-Michelle Gallero
BRAND MANAGER Shelley Rescober
ASSOCIATE BRAND MANAGER Michela Wilde

SPECIAL THANKS
Alexandra Bliss, Glenn Buonocore, Susan Chodakiewicz, Margaret Hess,
Brynn Joyce, Robert Marasco, Dennis Marcel, Brooke Reger, Mary Sarro-Waite,
Ilene Schreider, Adriana Tierno, Alex Voznesenskiy

ISBN 10: 1-60320-032-0
ISBN 13: 978-1-60320-032-5
Library of Congress Number: 2008903290

We welcome your comments and suggestions about TIME Books. Please write
to us at: TIME Books • Attention: Book Editors • PO Box 11016 • Des Moines, IA
50336-1016

If you would like to order any of our hardcover Collector's Edition books,
please call us at 1-800-327-6388 (Monday through Friday, 7 a.m.–8 p.m.,
or Saturday, 7 a.m.–6 p.m., Central time).

PRINTED IN THE UNITED STATES OF AMERICA

ii

Charge! *Blue wildebeests* (Connochaetes taurinus) *vault into the Mara
River during migration season in the Masai Mara National Reserve, Kenya*

SUZI ESZTERHAS—MINDEN PICTURES

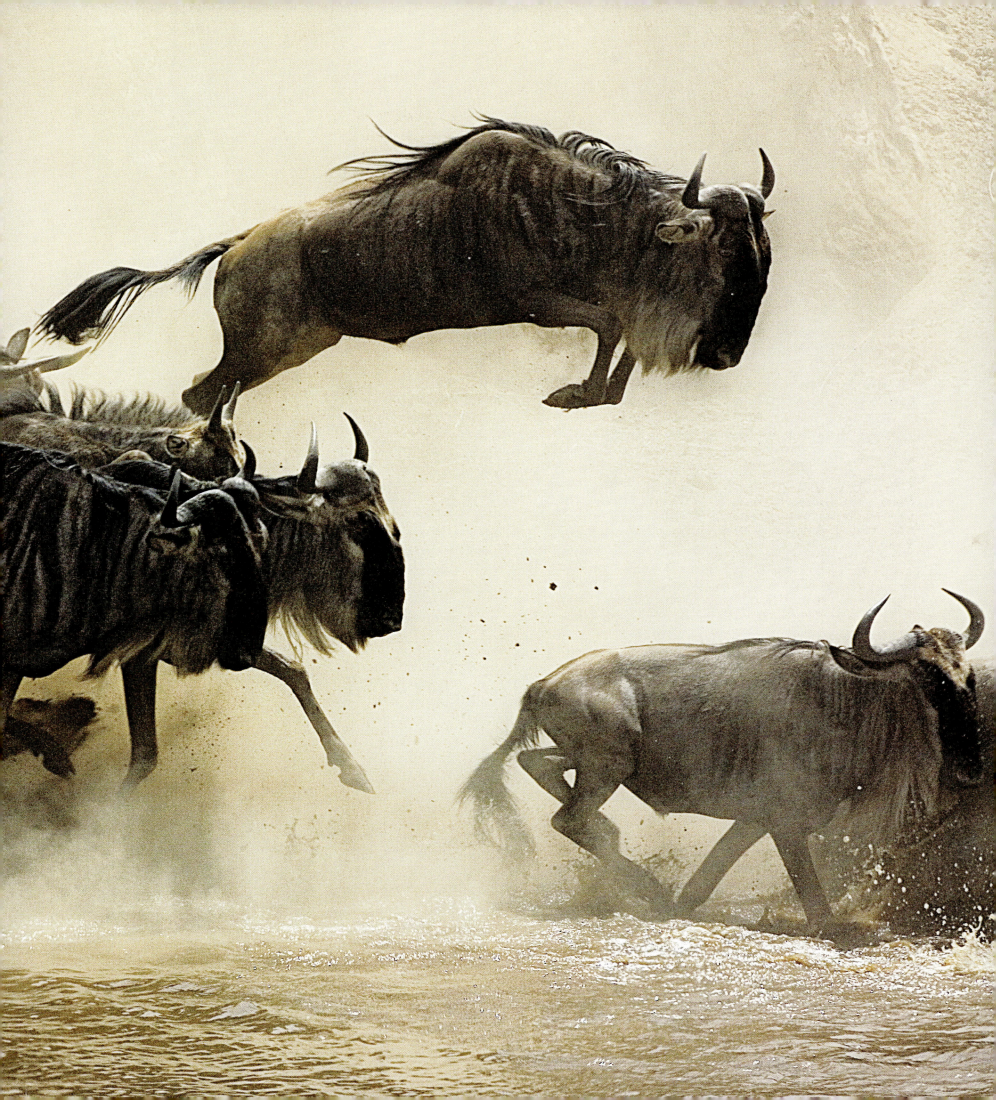

contents

KEREN SU–CORBIS

Crop circles *Cultivated fields of canola surround cone-shaped outcroppings of hard rock around Guizhou, China. In karst topographies like this one, softer rocks have been fully eroded by weather, but harder ones are still undergoing erosion*

introduction

vi

Planet of Wonders

"Nature is what we see," wrote the great poet Emily Dickinson. We often miss the beauty and simplicity of nature, she suggests, because of our "busy-ness" and distractedness. These days, we often miss the glories of nature because of justifiable concerns that climate change and the challenges of sustainability may efface some of those glories. But there is much to see in *Planet Earth: An Illustrated History,* for the purpose of this book is to make you stop and revel in the diversity, fecundity and majesty of our planet and its life-forms. Its extraordinary beauties only reaffirm the countless reasons we should care about the future of life on Earth.

This book is not meant to be a textbook or an encyclopedia of the natural world. Even so, *Planet Earth* offers readers a wonderful and wonderfully visual intro-duction to all the natural sciences: biology, zoology, geology, meteorology, oceanogra-phy and animal behavior. It is a kind of visual poem that invites us to see the glories of the natural world. (Ms. Dickin-son would be proud.) Inside, in exquisite photography, you will see nature's eternal and deadly dance between predator and prey, the curious and improbable ways that species adapt to their ecosystems, the fascinating ways that animals and plants reproduce and mature, the lyrical beauties of our most remote and familiar land-scapes. Share the thrill of scientists who are dissecting the first intact specimen of a colossal squid; smile as you watch a beluga whale blowing doughnut-shaped rings of air, just for fun; and marvel as a fuzzy caterpillar blossoms into a butterfly whose wings are as clear as glass and as toxic as a nightshade plant.

The book explores the planet by dividing it into six broad zones first described by the ancient Greeks yet still used by scientists today: the atmosphere, the pedosphere (the land planet), the hydrosphere (the water planet), the biosphere (the living planet), the cryosphere (the polar zones) and the geosphere (tectonics and infrastructure). But none of these spheres exist on their own: they survive and thrive through a complex interplay—as we see when a sand-storm in Africa sends minerals essential to life across the Atlantic to the Brazilian rain forest; or when the hard exoskeletons of billions of tiny dead animals, coral polyps, combine to form one of the planet's largest geographical wonders, Australia's Great Barrier Reef.

The force that drives the water through the rocks, wrote Dylan Thomas, drives our blood. Everything connects. So, have a look, and enjoy the view. Earth is for the living, said Thomas Jefferson, and *Planet Earth: An Illustrated History* is for you.

—*Richard Stengel*
Managing Editor, Time

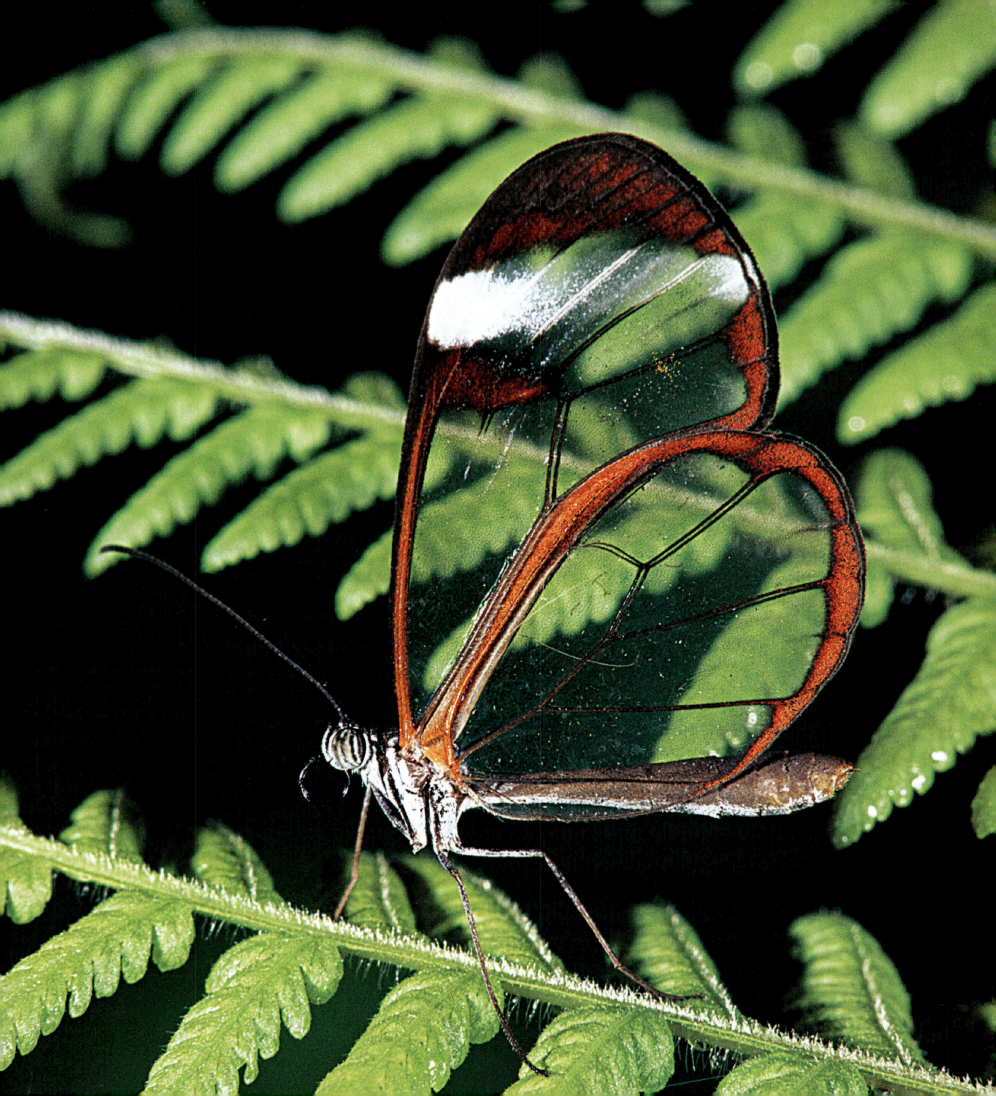

atmosphere

at·mos·phere *(n.)*
[Gk *atmos* vapor + Gk *sphaira* ball]
a gaseous mass enveloping a heavenly body (as a planet
or satellite); the world of the air

Smudges *Morning fog made up of condensing water vapor cloaks a rain forest in Borneo*

Air's Layers
Scientists divide the planet's atmosphere into four distinct strata:

Troposphere: The lowest layer of the planet's blue cocoon is *our* layer: the ocean of air in which humans and animals live and weather events occur. It extends upward from the surface of the planet for 12 mi. (19.3 km); temperatures drop as the distance from Earth increases and the air thins. The troposphere's thickness changes with the seasonal position of the planet relative to the sun.

Stratosphere: The next layer of the atmosphere extends to 31 mi. (50 km) above the planet. Oxygen here is far too scarce to support life—but temperatures actually increase in the higher regions of the troposphere, for this is where the ozone layer lies, and ozone heats up as it absorbs the sun's harmful ultraviolet rays.

Mesosphere: The third layer of the atmospheric onion extends 53 mi. (85 km) above the planet. Beyond the reach of research balloons, it is a relatively unexplored region of the atmosphere.

Thermosphere: The atmosphere's highest layer—made visible by auroras—extends to the verge of outer space, some 430 mi. (692) above Earth. Its thin air makes up a tiny fraction of the atmosphere's total mass.

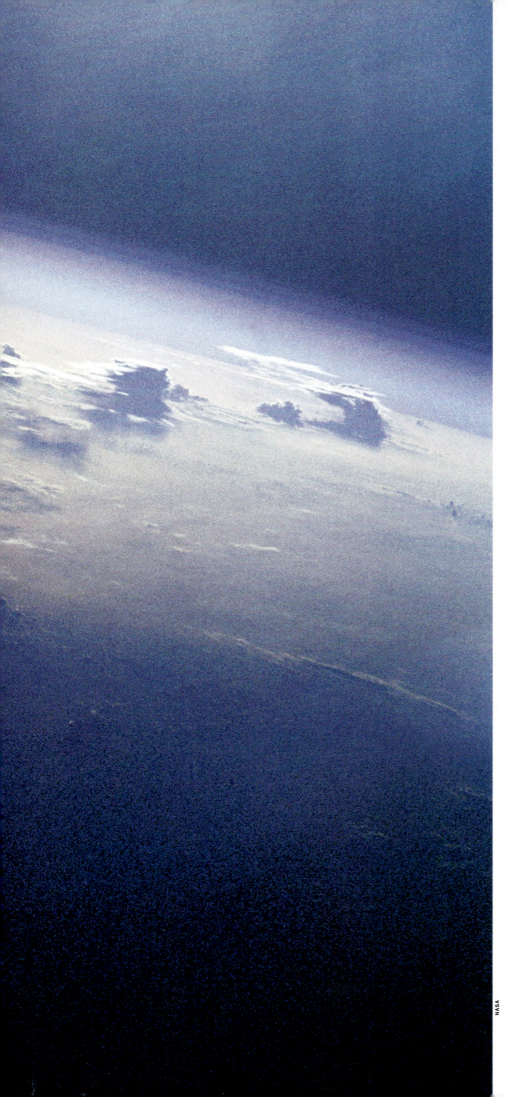

The Blue Cocoon

Of all Earth's wonders, perhaps the most wonderful is something that often is invisible and is almost always taken for granted: the atmosphere, the cocoon of gases that envelops the planet and makes life possible. All of human history (until very recently, with the advent of space travel) and all phenomena associated with the globe's climate and weather have taken place in this relatively thin layer of gases, which can be seen as a ribbon of blue swaddling the planet in this NASA photograph. The atmosphere serves our world as a kind of celestial moat, a protective barrier that shields Earth from the damaging ultraviolet rays of the sun and also from the potentially harmful impact of the some 1.4 million small meteoroids that burn up and vaporize as they come in contact with it each day.

The crater-scarred surface of the moon, whose atmosphere is very thin, is a chilling reminder of what our planet might look like were it not for the atmosphere. And the extinction of the dinosaurs, now believed by many scientists to have been caused by the impact of an enormous object that barreled into the planet some 65 million years ago, is a reminder that some asteroids are much too large to be consumed by the planet's airy buffer zone.

Earth's vast ocean of air extends, if thinly, to some 430 miles above the planet's surface, where it merges with outer space. It is composed of gases such as nitrogen, oxygen, argon, carbon dioxide and water vapor, as well as the host of small, wind-borne liquid and solid particles that scientists call aerosols: dust and soil, pollen, ash from volcanoes, sea salts churned up and made airborne by breaking waves. It is these particulates that turn the sunset red and orange, when the rays of the sun strike Earth through a thick swath of the atmosphere as the star declines to the horizon.

Nitrogen and oxygen make up 99% of the atmosphere; yet the carbon dioxide (CO_2) that composes only some 0.03% of air is the focus of grave scientific concern. Carbon dioxide and water vapor are greenhouse gases; like the panes of glass on a greenhouse, these substances allow solar heat to pass through the atmosphere but not back out, trapping it inside. As the amount of CO_2 in the air grows, largely owing to mankind's burning of fossil fuels, the resulting gradual heating of the planet is driving unpredictable climate change. ∎

Orb of air *The atmosphere, which is most often seen by humans in the form of a red sunset or smog, is clearly seen as a ribbon of blue surrounding the planet in this 1999 photo*

5

Star Power

The sun makes life on Earth possible, yet the bond between our planet and the star we revolve around is both so intricate and so all-pervasive that some of its aspects can easily be overlooked. Night and day, the seasons, the climate, the atmosphere, the tides: all these elemental facets of life on Earth reflect our dependence on the sun.

Consider solar flares, or prominences, the phenomena captured in the picture at left. A solar flare is a gigantic eruption of the ionized gases, or plasma, that make up the surface of the sun, where the daily forecast typically calls for temperatures of 9-10,000°F. Some solar flares are hundreds of thousands of miles long, so vast they could straddle the distance between the Earth and the moon. Flares are only the most spectacular display of a process that is constantly taking place within the sun: the emission of charged, or ionized, particles from the star in the form of solar wind. When these particles reach Earth, they can light up polar skies in the form of auroras.

Solar flares, like the magnetic storms we call sunspots, peak in an 11-year cycle, for reasons we do not yet fully understand. At such times, the flares can play havoc with mankind's more advanced systems. In 1989 a massive solar flare disrupted Canada's power grid, shutting it down in some areas and putting all sorts of radio-activated devices on the fritz. Homeowners in Toronto who watched their garage doors opening and closing over and over again for no visible reason may have directed their ire at their local utility provider but should instead have blamed that usually beneficent orb, old Sol. ∎

Sun Spottings *At left, a giant solar prominence erupts on Sept. 14, 1999, in an ultraviolet image recorded by NASA's SOHO spacecraft (Solar and Heliospheric Observatory). The white areas in the image are the hottest. At right, the sun's corona is seen during the last stages of a total solar eclipse on June 21, 2001. The corona, only visible from Earth during eclipses, is made up of plasma, charged particles, and is 200 times hotter than the surface of the sun, for reasons not yet fully explained. This image has been slightly enhanced to make the corona more visible and to simulate its appearance to the naked eye*

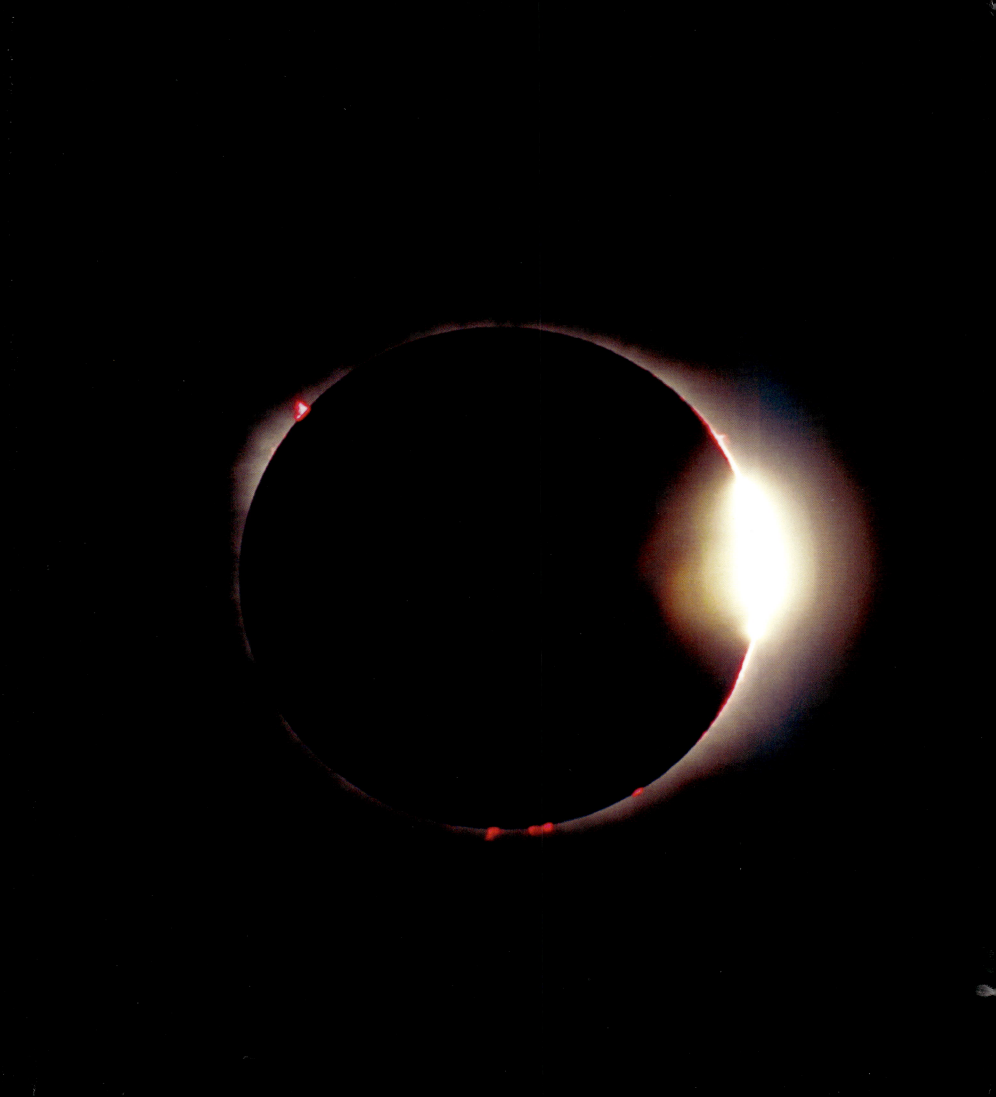

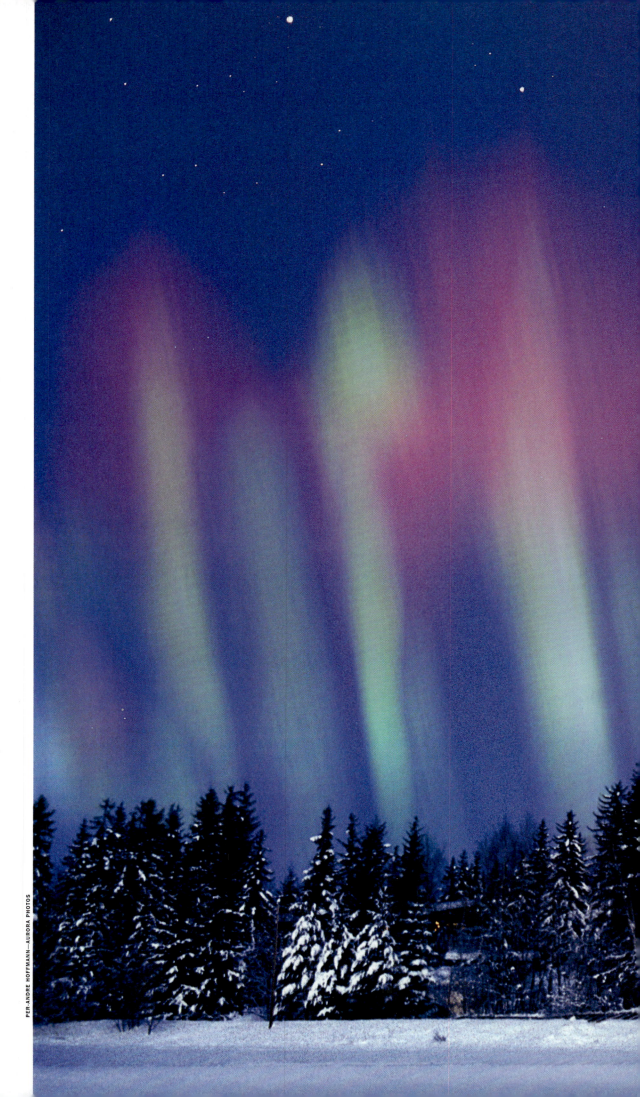

Visions in the Sky

A full-on display of the aurora borealis or aurora australis—the northern and southern lights— is among nature's most breath-taking wonders. Generally visible only in regions closest to the North and South poles, the two auroras at their best are staggeringly beautiful, rainbows on steroids. In addition to their eerie, iridescent splendor, the auroras are also among the largest of Earth's wonders visible to the naked eye. These natural light shows illuminate the sheer scale of the planet, beaming across hundreds of thousands of miles of the thermosphere to bring this vast, normally invisible highest region of the atmosphere into sudden, bewitching focus.

Most often shimmering like curtains but at other times beaming like the rays from a giant flashlight, the auroras have transfixed viewers since the dawn of history. The folktales of many northern-dwelling peoples associate them with mythological entities. Finns believed their light shone from fiery foxes; other, perhaps hungrier, Scandinavians regarded them as the reflections of vast schools of herring. Algonquin Indians saw them as departed ancestors dancing around a fire, and ancient Scots agreed, calling the lights *na fir-chlis*, "merry dancers."

Only since the first years of the 20th century have scientists, led by Norwegian physicist Kristian Birkeland, begun to explain the complex celestial mechanisms that create auroras. The process begins with the solar wind, the constant flow of ionized gases, or plasma, that is emitted in all directions by the sun. When these electrically charged particles flow into Earth's magnetic field, or magnetosphere, they are excited and emit energy in the form of colored light. The auroras peak in unison with the sun's 11-year cycle of sunspot activity, but intense solar flares can produce spectacular displays at any time during the cycle. These phenomena are also present in skies far from Earth: future space travelers can look forward to enjoying the auroras that have now been documented on Jupiter, Saturn, Mars, Uranus, Venus and Neptune, as well on three of Jupiter's moons: Io, Europa and Ganymede. ∎

Shimmering *The aurora borealis appears in its most common "curtain" form above a home in Kautokeino in northern Norway*

8

PER-ANDRE HOFFMANN—AURORA PHOTOS

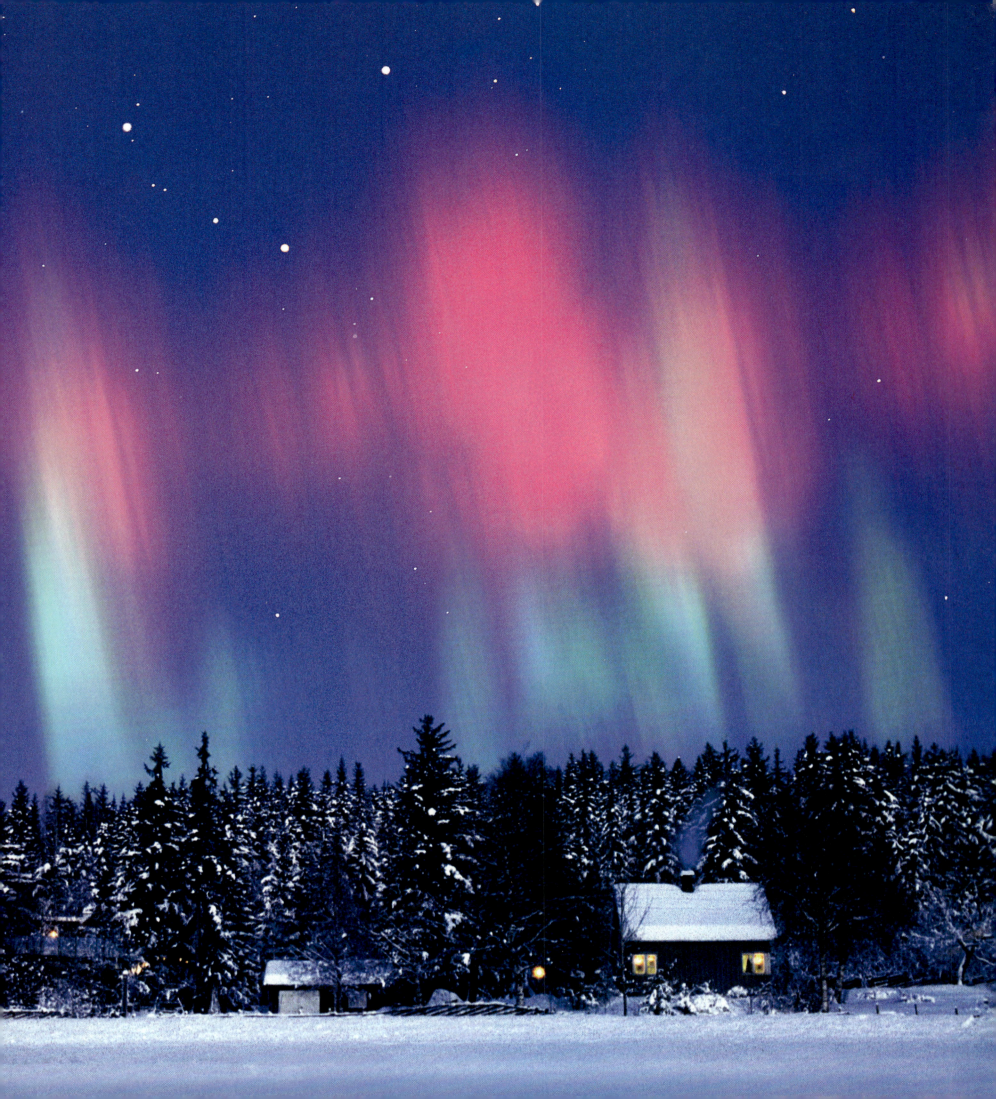

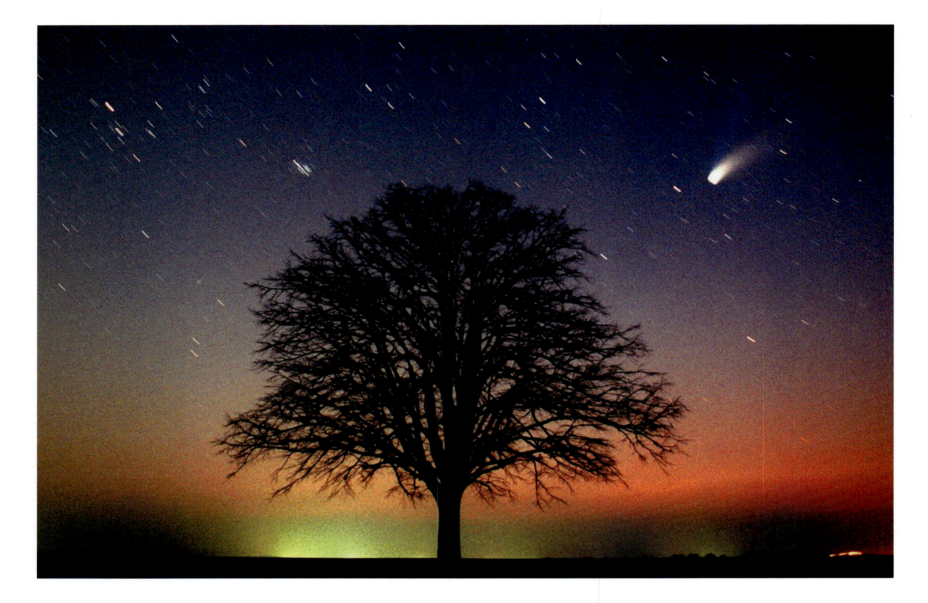

Just Passing By

On Dec. 25, 1758, a visitor from the heavens brought great tidings to Earth. That Christmas night, Johann Georg Palitzsch, a German farmer and amateur astronomer, noted a tiny smudge of light in the sky. This sighting was the first proof of one of the most hotly debated scientific issues of the time: noted British astronomer Edmond Halley's prediction that the comets referred to in histories of the years 1682 and 1531—as well as the comet viewed by the famed pioneering astronomer Johannes Kepler in 1607—were all observations of the same heavenly body, which is visible from Earth every 75 years or so as it orbits the sun. Halley's estimate that the comet would return in 1758 was thus proved true in the last week of the year. Sadly, the scientist died in 1742, too early to see his prophecy fulfilled.

Early humans believed comets were portents that presaged historic events. As outlaws in the sky that do not follow the familiar patterns of the stars and planets, comets and their long, wispy tails have long been of special interest to astronomers. At one time they were believed to resemble aggregates of ice pebbles akin to flying shoals of gravel. In the mid-20th century, U.S. astronomer Fred Whipple proposed that comets were conglomerates of ice and dust, and flybys of Halley's last appearance in 1986 and of Comet Borrelly in 2001 confirmed that those comets indeed resembled "dirty snowballs." However, data from Borrelly also showed that it has a hot, dry surface, so scientists remain uncertain as to the amount of ice present within any given comet.

Scientists enjoyed their closest encounter with a comet in 2005, thanks to NASA's Deep Impact mission, in which a spacecraft sent a probe crashing to the surface of Comet 9P/Tempel. The probe successfully excavated debris from the comet's nucleus, which photos indicated was less dusty and held more ice than predicted, unlike Borelly. The debris was also finer than expected, more like talcum powder than sand.

A comet's signature tail is created by the same force that shapes auroras: the solar wind, made up of charged particles released by the sun, excites the ice and dust in a comet. These charged elements are in turn released in the glowing arcs of the tails, which sometimes are clearly seen to be twins, one of gas and one of dust, which always point away from the sun. ∎

Voyagers *At left, Comet Hale-Bopp lights up the sky in Gotha, Germany, on April 2, 1997, almost two years after it was discovered independently by Alan Hale in New Mexico and Thomas Bopp in Arizona on July 23, 1995. Hale-Bopp put on one of the more prominent displays of any comet in recent decades.*

On this page is Comet McNaught, photographed over Dunedin, New Zealand, on Jan. 18, 2007. Discovered by British-Australian astronomer Robert H. McNaught, this was a very bright comet; visible to the naked eye in the Southern Hemisphere early in 2007, it could even be seen during daylight hours by those with sharp eyesight.

"Non-periodic" comets like McNaught orbit the sun on a cycle lasting longer than 200 years; "periodic" comets like Halley's have shorter cycles. "Great comets" are those that can be seen with the naked eye.

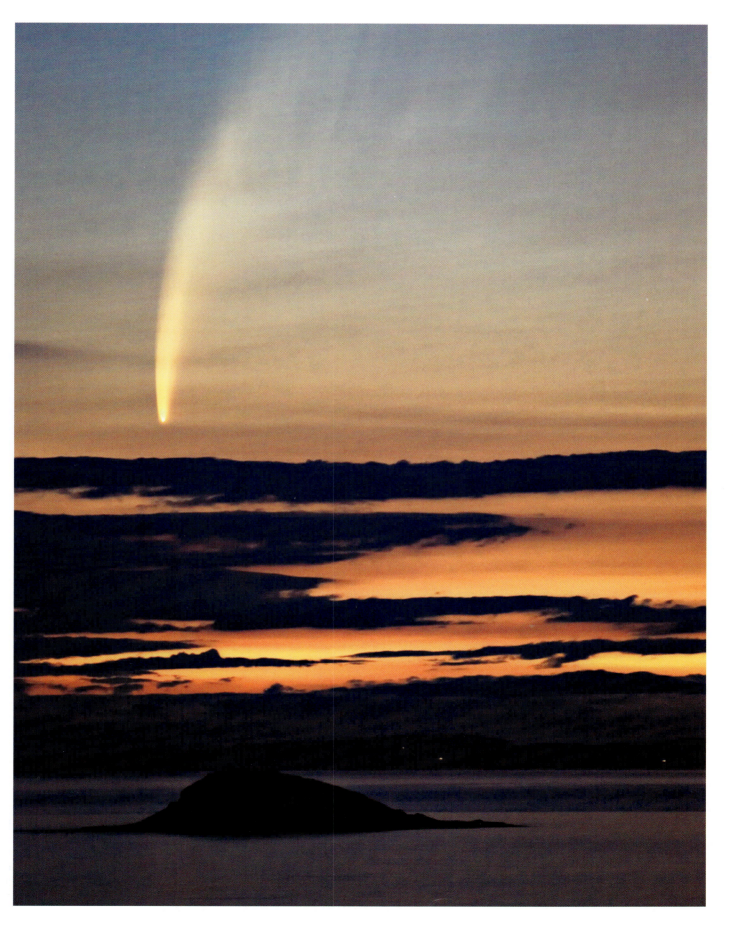

11

DAVID CURTIS—REUTERS—LANDOV

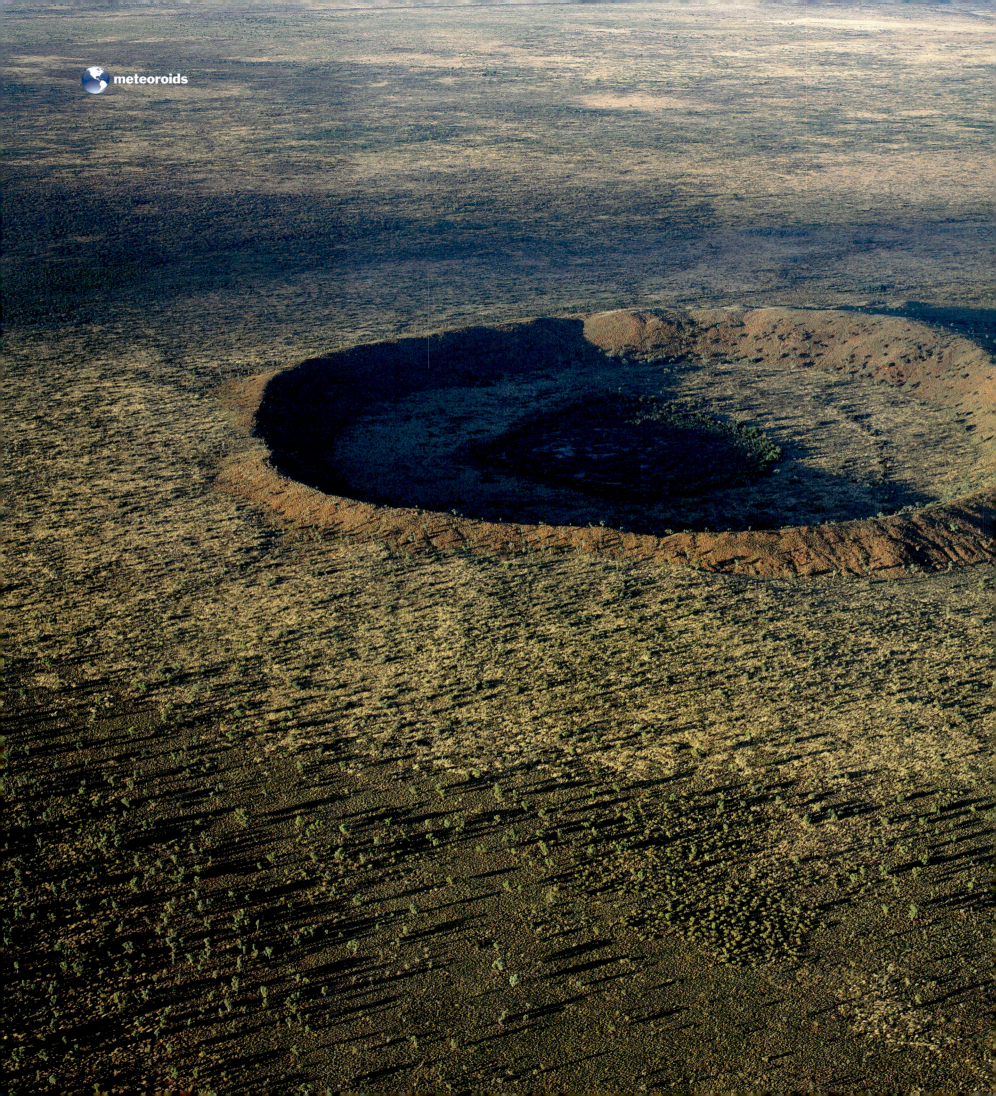

Celestial Tattoos

Each day some 1.4 million meteoroids become captives of gravity and pass into Earth's atmosphere. The vast majority of these unexpected visitors are small objects that die memorably, heating up and disintegrating as they encounter the planet's invisible barrier of air and leaving fiery scrawls of sparks across the sky. Other meteoroids, like those we see during the Leonid and Perseid meteor showers, are the predictable result of the planet's annual rendezvous with clusters of small objects also in orbit around the sun. And a very few meteoroids are of such an enormous size as to change the course of history.

One such impact with a celestial object estimated to be 6 miles (9.6 km) in diameter took place in the region of Chicxulub on Mexico's Yucatán Peninsula some 65 million years ago. That event is now believed by many scientists to have sent so much debris into the planet's skies that much of its vegetation died off, resulting in the extinction of the dinosaurs. Yet meteoroids may also be life givers; some scientists believe life may first have traveled to Earth in the form of bacteria carried on them.

The terminology of these heavenly bodies is precise: meteoroids are small objects drifting in outer space; meteors are meteoroids that have entered the planet's atmosphere and are often visible as "shooting stars"; meteorites is the term used to describe a meteor once it has landed on Earth. One such unexpected arrival took place in Freehold Township, N.J., on Jan. 2, 2007, when a meteor crashed through the roof of a home, bounced off a tile floor and came to rest embedded in a wall, now a meteorite. Roughly the size of a golfball, the object weighed a bit less than a pound. Fortunately, the event caused no harm to human beings—or dinosaurs. ■

13

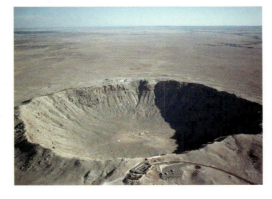 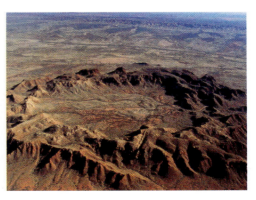

Too-Close encounters *Three impact craters—at left, Wolfe Creek in Australia; above left, Barringer Crater in Arizona; above right, Gosses Bluff in Australia—offer dramatic evidence of the result of collisions between Earth and large celestial objects. The possibility of such collisions is now of consuming interest to scientists, especially since the 21-part Shoemaker-Levy 9 comet smashed into Jupiter in 1994 with a force far exceeding that of mankind's entire current arsenal of nuclear weapons*

Collision Course?

"That one would have punched right through the atmosphere with no trouble," Donald Yeomans told TIME early in 2008. Yeomans is the director of NASA's Near Earth Objects (NEO) program, which means he's in charge of hunting comets and asteroids whose solar orbits put them on a potential collision course with our planet. He is referring to 2007 TU24, a 750-ft. (229 m) -long chunk of rock that went whizzing past our world on Jan. 29, 2008, going 6 miles per second—yes, that works out to be 21,600 m.p.h.

Spotted the previous October, TU24 was listed by NASA as a "current impact risk" until just over a month before it flew by. If it hadn't missed us, Yeomans estimates, the asteroid would have survived Earth's only line of defense—the atmosphere, which burns up all but the largest objects inbound from space—and would have detonated with an explosive force equivalent to 100,000 Hiroshima-sized atom bombs. Such a blast over land could erase an area the size of New England. If it hit the ocean, its impact would have sent massive tsunamis radiating in every direction.

"Hundreds of tons of interplanetary material rain down on the Earth every day," Yeomans says. "Most of these are very small particles, but we get objects the size of a basketball every 24 hours or so, and something the size of a Volkswagen roughly once a week." All of them are incinerated by the atmosphere. But any asteroid with a diameter of more than 460 ft. (140 m) is likely to penetrate our protective blanket of air and cause serious damage on the ground. "That size would cause a regionally destructive event," he says. "Objects in the range of 1,000 ft. (304 m) across would devastate entire countries. Anything more than 1 km in diameter would cause worldwide problems."

Not so long ago, nobody was looking for killer space rocks. "In the early 1990s, our biggest problem was the 'giggle factor,'" Yeomans says. "People assumed we were nutty scientists or else interpreted [our concerns] as a cynical scare tactic to get our research funded. But in 1998, two not very good movies about objects from space potentially devastating the planet—*Deep Impact* and *Armageddon*—were big hits, and suddenly the public and elected officials were willing to take the threat seriously. That was the year Congress finally agreed to budget money for the NEO program."

Since 1998, Yeomans and his colleagues have been systematically scanning the skies for "asteroids that have Earth's name on them." So far, they have identified 948 "Potentially Hazardous Asteroids," space rocks close enough to slam into Earth and large enough to penetrate the atmosphere. That's about 90% of the biggest global threats, they believe. They're now turning to the second phase of their search: compiling a catalog of the far more numerous asteroids that could cause regional or national devastation. More than 50 of those big enough to make the regionally destructive cut are expected to make close approaches to Earth in 2008 alone, and fully half of these were spotted for the first time in the past five years. "We're going around the sun in a swarm of near Earth objects, many of which could hit us," Yeomans observes.

But what's the point in spotting incoming artillery if you can't do anything about? "Actually, there's quite a lot we could do about it," Yeomans says. He points to the statistical likelihood that an incoming asteroid large enough to cause widespread destruction would be spotted as long as decades in advance. "We think we've found most of the very large asteroids," he says, "and we're now tracing their movements into the future. So almost certainly, if one of these is going to hit Earth, we'll know 20 to 40 years in advance."

Given that amount of notice, Yeomans says, current technology could give the asteroid a slight nudge, just enough to speed it up or slow it down slightly. "Over the vast distances and lengths of time we're talking about," he explains, "this would be enough to ensure that the asteroid crossed the path of Earth's orbit either too early or too late, and simply miss us."

This gentle shove could be achieved in a number of ways. "A rocket engine the size of the one on the space shuttle would be more than big enough," Yeomans says. "Or a lens to concentrate incoming solar energy could be used to boil off part of the surface and create a jet effect. It might even be possible to attach a solar sail to the object, a large membrane that would be 'pushed' by solar radiation the way a canvas sail is by wind." One nonstarter as a tactic, he says, is "the Bruce Willis approach. You wouldn't want to blow up a large asteroid, because then you'd have a shotgun blast of incoming debris, rather than a single bullet."

Asked if he worries his labors may be in vain, Yeomans notes that large asteroids have already gouged out more than 300 impact craters around the land planet, with many more likely still undiscovered or made unrecognizable by the passage of time. "More impacts are coming," he says. "It's a question of when, not if." ∎

Burnout *A meteor shower paints streaks in the sky over Joshua Tree National Park in California. Unlike the "killer" NEOs tracked by NASA, the objects in such annual meteor showers as the Perseids and the Leonids are too small to pass through the atmospheric barrier intact and damage the planet*

RICHARD CUMMINS—CORBIS

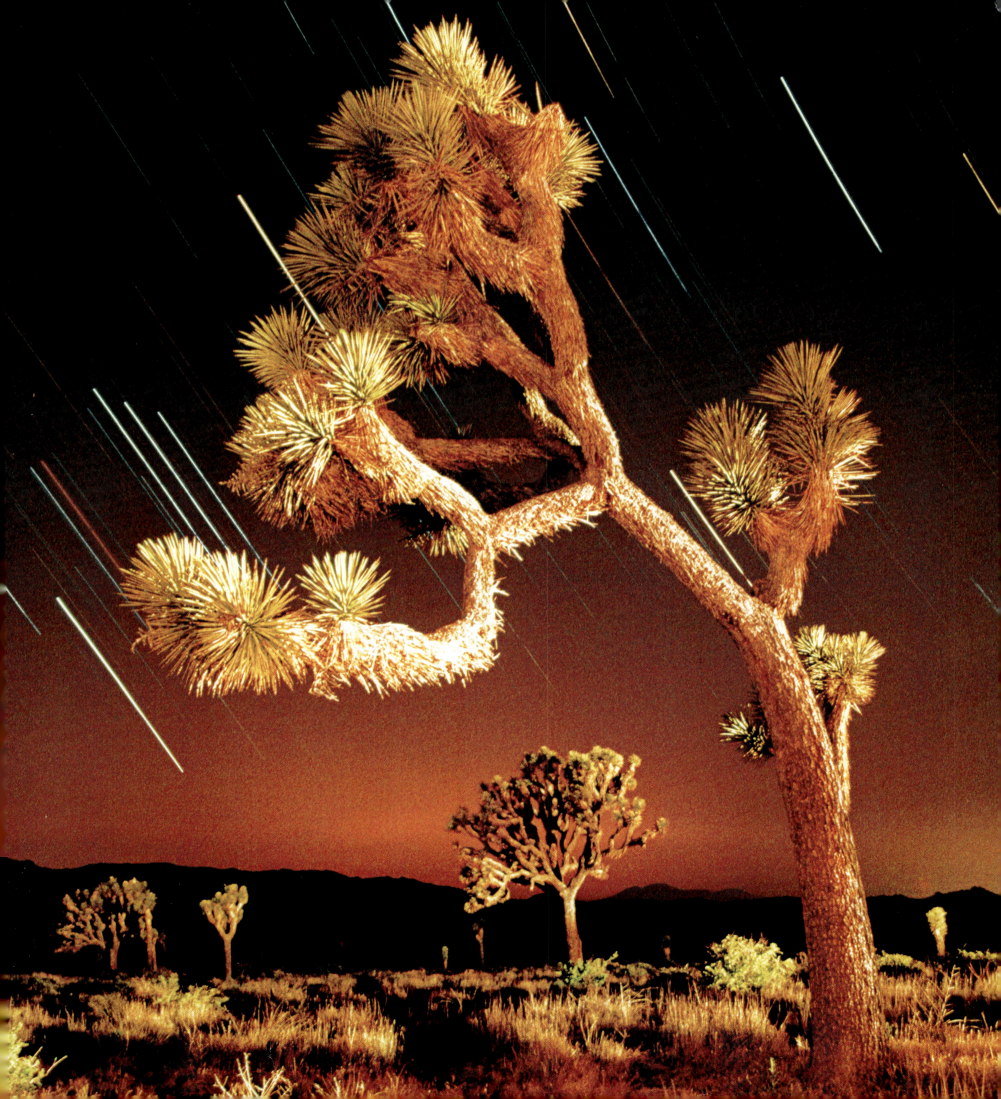

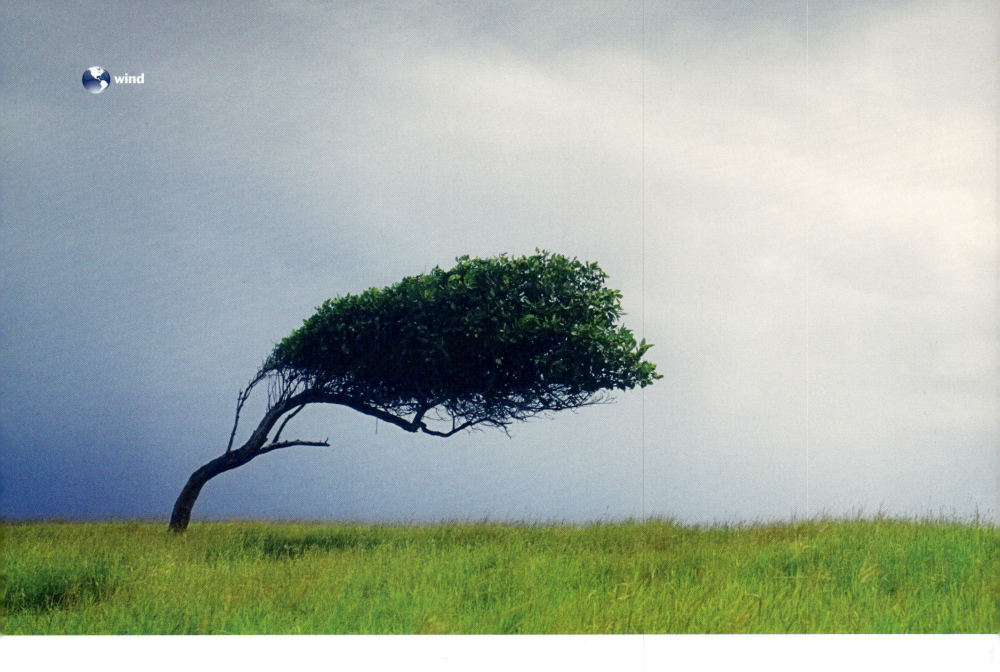

Breath of the Gods

"The wind goeth toward the south, and turneth about unto the north," the Old Testament's Book of Ecclesiastes reports. "It whirleth about continually, and the wind returneth again according to his circuits." This ancient forecast is still accurate, but what exactly, uh, driveth the wind, one of nature's most essential, if unseen, forces? The circulation of air is powered by the same source from which all earthly energy comes, either directly or indirectly: the sun.

As the sun's warming rays fall upon the planet, the air doesn't toast evenly: the equator receives more direct, concentrated rays than do the poles, so temperatures around the equatorial belt are higher. This mass of warmer air responds by expanding and floating upward. Since the expanding air is thinner than the surrounding atmosphere, as it rises, there's less of it near the ground, causing a local drop in air pressure. Since nature abhors a vacuum, nearby masses of cooler,

denser air (which is necessarily under higher pressure) rush in to fill the empty spaces.

This movement of air is the wind. Its direction is determined by the relative positions of the high and low pressure zones, and its speed is a function of the difference in pressures. Although the temperature gap between the equator and the poles is one of the primary drivers of our planet's wind, there are others: land and water absorb and hold the sun's heat at different rates, as do various kinds of terra firma. All of these asymmetries lead to local differences in air temperature, which are registered in the behavior of the wind.

The wind helps shape life on the earth and even shapes the planet itself: moving air ferries particles of sand and soil, as well as seeds, across vast distances (sometimes over entire oceans and continents). It carries both the water (in the form of vapor) that gives life and the microbes that sometimes take it away, causes clouds (and most

other weather-related phenomenon) to form, and it actually sculpts the ground, eroding solid rock over thousands of years. So familiar is the wind that local gusts have been christened with their own names, from A to Z: the Abroholos is a summer squall off the coast of Brazil, while Zephyr is the ancient Greek name for the West Wind.

Winds can even speed up and slow down the planet's rotation. El Niño storms and other strong winds that blow counter to the planet's spin can exert enough frictional drag on its surface to produce a small but measurable decrease in its speed of rotation, thus lengthening each day ever so slightly. Winters with strong westerly winds in the northern hemisphere (which puff in tandem with the earth's spin) produce a minute increase in the world's twirl, thus shortening each day by a few thousandths of a second.

The whirling globe, in turn, can drive the winds: the Coriolis force created by the earth's

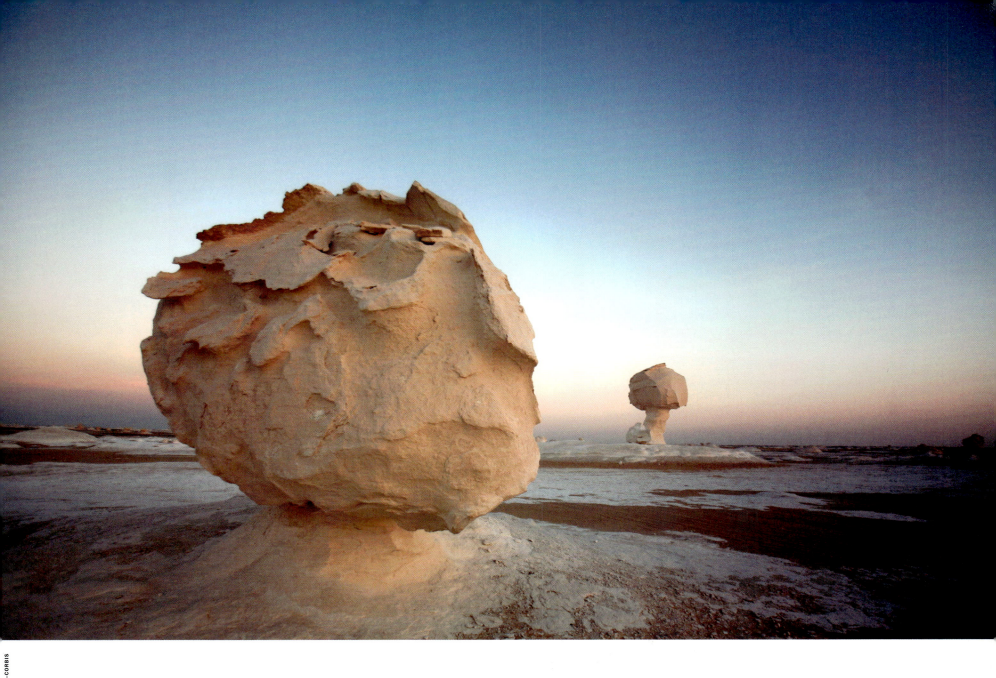

spin makes prevailing winds blow from west to east in the northern hemisphere and from east to west in the southern. It also causes hurricanes to spin counterclockwise above the equator and clockwise below.

Much of our knowledge of the wind is recent. Jet streams, the ribbons of high-altitude wind that gust around the globe at speeds of up to 250 m.p.h. (400 km/h), were first observed by amateur meteorologist Clement Ley in the 1880s and were not actually encountered until the 1930s, when pioneering aviator Wiley Post took a small plane up to 40,000 ft. (12 km) and found himself clipping along at twice the speed his engine could produce. Yet these streams play a key role in shaping the planet's climate. The more we learn about this potent but invisible force, the more the ancient Greeks seem to have had the right description for it: wind, they claimed, is the breath of the gods. ■

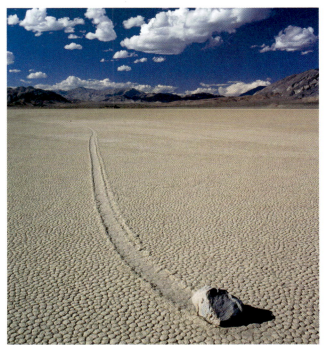

Shooting the breeze *The wind is invisible, but these three pictures capture its power. At left above, a cypress tree on the Caribbean island of Barbados has been contorted into a permanently twisted shape by steady breezes. At top right, winds have eroded the outer layers of chalk deposits to shape odd globular forms in Egypt's White Desert, the Sahara el Beyda.*

At left, a strong gust of wind has moved a rock across the dry bed of the Death Valley desert in the U.S., leaving behind a clear trail of its movement.

Forecast: Monsoons of Grit

The Arabic words for "wind" and "phenomenon" merge to form the term haboob, which scientists use to describe the enormous sand and dust storms that are a regular feature of life in many desert climes. Although haboobs form primarily in a broad swath of arid land stretching from northern Africa across the Arabian Peninsula to Iraq and Iran, they also occur in other areas of the world, including the desert regions of the U.S. Southwest.

Haboobs can be thought of as dry monsoons that pelt the ground with particulate matter instead of rain. They generally form when the low-pressure conditions that create thunderstorms collapse. As cold air from high altitudes rushes into the former area of low pressure, it first thrusts toward the ground, then is deflected outward. The resulting winds may pick up as much as several hundred tons of loose desert debris. The unforgettable result is a giant brown or black wall of violently churning grime, most often 1,000 to 3,000 ft. high and as much as 60 miles wide, whose winds bear suspended particulates at up to 60 m.p.h.

In this picture, a haboob bearing sand and dust from the Sahara Desert rolls into Khartoum, Sudan's capital. Residents of the Middle East are so familiar with such storms that they have given them specific names. The season's first storm, which usually arrives in the last week of May, is called al-Haffar, or "the Driller," because it scrapes huge holes in desert sand dunes. The next, which often comes in early June, is called Barih Thorayya, since it arrives with the dawn star, Thorayya. The last storm of the season is al-Dabaran, "the Follower"; it's infamous for carrying a form of microscopic dust that finds its way into every crevice and corner in its path. ∎

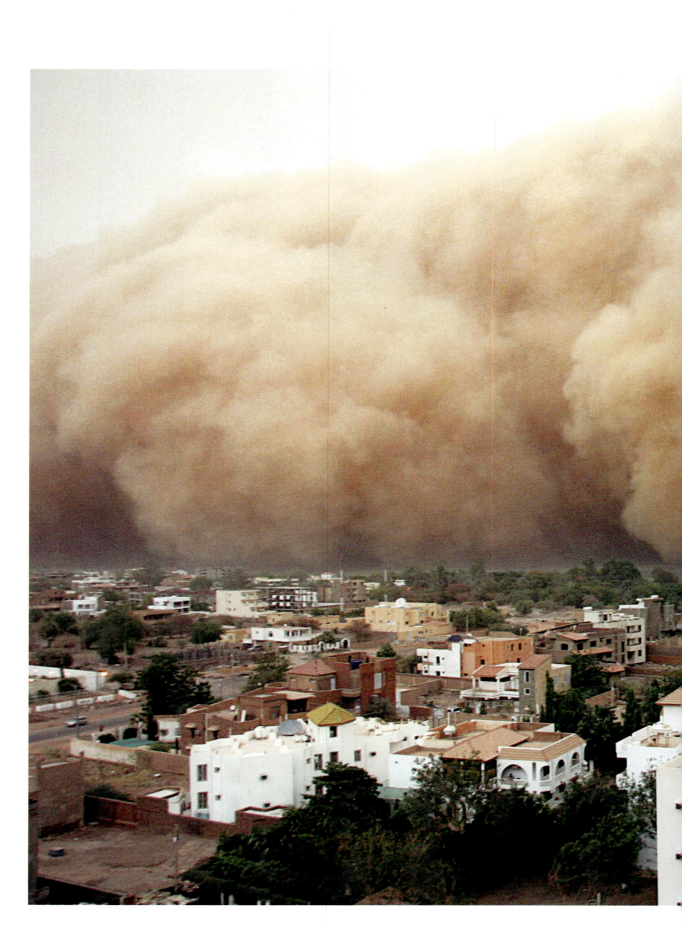

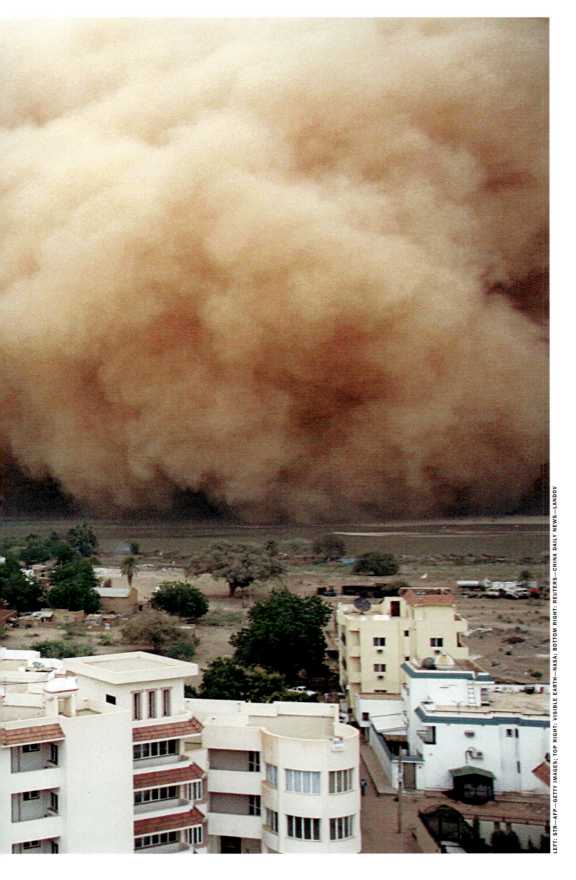

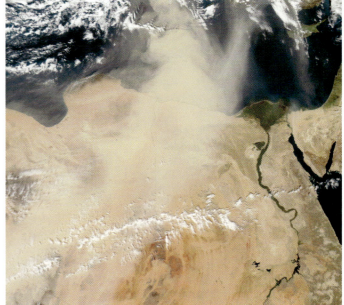

Special delivery from Africa *Haboobs can be so enormous as to straddle continents: in extreme cases, sand kicked up by North African haboobs can be deposited as a film of talcum-like dirt on cars in southern Europe. In the satellite image above, sand from the Sahara Desert is moving north across Egypt and crossing the Mediterranean Sea. Next stop: Europe. The Nile delta is visible as a triangle of green to the right of the sandstorm. Scientists are only beginning to probe the important role played by sandstorms in moving minerals and seeds around the globe*

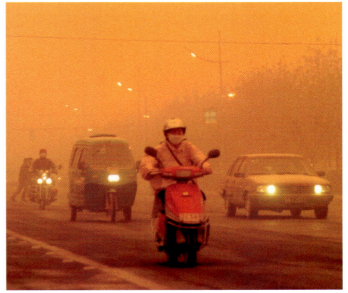

Sandstorms in an oasis city *Motorists drive through a haboob in Turfan (Turpan), an oasis city in northwest China that is surrounded by arid plains and receives less than 1 in. of rainfall a year. The nearby Turfan Depression, a trough created at the border of two tectonic plates, makes Turfan one of the world's lowest-lying cities. An ancient system of wells and canals brings water into the city, making it habitable for humans*

Hammer of the Gods

The Greeks called lightning the "thunderbolt" and depicted it as a jagged line of energy hurled by Zeus to dazzle and intimidate human beings. And while we now know that lightning is a form of electricity rather than a divine diversion, scientists still don't completely understand its complex mechanisms. We know that most lightning begins when clouds acquire an electrical charge, or become ionized, with the upper portion usually positive and the bottom portion most often negative. But we still don't understand in full the forces that drive the charging of the air. On one point there's no doubt, however: this ionized air is highly conductive and provides a pathway for electrical energy to flow to earth.

A strike occurs when an ionized column of air connects two areas with opposite charges, which are always attracted to each other. As the ionized air extends its force outward in the form of negatively charged "stepped leaders," the ground responds to this strong electrical field by sending "positive streamers" upward. When a stepped leader meets a positive streamer, a current flows between cloud and earth in the form of plasma, discharging energy in a familiar one-two punch: FLASH! … BOOM! The delay between the blinding flash of light and the shockwave we hear as a sonic boom is everyday proof of a familiar principle: light travels far faster than sound. ■

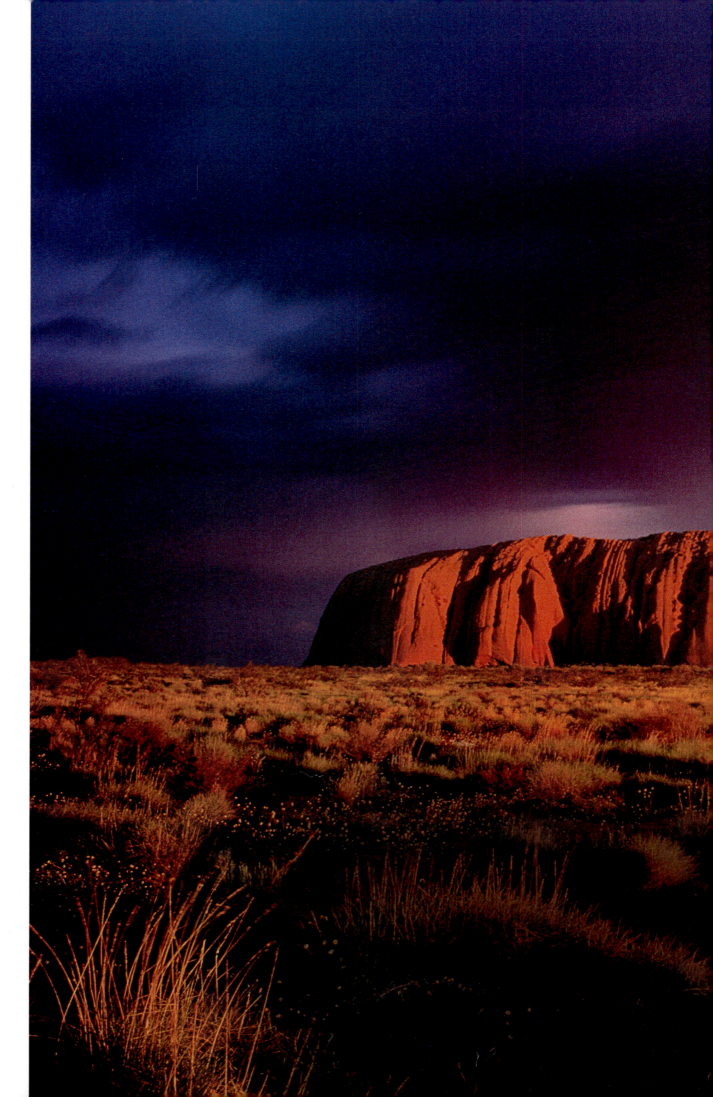

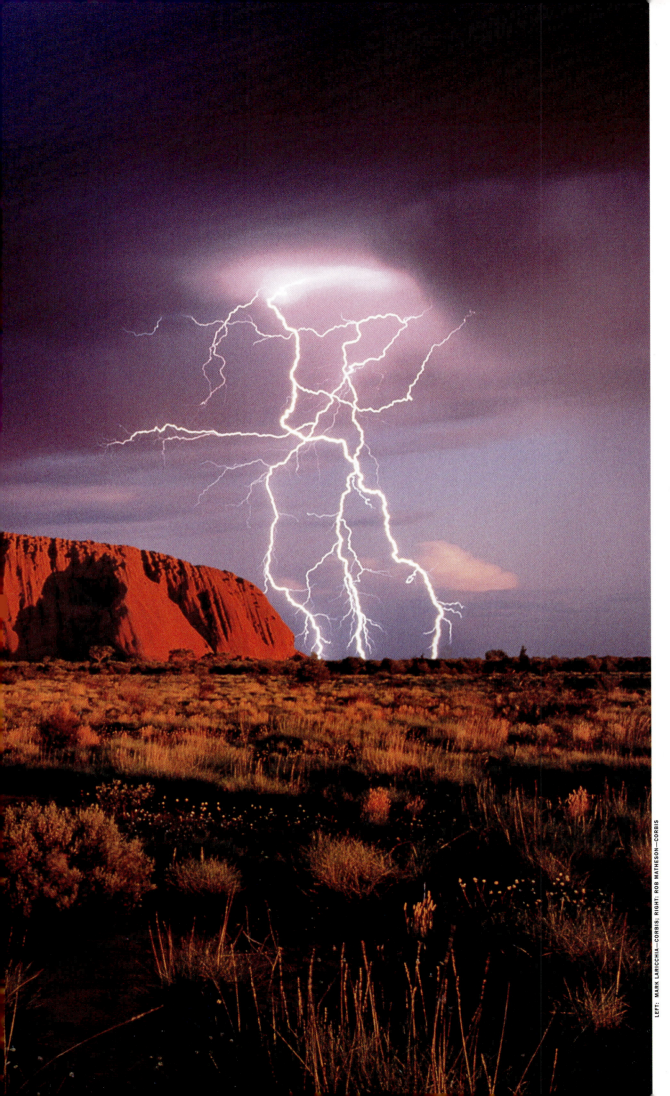

Nature's fireworks *Lightning strikes are more common around the globe in regions where both temperatures and humidity levels are high. For those reasons, areas near the equator generally experience more electrical storms. The most lightning-prone region on the planet is in the Democratic Republic of Congo. In the U.S., the region that experiences the highest number of lightning strikes each year is central Florida, where afternoon thunderstorms are almost a daily occurrence.*

At left, lightning bolts touch ground at Ayers Rock/Uluru in the Australian outback, one of the planet's most striking geological formations; above is a twin strike in Rio de Janeiro.

From the dawn of history, lightning was one of the great scourges of mankind, often sparking deadly fires. It was not until the 18th century, when scientists and educated laymen like Benjamin Franklin began delving into the secrets of electricity, that the threat of fire from lightning was finally reduced. Franklin was one of the first to propose that lightning strikes were a form of electricity and could be diverted safely into the ground by the use of metal rods mounted on rooftops. This theory, controversial and even the subject of mockery when first advanced, was proved correct by French scientists on May 10, 1752—making Franklin celebrated around the world as a benefactor of mankind.

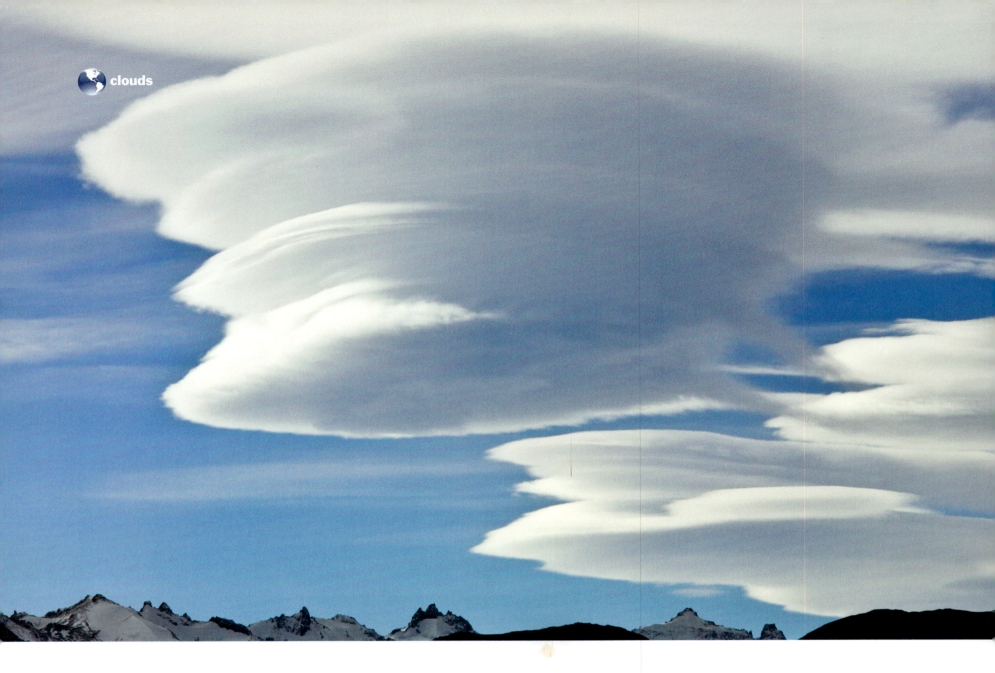

Altitude with Attitude

Water is a shape shifter: familiar in its liquid and frozen forms, it is invisible in its third form, as a vapor, until it coalesces into clouds overhead or shrouds us in ghostly fog. Clouds, in turn, are one of nature's everyday wonders, hiding in plain sight until they are touched with the sun's glory at sunrise and sunset or pile up to form a lightning-generating, anvil-headed cumulonimbus thundercloud.

Scientists divide clouds into two main categories: stratus clouds, which form a horizontal plane in the sky, and cumulus clouds, the puffy ones with cotton-candy shapes. Cloud formations reflect the influence of different levels of the atmosphere: wispy, high-flying cirrus clouds reach into the troposphere, 20,000 ft. (6,000 m) above the planet; towering middle-level clouds, identified by the prefix *alto-* (e.g., alto-stratus, altocumulus), range from 6,500 to 20,000 ft. (2,000 to 6,000 m) above our heads; low-flying clouds (including stratus and cumulus) hover around 6,500 ft. (2,000 m). When clouds come in for a landing with the ground, we call them fog. Each of the categories above is further subdivided into classifications and combinations that are of interest primarily to nephologists—an old-fashioned word for meteor-ologists who study clouds.

Since clouds are creatures of the wind, they can assume some fascinating shapes. The picture at the top of the right page shows a shelf cloud dominating the sky above Clearwater, Fla. A shelf cloud's distinct edge typically delineates the limit of a weather front; in this case, it's the leading edge of a tropical thunder-storm moving above the coastline.

Lenticular clouds are lens-shaped formations generally found at high altitudes and often shaped by the flow of wind over a mountain range. The picture above shows a tall lenticular cloud that formed above the Fitzroy Massif in Los Glaciares National Park, Argentina. At right is an unusual diamond-shaped lenticular formation above Mount Everest. ∎

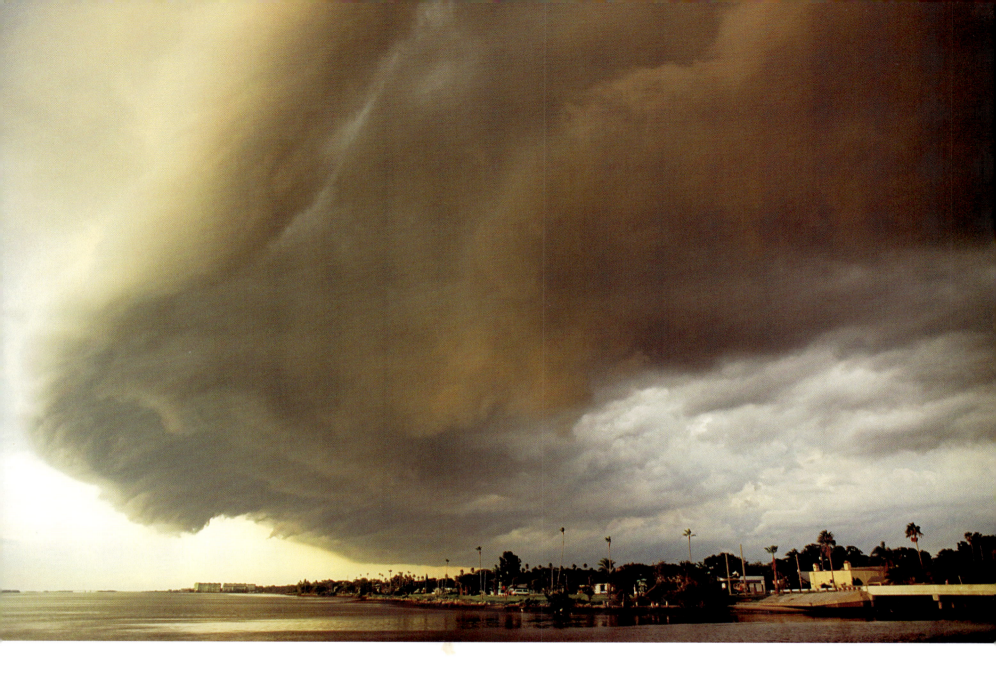

TOP: ED DARACK—SCIENCE FACTION—GETTY IMAGES; BOTTOM: JIMMY CHIN/AURORA PHOTOS

Proud clouds *A trio of splendid cloud formations: top left is a lenticular cloud in the Andes; above is a shelf cloud above Clearwater, Fla; at right, a diamond-shaped lenticular cloud atop the Himalayas.*

While some areas across the globe experience regular cloud patterns, only a few unusual cloud formations recur frequently. The best known is perhaps the "Morning Glory," a tube-shaped cloud that can be 600 miles (1,000 km) long; similar to a shelf cloud, it accompanies severe weather formations in northern Australia's Gulf of Carpentaria.

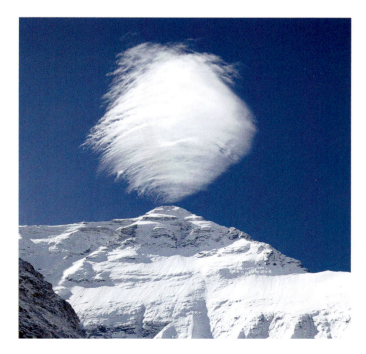

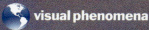

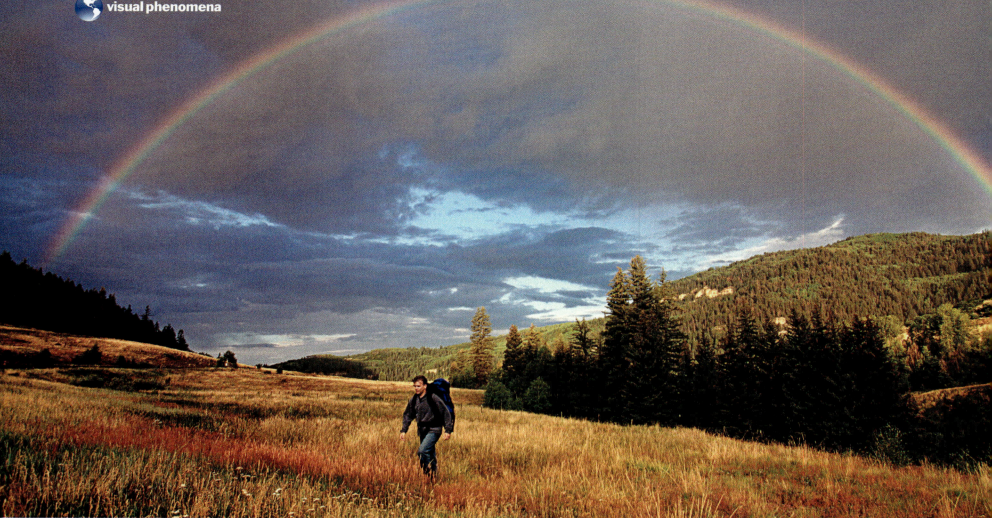

Spectacular Spectrums

Most of us would heartily agree with William Wordsworth: "My heart leaps up when I behold/ A rainbow in the sky." It's difficult not to be dazzled by this evanescent visual phenomenon, which the Old Testament calls a sign of God's covenant with Noah after the flood. The allure of this offspring of sunlight and raindrops never dims: British rock group Radiohead titled their 2007 hit album *In Rainbows*.

Rainbows are the most common form of a number of fascinating visual phenomena that adorn the skies of the planet, some so fragile that they simply can't be photographed. But what is it, exactly, we're beholding when our heart makes that familiar leap?

Rainbows are formed by the interplay between water and light. When white sunlight moves through a water droplet, it is refracted, or bent, and splits into the seven visible colors that compose it: from the outside in, that's red, orange, yellow, green, blue, indigo and violet (or "Roy G. Biv," the mnemonic chap well known to schoolkids). Why? Because each of those colors operates on its own distinct wavelength. In this case, raindrops are acting like the prisms through which Isaac Newton passed light and separated it

in his pioneering work on the science of optics.

There's more to rainbows than meets the eye: the light spectrum actually forms a circle in the sky, but our view of it is limited by the horizon, so a rainbow appears as a semicircle. But from an airplane, it's possible to see Mr. Biv as a complete circle.

An even more elusive optical event—a moonbow—occurs when moonlight passes through raindrops or water vapor and forms a circular spectrum. Moonbows are generally only seen on clear nights when the moon is full; certain of the world's waterfalls, like Africa's Victoria Falls and Lower Yosemite Falls in California, lower right, are noted for the frequency with which they spawn moonbows.

Sundogs are another of nature's fascinating optical phenomena. Scientists call them parhelions; they most often form when the sun is low in a sky filled with ice crystals within cirrus clouds. The effect varies: sometimes two false suns appear on either side of the star; at other times a full halo is visible; sometimes the visual effect more resembles a stained smudge of light with a tail than it does a false sun. In all cases, your eyes aren't playing tricks on you; nature is. ∎

Arcs of light *Above, the sky is clearing, but enough water is suspended in the atmosphere to form a rainbow in New Mexico.*

Top right, a parhelion, or sundog, composed of a solar halo and two false suns forms as ice crystals refract sunlight in the Nunavut territory in northern Canada.

Bottom right, a faint moonbow shimmers over Lower Yosemite Falls.

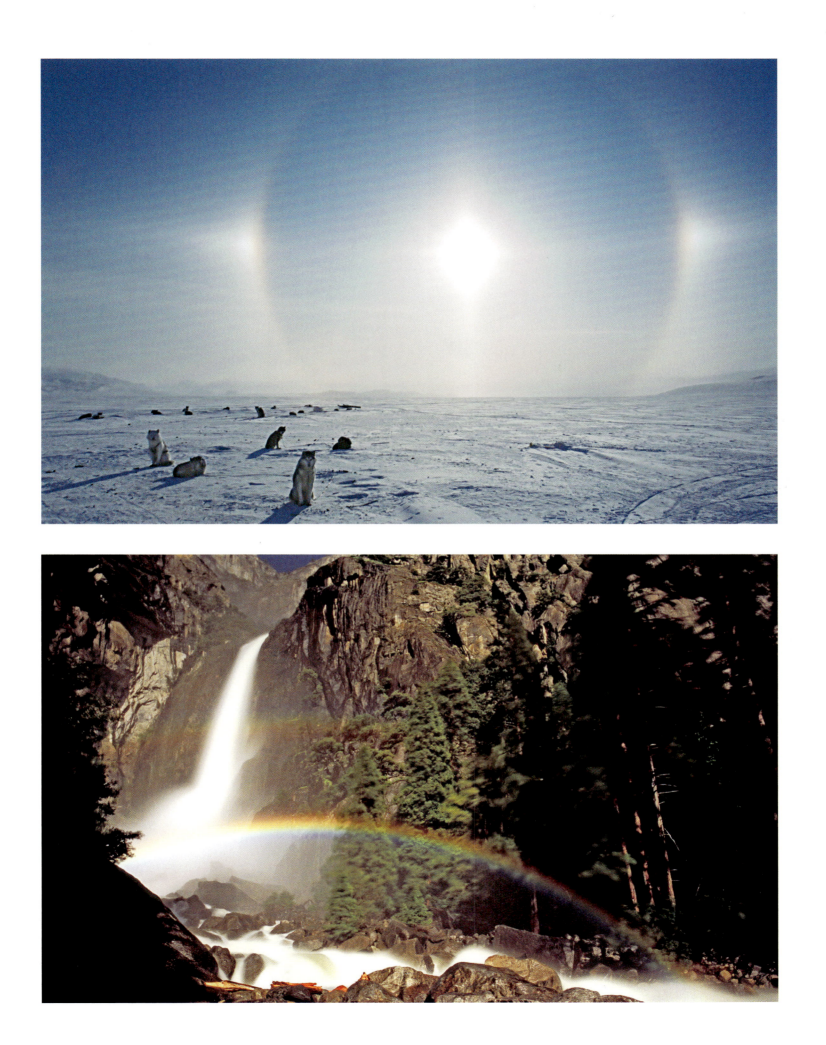

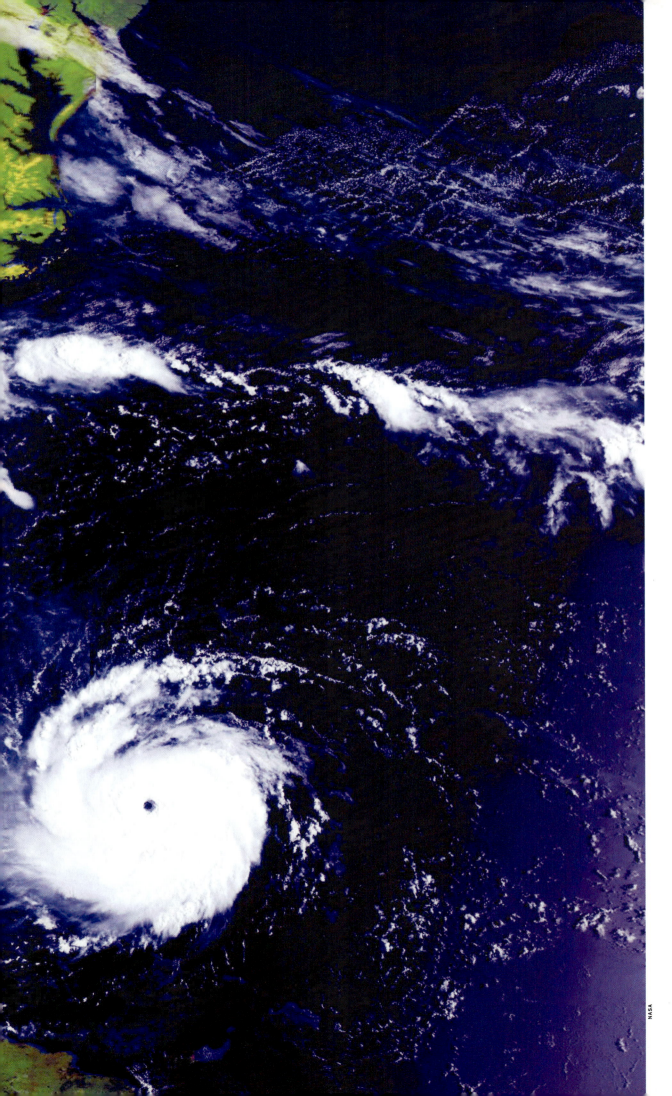

Seeing Triple

The good news: the alarming vision on these pages does not show a trio of three massive hurricanes heading across Florida and the U.S. Gulf Coast at once; this view from a NASA weather satellite is a composite image that traces the position of Hurricane Andrew as it moved from east to west (right to left) across the Florida peninsula and the Gulf Coast, on the days of Aug. 23, 24 and 25, 1992.

The bad news: Andrew was one of the most devastating hurricanes in U.S. history. The Category 5 storm unleashed steady winds with speeds up to 155 m.p.h. (250 km/h), with occasional gusts of much higher speed. The big blow claimed 65 lives and caused more than $38 billion in damage (in 2008 dollars). In the years since 1992, hurricane activity has risen dramatically along the Gulf Coast. A quartet of big storms pummeled the region in 2004, and the battering of New Orleans by 2005's Hurricane Katrina was the worst natural disaster to strike a major U.S. city since the San Francisco earthquake and fire of 1906.

Demonstrating the complex relationships that drive Earth's weather events, many of the big storms that plague U.S. coastlines are spawned in Africa. Most Atlantic hurricanes originate in "easterly waves," disturbances in barometric pressure and wind speed caused when extreme heat from the Sahara Desert in north Africa butts up against cooler temperatures along the Gulf of Guinea on the west African coast.

As an easterly wave moves west across the Atlantic, it develops into a hurricane in a four-part process. The wave, which meteorologists call a tropical disturbance, becomes a tropical depression when its winds reach speeds of up to 38 m.p.h. (61 km/h) and begin to rotate around a central vortex. The depression becomes a tropical storm when wind speeds increase to 39 to 73 m.p.h. (63 to 117 km/h) and the central vortex becomes more delineated. The final hurricane stage is reached when winds exceed 74 m.p.h. (119 km/h). Hurricane Andrew's peak gusts in southern Florida were never properly recorded: the storm destroyed all official measuring equipment on the ground. ■

27

Twisters in Transition

Tornadoes are among nature's most unpredictable events: once a twister drops down from a supercell cloud and starts raising a ruckus, it's very difficult to anticipate the exact path it will follow. But for many decades, these frightening storms at least followed certain patterns: they were usually confined to a sector of the nation's midsection dubbed Tornado Alley, which runs from Oklahoma up through Kansas and Missouri and east to Illinois, Indiana, Ohio, Tennessee and Kentucky. And they appeared during an annual, predictable season that ran from spring into the first weeks of summer.

Of course, as the U.S. National Oceanographic and Atmospheric Agency (NOAA) reminds visitors to its website, in italics for emphasis: *Violent or killer tornadoes do happen outside Tornado Alley every year.* And *Tornadoes can happen any time of year.* Until recently, these warnings seemed pro forma, a dutiful acknowledgment that even Uncle Sam can't predict the weather. But consider the events of March 14, 2008, in downtown Atlanta. While 18,000 fans filled the Georgia Dome for the Southeastern Conference basketball tournament and 16,107 NBA fans jammed Philips Arena for a game between the hometown Hawks and the Los Angeles Clippers, a twister cut a six-mile (10 km) path of ruin through the city's heart. Winds

gusted up to 130 m.p.h. (209 km/h), crushing homes, ripping façades off buildings, downing trees and shattering glass.

When the Weather Channel's version of March Madness ended, some 27 people had been injured in the first tornado ever to strike in the downtown of Georgia's capital city, and officials estimated the damage at $250 million. The next day, smaller twisters claimed two lives in areas of rural Georgia.

Tornadoes are also jumping the tracks of their predictable seasons these days. Over the four days from Jan. 7 to 11, 2008—in the depths of winter—a barrage of 72 separate tornadoes roared across southern Missouri, northwestern Arkansas, Alabama and Mississippi; four people were killed. Less than a month later, on Feb. 5-6, a staggering 82 confirmed tornadoes touched down in Tennessee, Arkansas and the southern Ohio Valley, killing 58 people in four states. It was the deadliest tornado assault in the U.S. since 1985.

What's going on? Meteorologists fear that climate change driven by global warming is brewing up a new generation of tornadoes that will strike more frequently, with greater severity and over a broader swath of the country than before. Their advice: prepare today, for Tornado Alley is now Tornado Superhighway, and twisters are now storms for all seasons. ∎

Spinning mayhem

Tornadoes are most often spawned by supercell storms, like the one shown above, whirling above Nebraska on May 28, 2004. Supercells are severe thunderstorms that form around a constantly rotating updraft called a mesocyclone. The updraft tilts the inflowing air into a vertical position and sets its spinning.

Often, through a process not yet completely understood, an even more rapidly spinning funnel drops to the ground: a tornado. That's what happened in Pampa, Texas, in 1995, forming the twister shown on the page at right. The air pressure inside a tornado is much lower than the pressure outside it, creating a vortex that "inhales" anything around it.

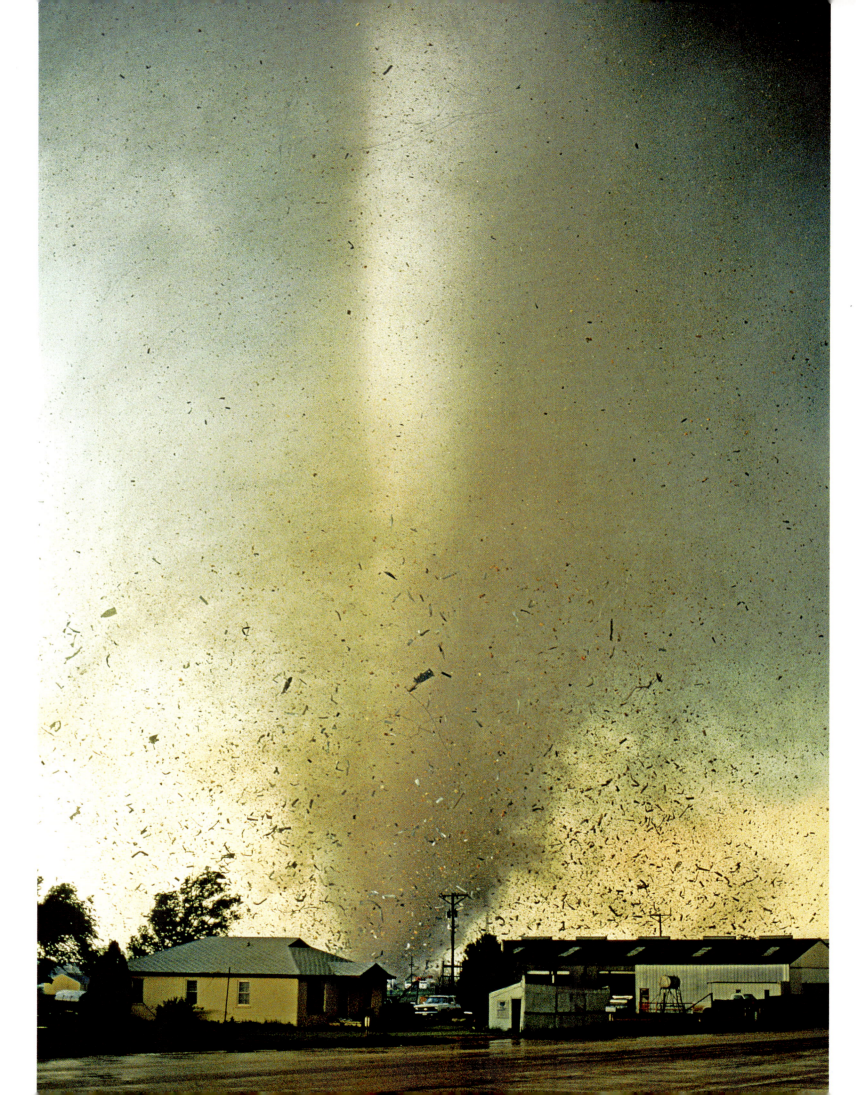

pedosphere

pe·do·sphere *(n.)*
[Gk *pedon* ground, earth + Gk *sphaira* ball]
the part of the earth's surface that contains the soil layer;
the land world

Dunes *A caravan of camels, top right, crosses the Sahara Desert in Mauritania*

Realms of Rain

Hothouses of the planet, rain forests are a testament to nature's sheer fecundity. Humid, viny, choked with vegetation, filled with the cries of exotic animals, these rich regions are laboratories of life, teeming with thousands of permutations of plants and animals: there are some 6,000 species of insects in the Central American rain forest, 6,500 species of orchids in the Indonesian rain forest. The operative word here is *rain:* a rain forest is a region that receives 68 to 78 in. (173 to 198 cm) of rainfall a year.

High humidity and abundant water supplies are the engines driving the phenomenal fertility of the rain forest—and all those green leaves, scientists have come to realize, make rain forests one of the foremost carbon reservoirs on the planet. Filtering carbon dioxide out of the air and replacing it with oxygen, rain forests are the thermostats of the globe, regulating temperatures and weather patterns. The Amazon rain forest, the world's largest, may produce as much as 20% of the planet's oxygen supply.

Though they cover less than 2% of Earth's total surface area, the world's rain forests are home to 50% of the planet's plants and animals. They are also reservoirs of invaluable genetic material. Many of our most powerful drugs—including those that fight diabetes, heart disease, malaria and arthritis—are derived from rain-forest plants. More than 2,000 tropical-forest plants have been identified by scientists as having anticancer properties, yet less than 1% of tropical rain-forest species have been analyzed for their medicinal value. Preserving rain forests from the accelerating rate of deforestation that currently threatens them will be an urgent environmental priority of the 21st century. ■

Treehugger *At right, a pale-throated three-toed sloth, Brady-pus tridactylus, eyes the camera from his perch on a tree in a rain forest in South America. Like reptiles, three-toed sloths cannot regulate their own body temperature; the leaf-eaters are at home high in the jungle canopy.*

On the right page, the Coca River in the highlands of eastern Ecuador takes a plunge at San Rafael Falls. This region of Ecuador's rain forest is temperate, owing to the high altitudes and cooler weather; scientists divide rain forests into two main classes, temperate and tropical, based on average annual temperatures.

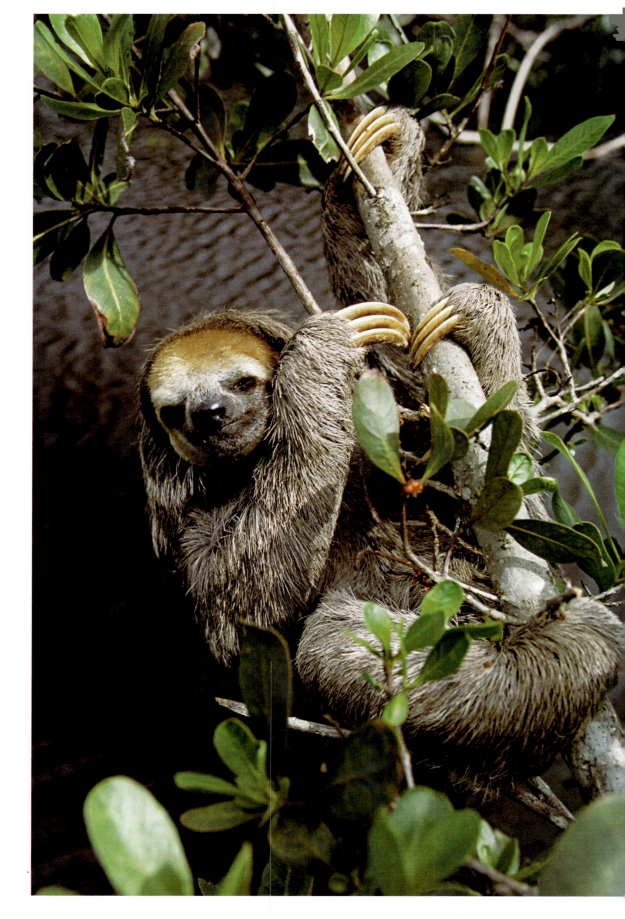

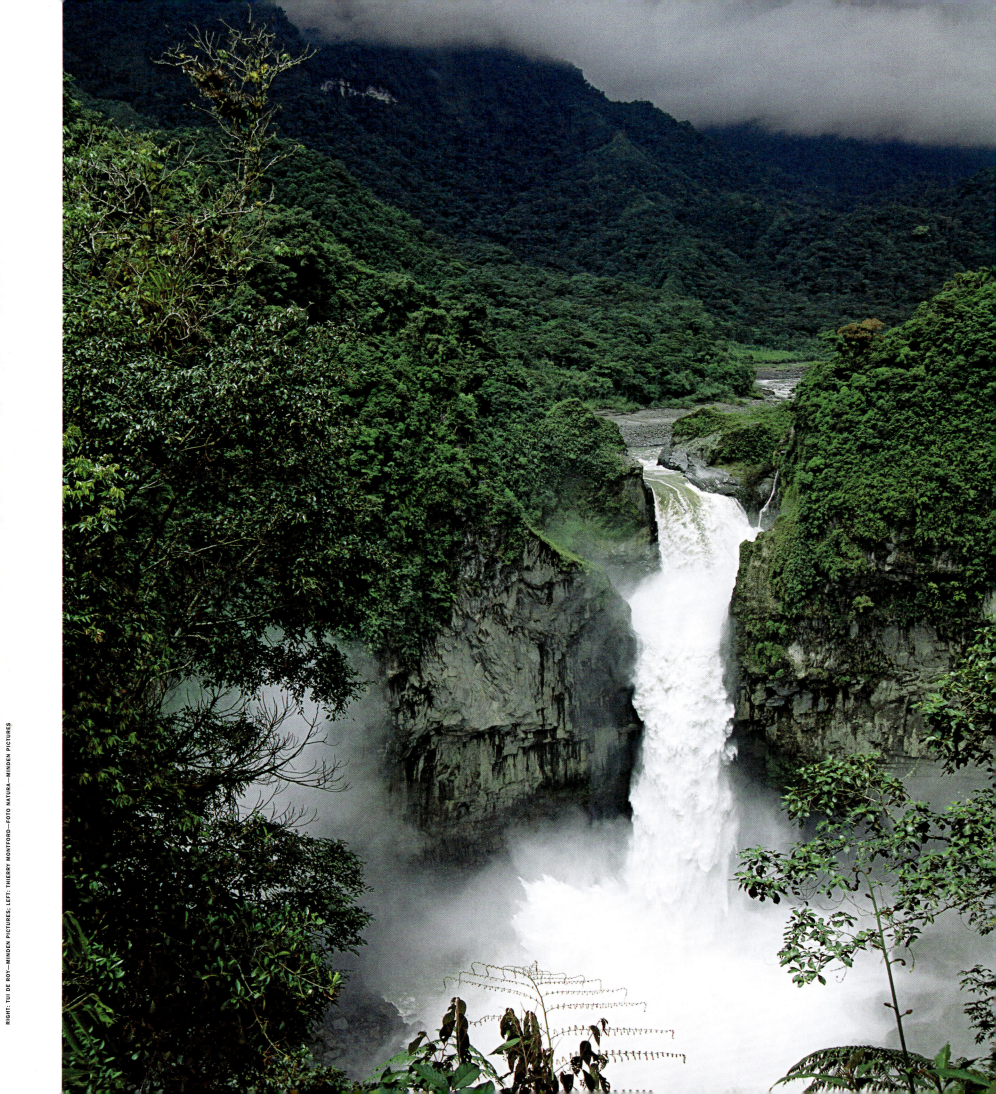

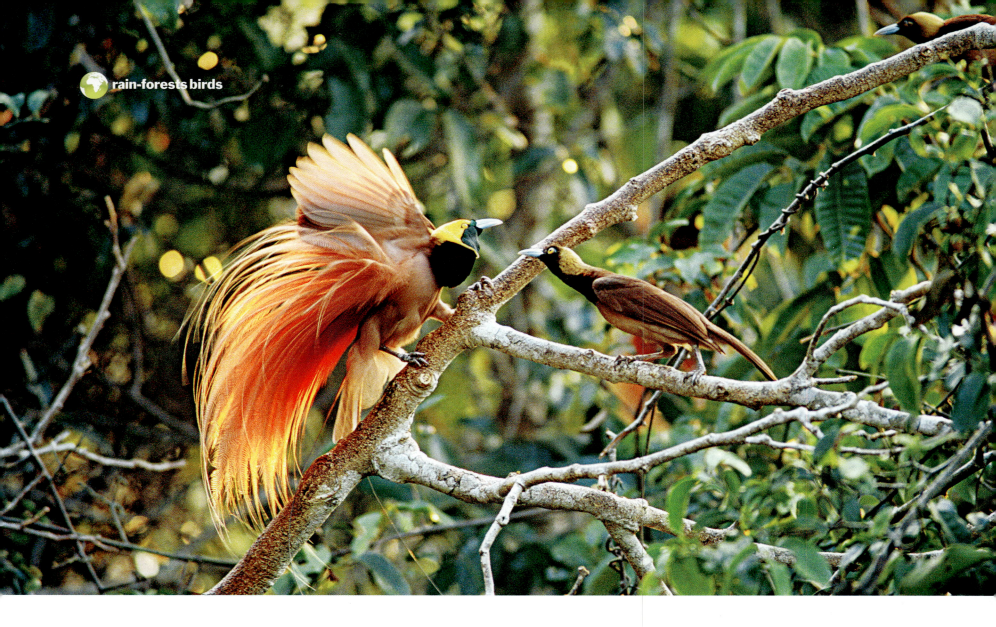

A Paradise of Plumage

Rain forests are nature's aviaries: a representative 4-sq.-mi. (10.3 sq km) swath of tropical jungle may contain up to 400 species of birds, and 1 of every 5 birds on the planet is believed to live in the Amazon rain forest alone. Indeed, birds are essential to the survival of the rain forest. Fruit-eating species like toucans soar and swoop hundreds of miles through the canopy, carrying seeds great distances from the parent tree. Research published in the late 1990s reported that three breeds of hornbill alone were the prime agents in the seeding of a quarter of all tree species within the rain forests of Cameroon.

The striking coloration of many tropical birds is driven largely by the need to attract mates. But the iridescent plumage is also a product of the birds' environment: although parrot feathers stand out like a rainbow to human eyes in the light of day, these colors behave differently in the muted, indirect light beneath a rain-forest canopy, especially in the perception of other animals, which see fewer colors than humans. Sadly, the bold plumage of rain-forest birds also attracts the attention of humans, who are willing to pay thousands of dollars to own them as exotic pets. And this, given the reliance of the rain forests on birds to spread the seeds of their flora, is bad news for more than just the birds. ■

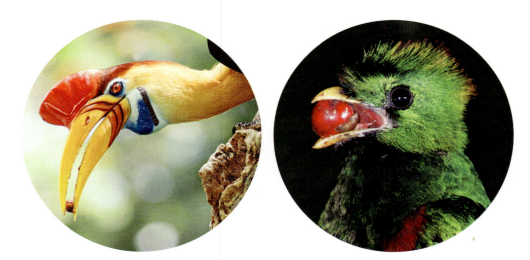

Jungle Kaleidoscopes *The 7.5-in. (19 cm) bill of a Toco toucan (Ramphastos toco), shown in Brazil on the facing page, appears large enough to make the bird top-heavy, but it is actually light and spongy. At top above, a male Raggiana bird of paradise (Paradisaea raggiana) struts his stuff for a prospective mate in Papua New Guinea.*

At left above, the Sulawesi red knobbed hornbill (Aceros cassidix) is a monogamous species that thrives in tropical forests. The resplendent quetzal (Pharomachrus mocinno), above right, is widely considered the most beautiful bird on the planet; it was regarded as a deity by the Maya and Aztecs.

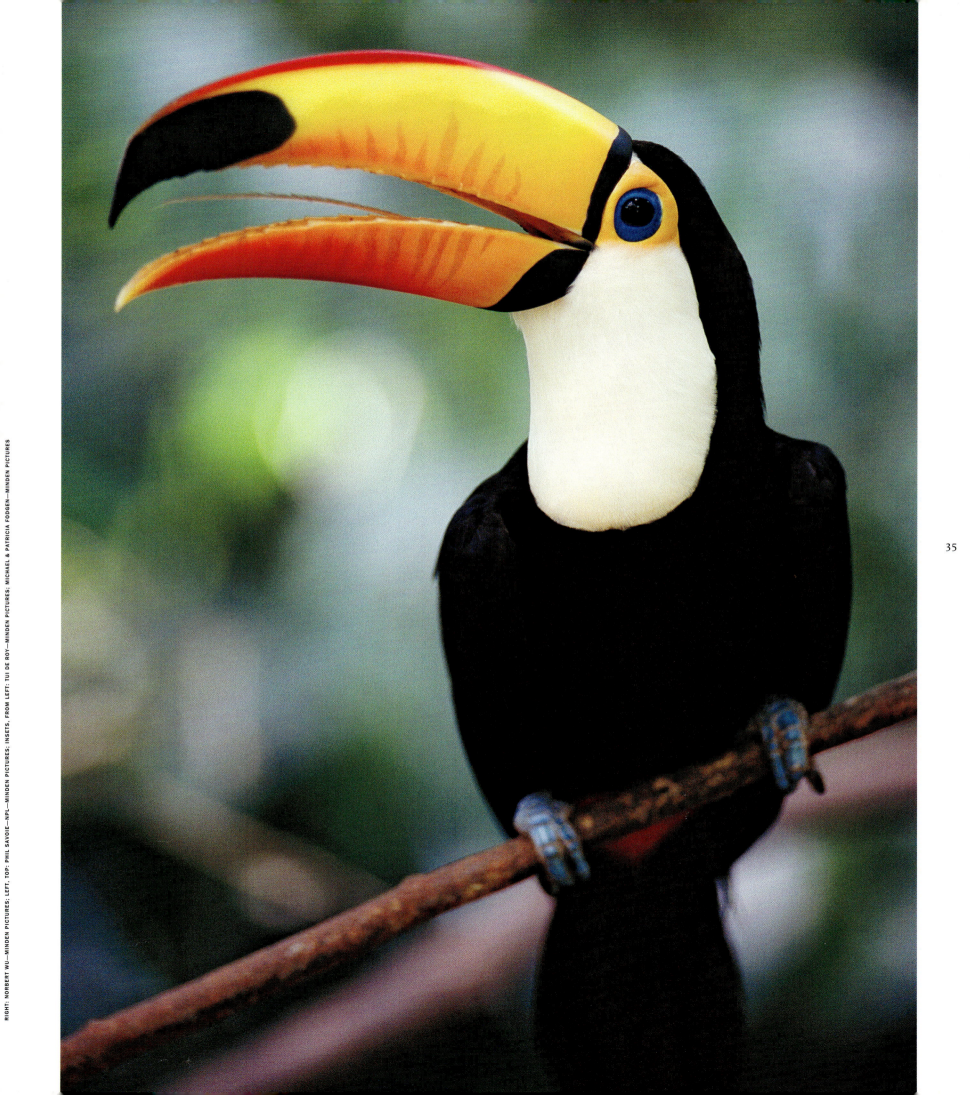

35

Artery of a Continent

Like many of the planet's great rivers, the Amazon is the offspring of a mammoth mountain range. But the Amazon doesn't merely drain the great snows of the Andes; its history has been shaped by them. The mountains, formed by the clash of two tectonic plates, thrust a rocky barrier, or cordillera, as high as 20,000 ft. (6,096 m) along the entire west side of the South American continent. As a result, rains that fell on the eastern slopes of these mountains, though less than 100 miles (160 km) from the Pacific Ocean in some cases, needed to drain across the entire width of the continent to the Atlantic.

Initially the waters flowed into a giant inland sea in the center of South America, but at some point within the past 2 million years, these waters rose high enough to break free to the east, and the Amazon was born. The sedimentary basin of the former sea became one of the planet's great tropical rain forests, and again the Andes played a part, trapping moist winds from the jungle and sending them back as rain clouds in a fertile feedback loop.

This massive waterway is by far the largest river on the planet, though the Nile is a tad longer. It drains an astounding 40% of South America's landmass and plays a major role in ventilating the entire globe. Indeed, in a 2005 study published in *Nature* magazine, researchers found that the Amazon and its tributaries are "breathing" more quickly than was previously thought. The great rain forests of the Amazon basin absorb carbon dioxide, retain it, convert it into oxygen and release it in a cycle lasting an average of only five years. Earlier, scientists had believed this cycle took decades, even centuries. If the Amazon and the rain forests it feeds are the heart of the planet's cardiopulmonary system, then Earth's pulse seems to be racing. ■

36

Come together *Two great rivers converge near Manaus, the largest city on the Amazon, some 800 miles (1,290 km) upriver from the Atlantic. The muddy river on the left is the Amazon, its waters laden with silt; the blue-black stream is the Rio Negro, largest of the Amazon's tributaries. The Rio Negro is a black-water river: it has a deep, slow-moving channel, runs through swamps and wetlands and is darkened by decaying vegetable matter. In the inset photo at right, the Amazon snakes through the rain forest in western Brazil*

KAZUYOSHI NOMACHI—CORBIS; INSET: CLAUS MEYER—MINDEN PICTURES

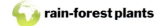

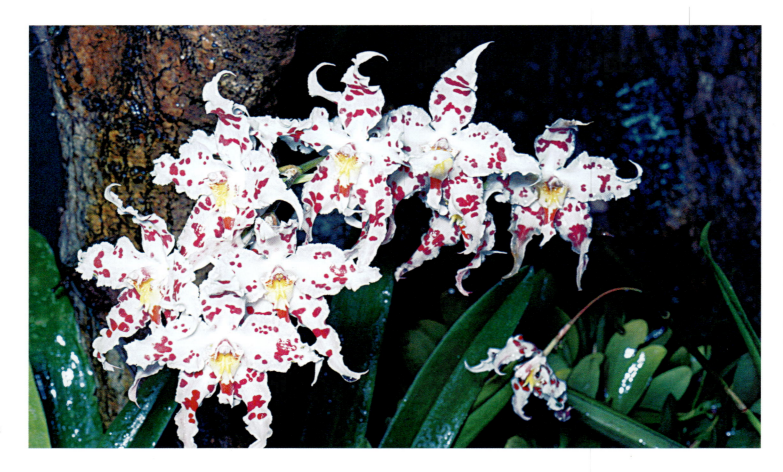

Orchids *There are some 300 varieties of orchid in the genus Odontoglossum; the beauties at left, Odontoglossum crispum, are native to the rain forests of Colombia. Almost all orchids are epiphytes, plants that grow by attaching themselves to other plants; since these "air plants" need not root in soil, they can grow high in the forest canopy, where they can thrive on more sunlight*

38

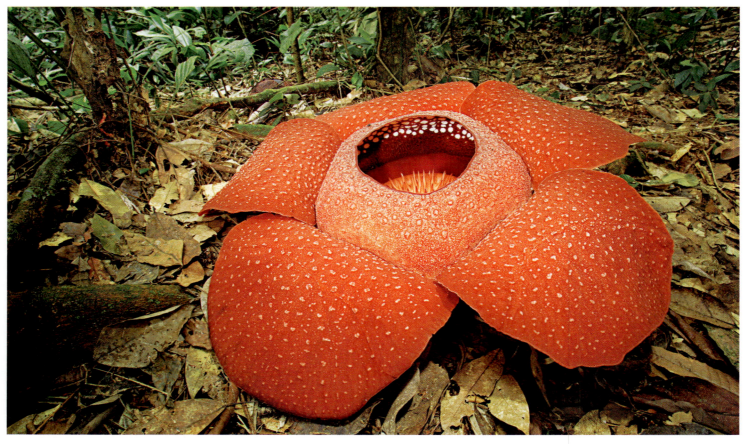

Rafflesia *Sorry, Texans: the largest flower in the world, Rafflesia arnoldii, is native to the South Pacific. Rafflesia are parasitic plants that nourish themselves from a host vine; their largest flowers can be more than 3.2 ft. (100 cm) in diameter and weigh up to 22 lbs. (10 kg). The flower emits a distinctive, very foul odor; it was named for the Briton who founded Singapore (and is the eponym of its famous hotel), Sir Thomas Raffles*

Bromeliads *This group of tropical and subtropical plants is very diverse; it includes both Spanish moss and pineapples. Bromeliads are distinguished by their stiff leaves and a central flower stem that often forms a receptacle that traps rainwater, providing a vital source of hydration for many animals. Most bromeliads are native to the Americas*

Lianas *Rain forests are so dense with vegetation that survival of the fittest becomes survival of the tallest. With precious sunlight dim on the forest floor, it's the plants highest in the canopy that thrive, so climbing vines plant their roots in the soil, then hitch a ride on trees to send their leaves toward the sun. Such climbers are called lianas, a name that identifies not a specific plant species but rather all such ascending vines*

Vegans: Not!

The moth on the left page is seconds away from a fateful surprise. Attracted by the sweet-smelling nectar of the pitcher plant, the creature will fly into the aromatic orifice of the plant, only to find that the aperture is a mouth, and it is now prey. The sides of the cavern into which it has fallen are slippery; at its bottom is a small body of liquid that first drowns, then dissolves, the moth. In some cases, pitcher plants contain insect larvae that help digest the prey.

There's a creepy quality to carnivorous plants: it's a rare 12-year-old boy who isn't fascinated by the allure of the Venus's flytrap, the most widely known of the insect-trapping plants. Perhaps it's the sense that these plants' clever hunting tactics—the inviting aroma, the false visual stimuli that telegraph "nectar" to hungry insects, the cleverly wrought trapping mechanism—seem the result of conscious artifice by the plants rather than adaptations resulting from natural selection. But of course it's the latter: the distinguishing quality of all carnivorous plants is that they are found in areas where the soil is not rich in nutrients, and thus the plants have been adapted to seek nutrition from alternate sources, such as insects.

Carnivorous plants feature a variety of trapping mechanisms. Some boast leaves that act much like flypaper to which their prey adheres. The Venus's flytrap has special hinged leaves, called snap traps, that close upon their victim once special trigger hairs are activated. Bladderworts have suction traps with hinged doors that open only one way—the way to death. ■

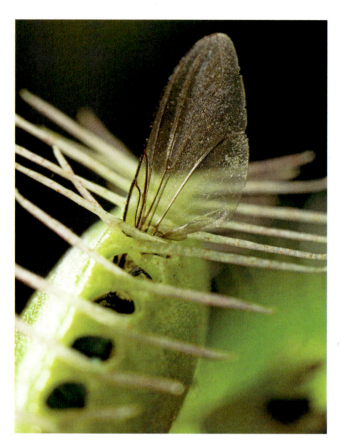

Going, going ... *At left, the hinges of a Venus's flytrap (Dionaea muscipula) close upon a victim. The trigger hairs that spring the trap are very sensitive; two hairs must be touched in quick succession before the lobes snap shut*

Below, a damselfly is trapped on the sticky tentacles of a spoonleaf sundew plant (Drosera intermedia), an example of a flypaper-style trap. The tentacles can bend to aid in enfolding the prey.

Botanists have identified nine distinct families and some 600 species of carnivorous plants.

41

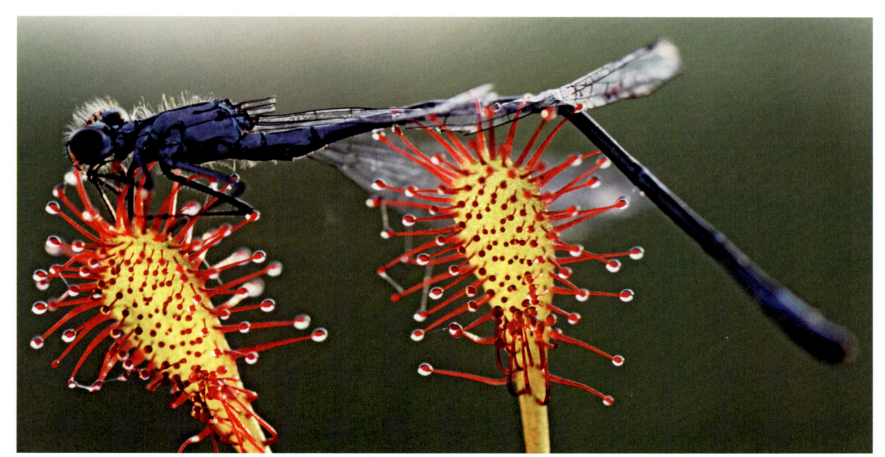

Charming

Many people claim to dislike frogs, and they are portrayed as charming princes transformed by an evil spell in our fairy tales. But it's still hard not to smile at the two-toned, long-fingered fellow at right. Amphibians don't get much more adorable or much more resplendent than the small frogs of the rain forest, whose vivid hues are a match for the colorful birds and flowers of the tropics—as well as a warning to predators, for many frogs secrete poisons from their skin.

If slime is a crime, rain-forest frogs are guilty, as are their relatives in the class Amphibia: newts and salamanders, toads and bullfrogs. Their skin is designed to be slimy and clammy; subdermal mucous glands keep it moist, as do the humid, wet places they call home: ponds, marshes, swamps and rain forests. For amphibians are creatures equally at home in two worlds, the watery hydrosphere and the solid pedosphere. Indeed, the life cycle of many specific amphibians recapitulates the long history of this group of sea creatures that adapted to life on dry land. Frogs, for example, begin their lives as tadpoles in the aquatic world, breathing through gills, then undergo a dramatic metamorphosis: their bodies develop arms, legs and lungs, and they emerge as terrestrial, air-breathing adults. Most of these cold-blooded vertebrates reproduce externally, with the male and female expelling sperm and unfertilized eggs at the same time. In some cases the parents guard the eggs until the larvae are fully developed.

In recent years amphibians have made news, but not for their charm. An ongoing study by the Global Amphibian Assessment group found that a total of 1,896 species—some 32 percent of the more than 5,900 known species of all known amphibians—are now considered highly endangered. Global climate change that is reducing and altering habitats, as well as the newly discovered fungal disease chytridiomycosis, are the twin engines driving this potentially irreversible decline in biodiversity. Sadly, those evil spells are no fable. ■

Peekaboo! A *splendid leaf frog* (Agalychnis calcarifer) *surveys his moist domain. Yes, splendid is part of his name*

42

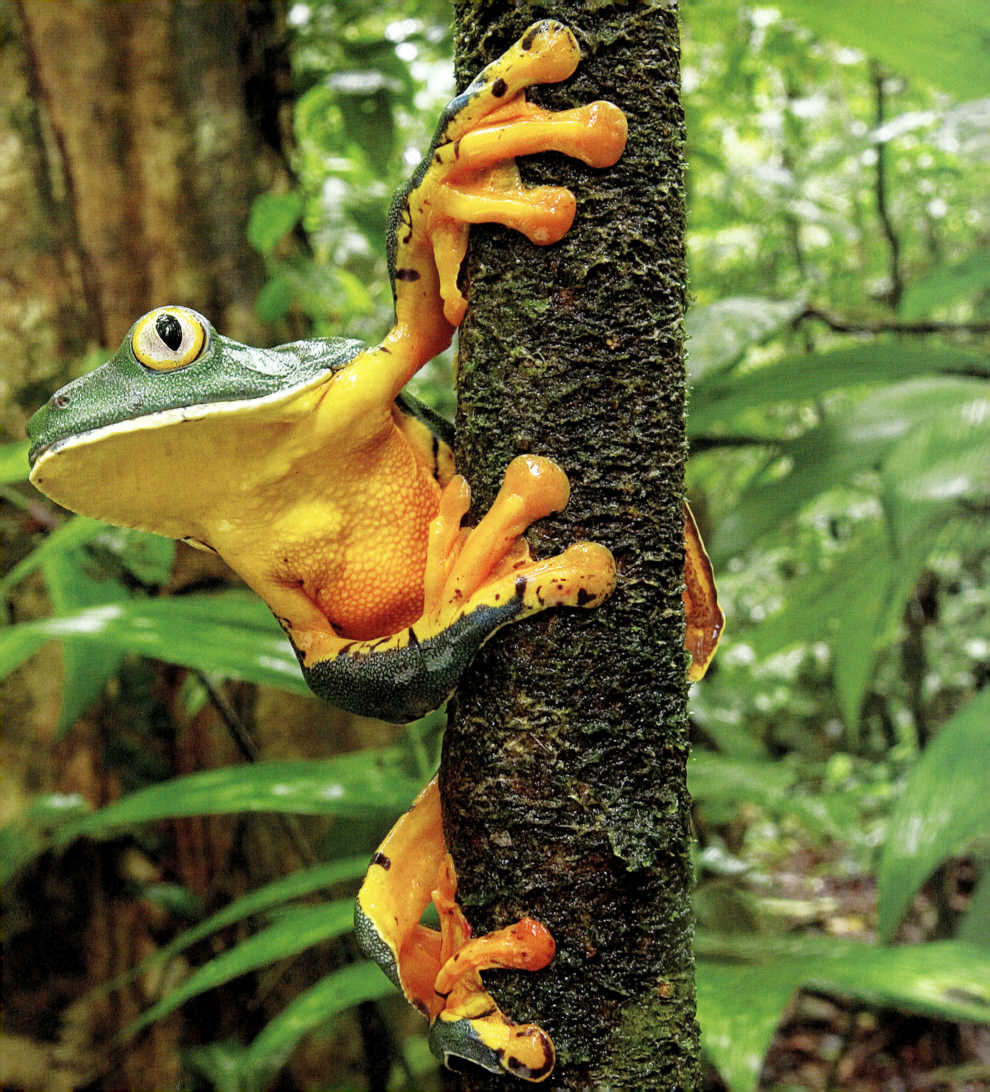

Great Plains

The planet's grasslands circle the globe along its temperate and tropical zones on both sides of the equator; in these wide-open spaces, millions of large animals make their home on the range. This big-sky country is known by many names: Americans call their broad Western prairies the Great Plains; Russians know their vast short-grass domains as the steppes. In South America, Argentina's gauchos herd steers on the pampas, while Colombia's vaqueros savor life on the llanos, and Africans refer to their vast tropical grasslands as savannas. Perennial grasses and nonwoody plants are the dominant vegetation here; trees and shrubs can be present but are often confined into distinct groves near running water.

Grasslands provide grazing ranges for much of the world's livestock, and though they are a naturally occurring phenomenon, many of them have now been partially shaped by human hands in order to keep them free of trees and shrubs. Such areas are called anthropogenic grasslands; some have been cleared of trees and stumps by farmers seeking room to plant, while others are burned by herders every year, who emulate wildfires sparked by lightning to keep trees out and grass thriving. The constant growth and decay of the wild grasses here, further fertilized by wildlife, create a rich, deep layer of topsoil that in some cases extends 20 ft. (6 m) below the amber waves of grain. ∎

Rising above it *A cheetah takes advantage of a dead tree to get a view of the savanna from above the tall grass that is the dominant feature of the landscape in Kenya's Masai Mara National Reserve*

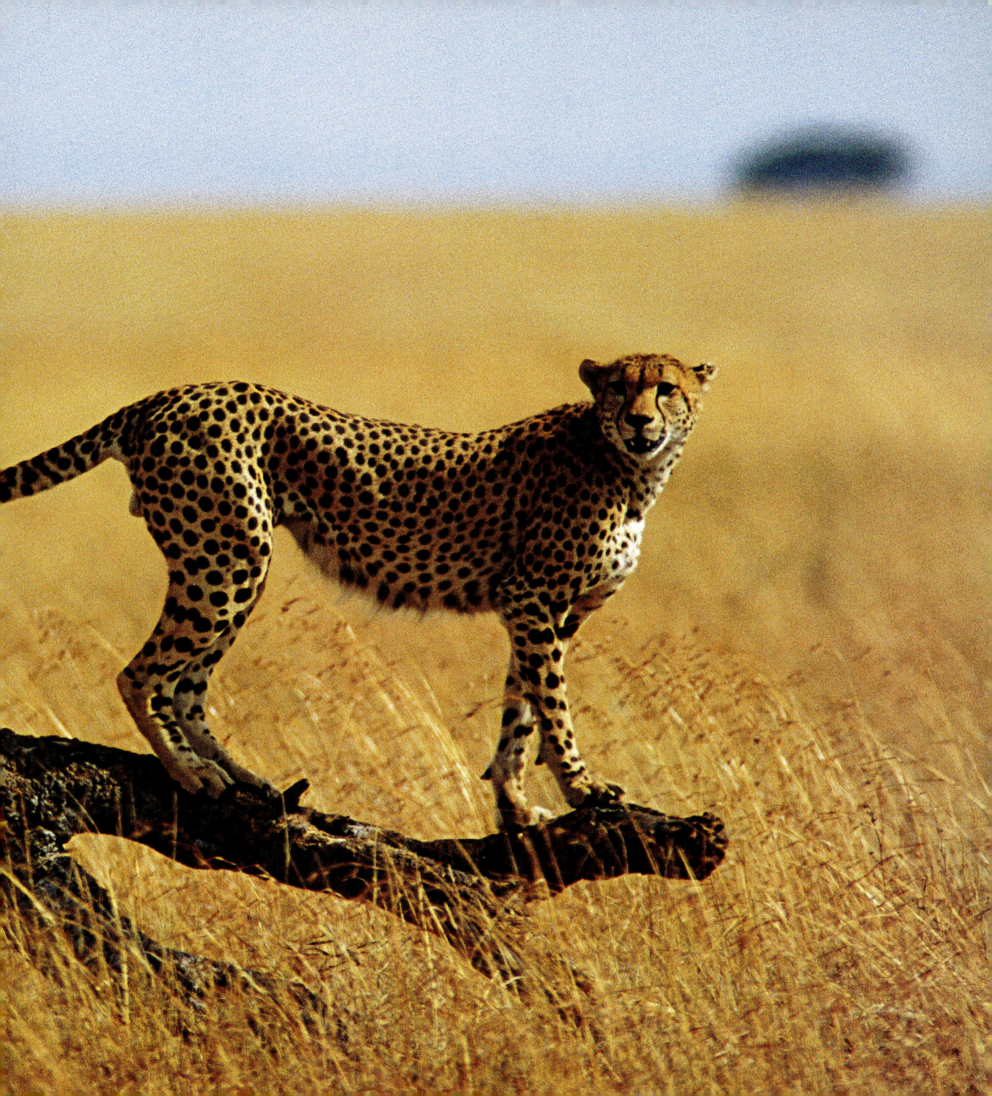

Our turf! *Watering holes on Africa's vast grassland, the Serengeti plain, can be models of democracy, as zebras, elephants, antelope and birds share a drink in peace. But some species are not meant to mingle: even the Serengeti's apex predator, the lion, beats a retreat when a far larger mammal butts in*

Okapi *Once known as "forest zebras" because of their striped rumps, okapi (Okapia johnstoni) are related to giraffes but prefer more forested terrain than giraffes, which are more at home in grasslands. These hoofed mammals are vegetarians; their long, prehensile tongues help them gather the 40-65 lbs. of twigs, leaves, grass and fruit they eat each day. Once more widely established, okapis are now found only in the forests of the Democratic Republic of Congo*

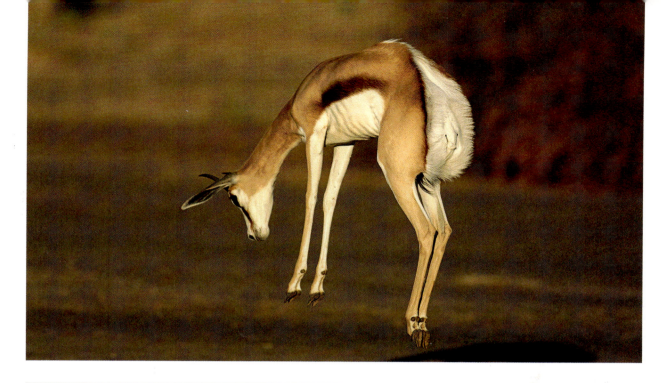

Springbok *Showing how it earned the first part of its name, this antelope* (Antidorcas marsupialis) *is demonstrating its flair at stiff-legged pronking—leaping vertically into the air. Scientists posit this behavior is meant to distract potential predators. Some springboks can pronk more than 10 ft. (3 m) high*

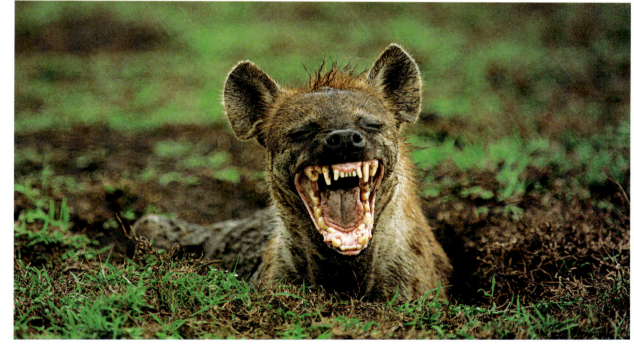

Spotted hyena *Famed as Africa's most adept scavengers, spotted hyenas* (Crocuta crocuta) *have very strong jaws—and strong stomachs that can digest parts of animals others cannot. Like many owls, they regurgitate indigestible matter such as hooves, hair and ligaments in condensed pellets. These highly social animals are expert hunters that prefer to stalk their prey in a group, or clan*

Common warthog *It's not among the planet's prettiest creatures; indeed, the common warthog* (Phacochoerus africanus) *is set apart by three sets of facial warts, and both males and females sport two long tusks. Hitching a ride here is a symbiotic bird that dines on parasites, the yellow-billed oxpecker* (Buphagus africanus)

LEFT: KONRAD WOTHE—MINDEN PICTURES; RIGHT, FROM TOP: RICHARD DU TOIT—MINDEN PICTURES; MITSUAKI IWAGO—MINDEN PICTURES; RICHARD DU TOIT—MINDEN PICTURES

Mobile homes *A group of wildebeests fords the Mara River during migration in Kenya's Masai Mara National Reserve. In spring, these big antelopes move from the dry grasslands to the forest; they return in late fall, when rains turn the plains verdant again. Migration is a significant survival strategy for a wide variety of animals, including birds and undersea creatures as well as land animals, who would otherwise starve due to seasonal food shortages. Migrating in large groups helps wildebeests and other hoofed mammals that are easy prey for larger animals in two ways: it is harder for predators to single out individuals from a pack, and there are more eyes, ears and noses to detect danger. For these wildebeests, the predator to be feared at the moment is in the river: crocodiles*

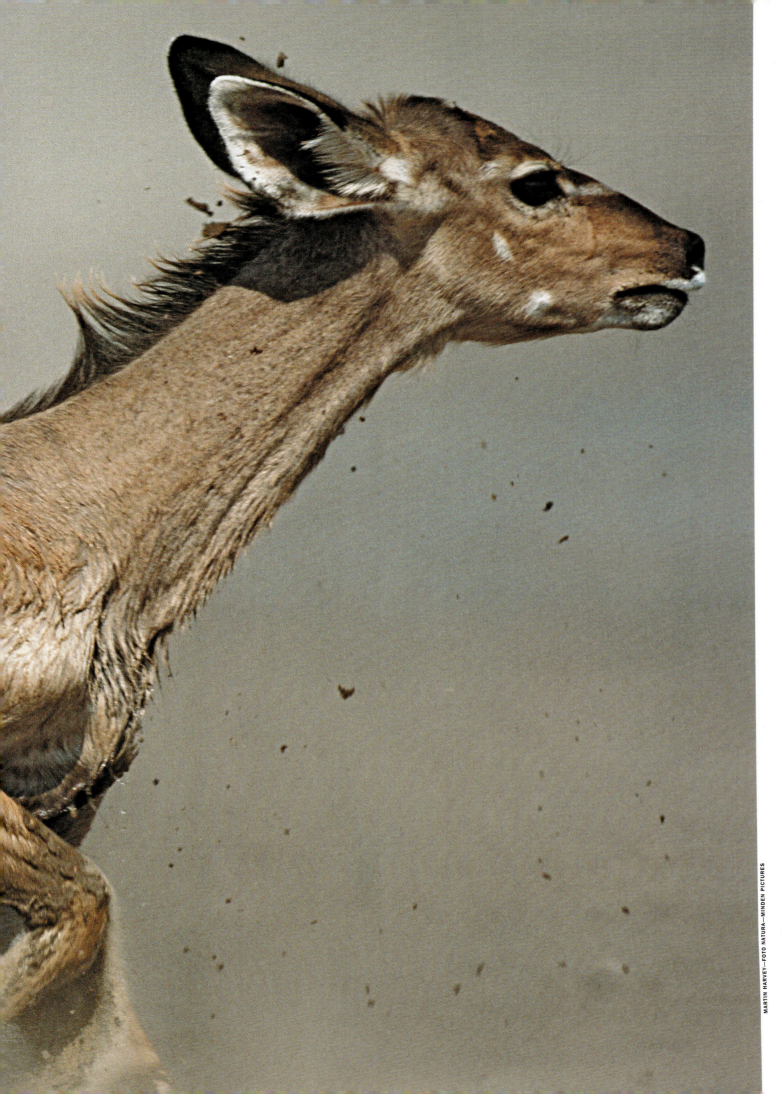

53

Last gasp *Outmatched, outraced and outweighed, this kudu, a type of antelope, is also out of time: it will soon succumb to the lioness that is attacking it on the Serengeti plain in Africa*

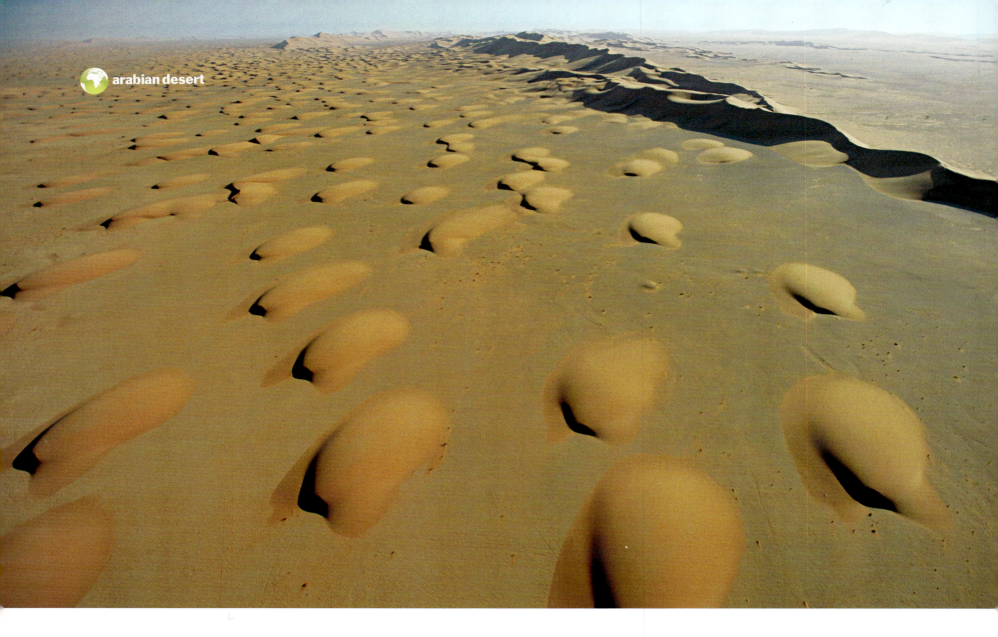

Empty Empire of Sand

For centuries, the southern section of the Arabian Peninsula has been known as the Empty Quarter. This vast arena of sand, which forms a rough oval as much as 1,000 miles (1,609 km) wide in some directions—the distance from New York City to Memphis—isn't empty at all, as scientists see it, though the infrequent appearance of humans, water, plants and other scenic relief may make for challenging sightseeing for the rest of us. There are no roads here, making the Empty Quarter one of the largest expanses of little-explored land on the map. Then there's the heat, always the heat: the thermometer can soar past the 130°F (54°C) mark on summer days and "cool down" to 85°F (30°C) at night. Small wonder, even Bedouin acclimated to high temperatures keep to the fringes of this inhospitable domain.

Not all deserts share the severity of the Empty Quarter, or Ar-Rub' al-Khali, in Arabic. Some, like the semiarid deserts of the U.S. Southwest, are bursting with color and filled with fascinating life-forms adapted to a region where freshwater arrives intermittently and in small portions: cactuses and succulents, birds and animals. The Empty Quarter is far harsher, one of the globe's ur-deserts. Indeed, geographers view it as essentially an eastern extension of North Africa's great Sahara Desert; the two were divided long ago by tectonic activity that created the Red Sea, the long channel that turned Arabia, once part of Africa, into a triangular peninsula.

It's the absence of water, of course, that both defines the desert climate and limits plant and animal life. The Empty Quarter receives an estimated 4 in. (10 cm) of rain a year, less than half of the 9.8-in. annual minimum that scientists use to define a desert environment. Even so, that's more than the planet's driest desert, the Atacama, high in the mountains of Chile, where there is sometimes simply no precipitation to measure in a year.

Since their weather is so stable, desert environments make excellent geological museums. In 1998 a team of scientists from the U.S. Geological Survey ventured into the Wabar region of the Arabian desert to study a meteorite impact area where three crater rims are visible from the ground. They found that the meteorite's three parts weighed some 3,500 tons and smacked into the planet with the force of the atom bomb exploded at Hiroshima. The scientists dated the impact to only 135 to 450 years ago, but to no one's surprise, there are no firsthand accounts of this event. ∎

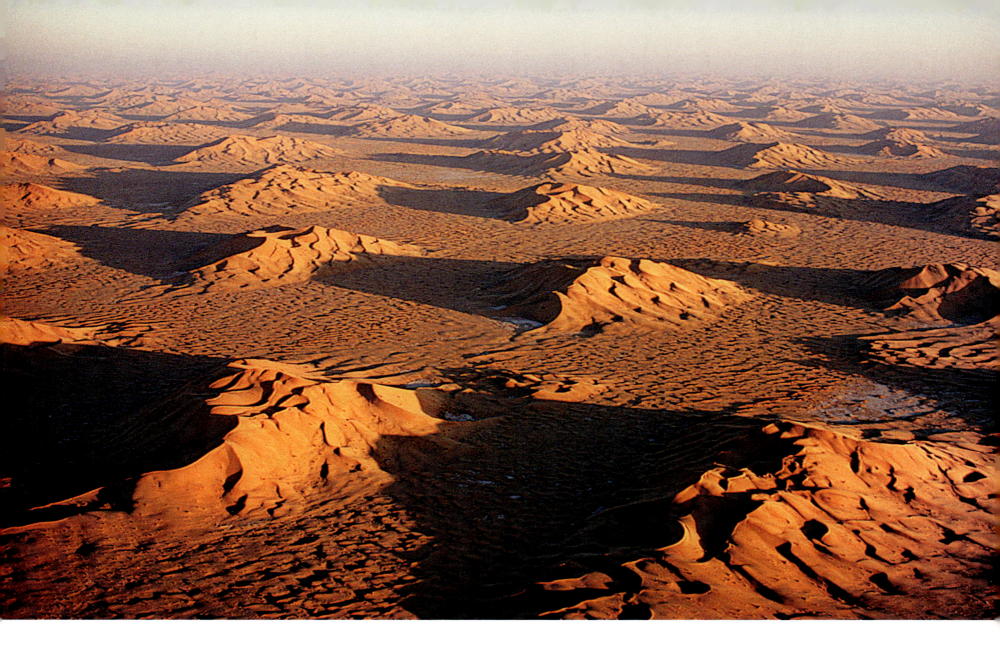

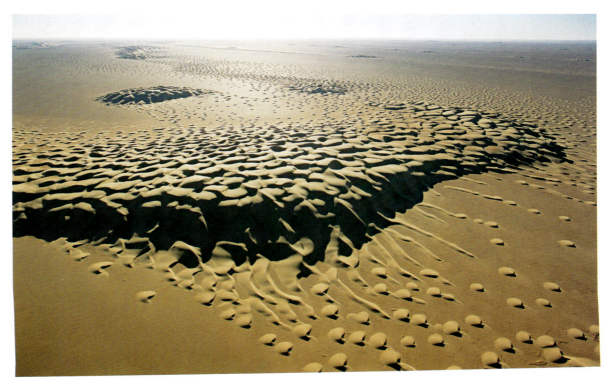

Windy cities *Three views of the Empty Quarter: at top left, a series of barchans, or arc-shaped dunes, in the Yemeni area of the Quarter reveals the direction of the wind that shaped them: it blew from left to right, leaving the hollow arc downwind.*

At top right, identically shaped dunes, sculpted by the wind, stretch to the horizon.

The barchan dunes at right are less clearly defined than those at top left, lacking the hollowed-out downwind arc. On the right and in the background of the photo, rocky ridges rise above the desolate landscape.

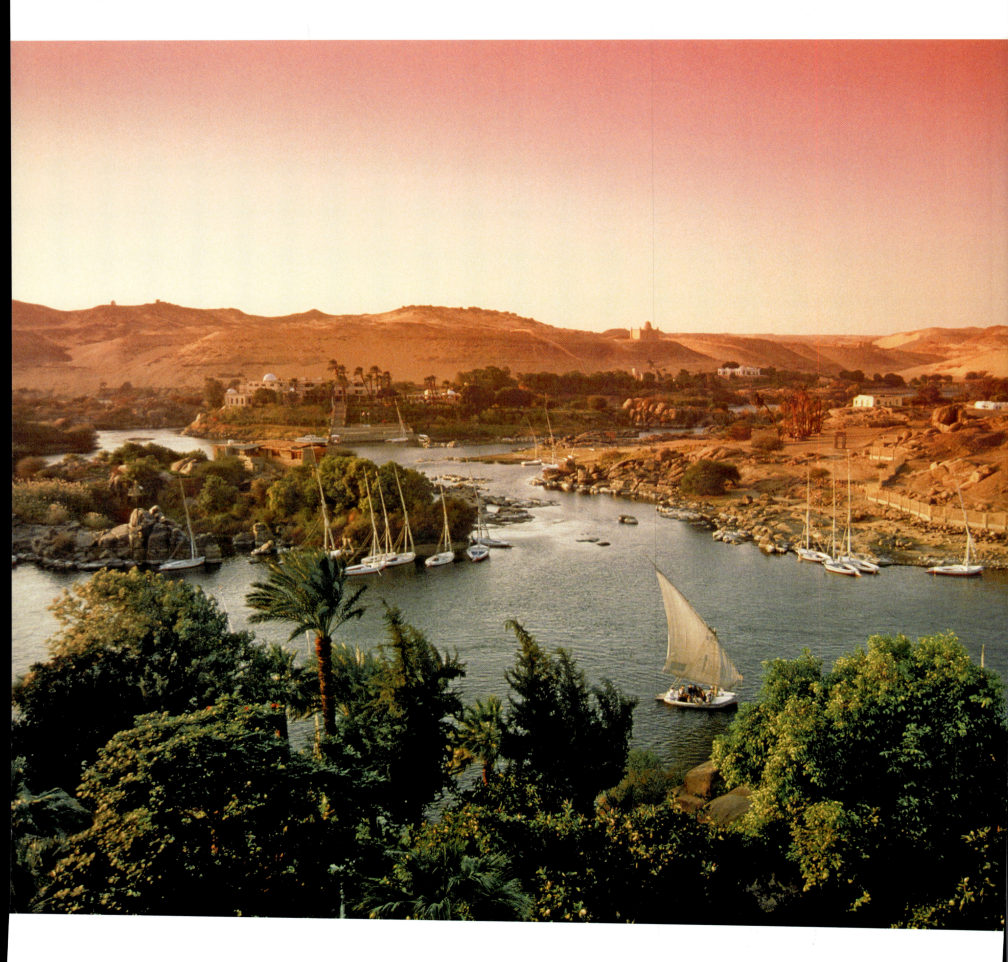

Lifeline

Agriculture and society assume a linear form in Egypt, as towns and farms cluster along the edges of northern Africa's life-bringing river, the Nile. The band of fertility, replenished annually by the river's famed floods, extends to an average of only about 1 mile (1.5 km) on either side of the river. This blue ribbon cutting through brown desert terrain makes up less than 5% of Egypt's total land area, but more than 95% of Egyptians live along the Nile floodplain.

The Nile is the longest river in the world, at 4,132 miles (6,650 km), and it drains an enormous swath of northern Africa, thanks to its two powerful tributaries, the White Nile and the Blue Nile. The White Nile, the longer of the two, flows from high in the mountains of Rwanda across Tanzania, through Lake Victoria and down through Uganda and Sudan, where its flow is severely retarded as it passes through the marshlands of the Sudd. The Blue Nile lies to the east of the White Nile, flowing from the highlands around Lake Tana in Ethiopia down into Sudan, where it joins the White Nile at Khartoum, one of the planet's great river-junction cities. It is by far the larger contributor, making up some 84% of the Nile's total flow. In March 2008, 10 northern African nations began meeting in Uganda in hopes of settling ongoing disputes about the use of the water flowing in the Nile and its tributaries.

Small wonder: the annual floods along the Nile, like the monsoons of South Asia, are one of the planet's great ongoing processes of hydrologic renewal, channeling not only freshwater but also rich, soil-building silt into an otherwise arid landscape. The broad, lush, fan-shaped delta where the Nile flows into the Mediterranean Sea is composed of soil borne from mountains thousands of miles away. Freshwater and silt are the twin pillars upon which early Egyptians created one of mankind's first great civilizations, while another of the river's gifts, the sedge plant papyrus, provided the Pharaohs' chroniclers with the medium to immortalize their deeds. ∎

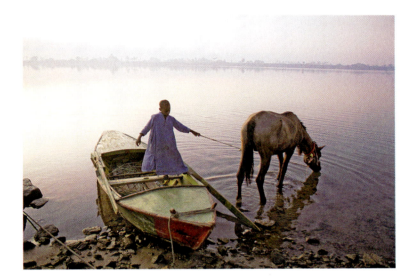

Life along the Nile *At left, feluccas ply the river at Aswan in Egypt. The building of the Aswan High Dam in the 1960s created Lake Nasser, a huge reservoir that extends into both Egypt and Sudan. When Egypt erected the dam in the 1960s, it was the first time human action had significantly altered the flow of the Nile, moderating the extent of its annual floods in hopes of stabilizing irrigation and preventing disasters.*

The historic civilization of Egypt was made possible by the Nile, and thousands of years later the river is just as essential to life in northern Africa. The photo at left illustrates the ruthless dichotomy that prevails along its banks, as arid desert sand dunes tower over the river, which may be thought of as a sort of long, narrow oasis. Above, a boy waters his horse in the river. Below is a Nubian village upriver, in Sudan, where the Nile's two tributaries unite.

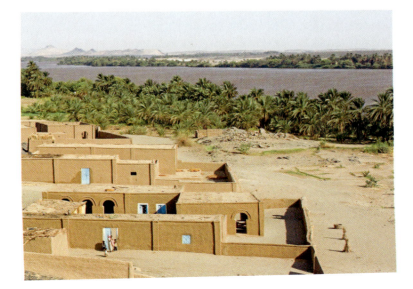

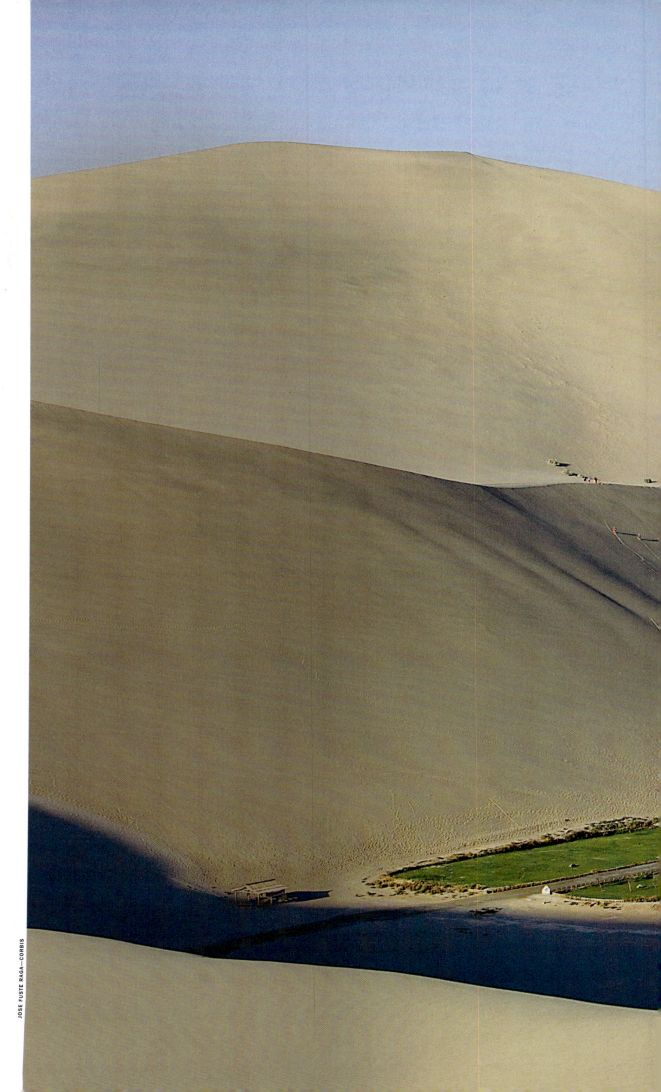

Mirage?

A sight for wondering eyes, Crescent Lake, or Yueyaquan, nestles at the feet of the gigantic sand dunes of the Kumtag desert. This archetypal oasis, fed by an underground aquifer, is located about 3 miles (5 km) southwest of the city of Dunhuang (pop. 100,000) in the northwest province of Gansu in China. Centuries ago, Dunhuang was a major stop along the northern branch of the great Silk Road that linked China to the Middle East and Europe. But today both the city and the nearby oasis are threatened by desertification, the process by which formerly arable regions become more desert-like, unable to sustain human life.

The sands of the Kumtag are encroaching on Dunhuang at a rate of about 13 ft. (4 m) a year, and the city has seen its water table drop by 39 ft. (12 m) since 1975, while Crescent Lake's average depth has declined from 12 to 15 ft. (4 to 5 m) in 1960 to 3 ft. (0.9 m) today. Concerned Dunhuang officials are now limiting immigration to the city and are regulating farming and water-use practices.

Desertification is a growing threat all around the planet, driven by agricultural processes such as overgrazing that strip nutrients from the land and deplete water resources, as well as by climate change that is increasing temperatures worldwide. The hardest-hit area is the Sahel region of Africa. This semiarid area along the southern fringe of the mighty Sahara desert has undergone severe drought and famine for decades, forcing millions from their homes as environmental refugees and creating severe social and political crises. A 2007 U.N. study found that some 50 million people will be threatened by desertification in the next 10 years, and an additional 2 billion may be uprooted by it in the future. Yet one person's environmental crisis is another's holiday: this photograph shows newly affluent Chinese vacationers enjoying a local sport, sledding down the sand dunes. ∎

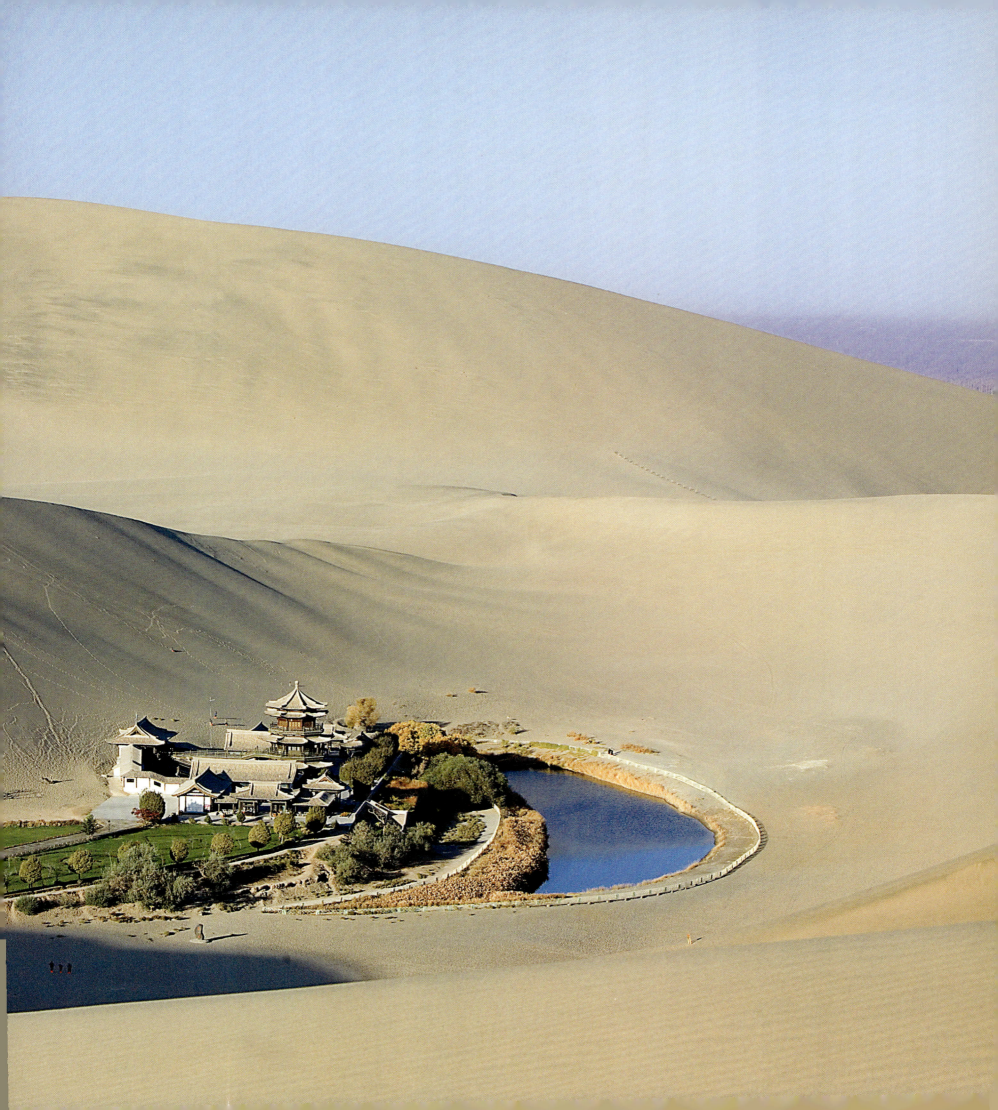

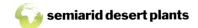

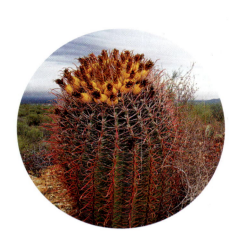

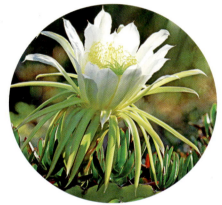

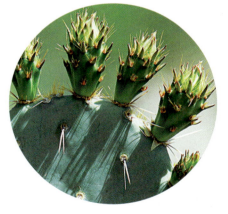

Plants of the semiarid desert *Arizona's Organ Pipe Cactus National Monument, left, is filled with Mexican golden poppies, short cholla cacti and tall, long-armed saguaro cacti, water hoarders that can take up to 75 years to grow a single branch.*

Above top, a barrel cactus grows small fruit buds that are shaped like pineapples and taste like lemons. Center, the queen of the night cactus conserves moisture by blossoming in darkness. Above bottom and right: two views of prickly pear cacti in the Chihuahuan Desert; these succulents spread themselves horizontally to collect water efficiently.

Brief Lives

Deserts aren't necessarily deserted. While the Sahara, Gobi and Arabian deserts resemble oceans of sand, semiarid deserts, like those of the U.S. Southwest, are bursting with plants adapted to surviving on 10 to 20 in. (25 to 50 cm) of rainfall a year: hundreds of species of trees, bushes, lilies, orchids and, of course, cacti (13 kinds) thrive here. Desert plants adapt to challenges—too much sunlight, not enough rain—in three ways: by hoarding water, going to sleep or, well, living fast and dying young.

Plants that accumulate water are succulents, and cacti are the best-known example of this group. The root systems of these moisture-hoarders are wide but shallow, so they can quickly capture the maximum amount of water from infrequent desert rains, which they can then store for decades, if necessary.

Plants that sleep through long periods without water only to awake and thrive after a shower, like the creosote bush, are called "drought dormant." Deeper roots help them continue to draw moisture long after a rain shower ends. During dry spells, such plants enter a comalike state, during which metabolic activity comes to a near standstill, and their rate of photosynthesis slows, before the kiss of a shower awakens the sleeping beauties.

But the oddest survival strategy of desert plants involves those that live briefly. "Drought avoidant" plants mature in a single growing season—often in autumn, when the mercury falls and the rains begin—and expend their resources on creating very hardy seeds that will sprout the following year or several years later, when adequate moisture is present. These desert "annuals" (or, more accurately, "ephemerals") make up half the plant life in some deserts, creating the explosive displays of spectacular wildflower blooms that light up the rugged landscape for a few memorable weeks each year. In the desert, beauty and brevity walk hand-in-hand. ■

61

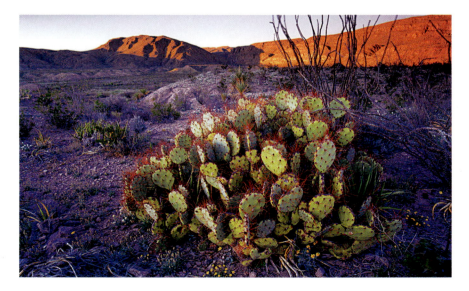

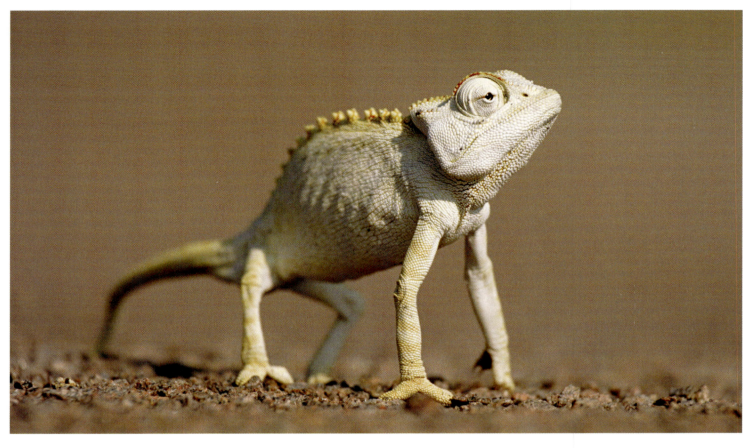

Namaqua Chameleon

Lizards are one of the largest groups of reptiles, with some 5,000 species found in various ecosystems around the world. Like Chamaeleo namaquensis at left, these cold-blooded critters are well adapted to life in scorching deserts. Along with snakes, lizards form the order Squamata, reptiles that are distinguished by their scaly skins. Most lizards are small, except for the Komodo dragon, or monitor, of Indonesia, which can be 10 ft. (3m) in length

62

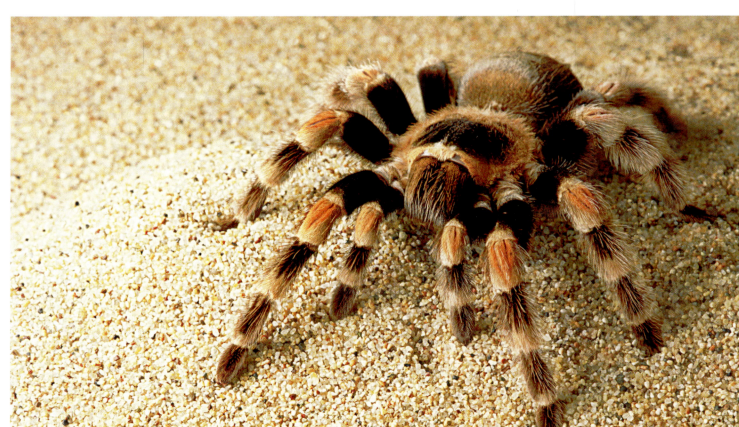

Mexican Red Knee Tarantula

Yes, these arachnids are big and hairy, and many folks find them scary. But the toxic bite of Brachypelma smithi and other members of the family Theraphosidae is more irritating than deadly to humans. Even so, these spiders are big enough to prey on lizards, mice and even birds. They are at home in hot climes, including semiarid deserts and tropical forests

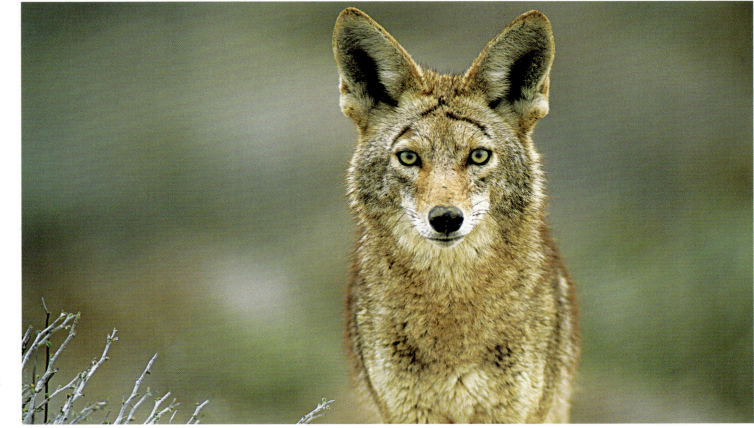

Coyote

Canines are among the most adaptable of species: dogs, wolves and their kin prosper in almost every ecosystem on land. The coyote, Canis latrans, *is at home in the desert but can range as far north as just below the Arctic Circle. Coyotes dwell only in the Americas; they are among the most vocal of wild mammals, using several distinct calls for greeting, warning, claiming territory and indicating their whereabouts*

63

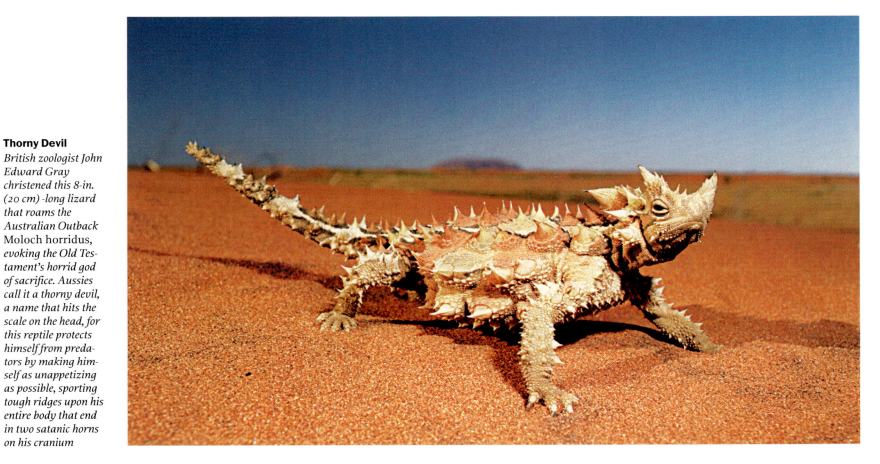

Thorny Devil

British zoologist John Edward Gray christened this 8-in. (20 cm)-long lizard that roams the Australian Outback Moloch horridus, *evoking the Old Testament's horrid god of sacrifice. Aussies call it a thorny devil, a name that hits the scale on the head, for this reptile protects himself from predators by making himself as unappetizing as possible, sporting tough ridges upon his entire body that end in two satanic horns on his cranium*

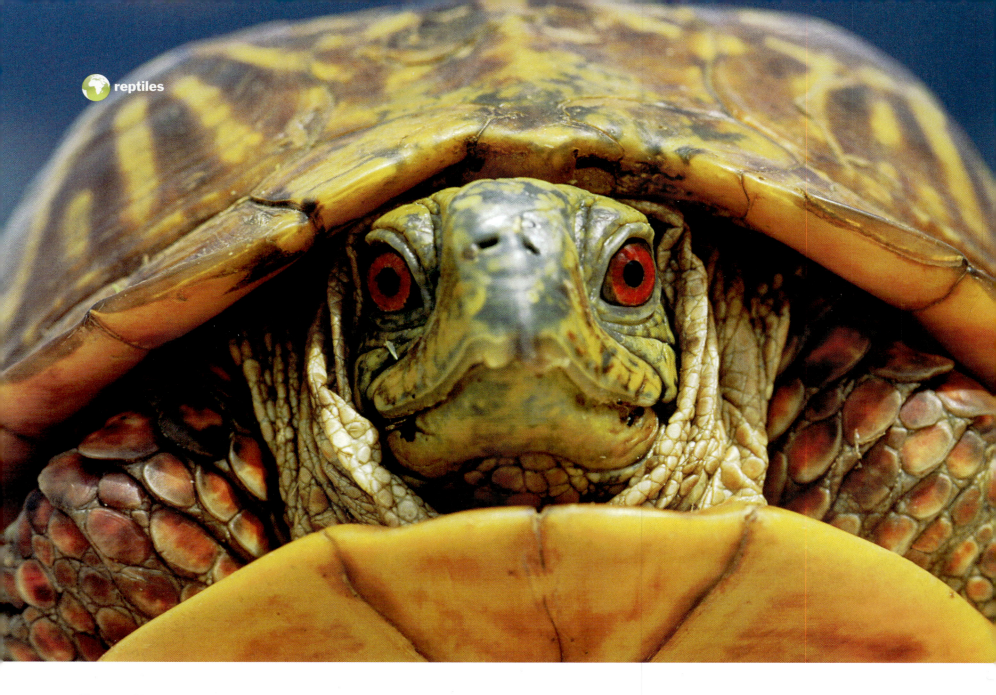

Respect Your Elders

At home in deserts and tundra, in marshes, rain forests and a few watery habitats as well, reptiles make up an enormous clan of loosely related creatures, all of which share a handful of defining characteristics. All reptiles are cold-blooded: they cannot regulate their own body temperature by metabolic means, forcing them to achieve a suitable temperature through behavior or habitat. All reptiles breathe with lungs rather than gills, and all share a distinguished heritage; they are descended from ancient, four-limbed amphibian animals. Scientists believe their paths diverged some 340 million years ago. The reptile family tree leads directly to dinosaurs (and thus to birds); today's reptiles are closely related to the long-extinct dinosaurs, whose name means "terrible lizard."

Some reptiles, like snakes, became limbless, slithering creatures. The majority, however, retain four limbs that end in claws. Most reptiles reproduce by laying eggs: some abandon their brood seconds after depositing them, others incubate their eggs, and some care for their young. The extended reptile family includes lizards, turtles and tortoises, as well as crocodiles and alligators, a total of more than 8,000 separate species. The class Reptilia is so disparate that a few seeming look-alikes have almost no connection to each other. Crocodiles and lizards bear a family resemblance, for example, but crocs are, genetically speaking, more closely related to birds than to lizards.

Despite their diversity and heritage, reptiles get a bum rap. Humans instinctively fear them; some biologists believe this is an evolutionary holdover, for long ago, the only predators able to reach baby primates in trees were snakes. Scaly and cold, reptiles often play the villain in stories and films, including, of course, that evergreen best seller, the Book of Genesis. ■

Reptile fashion: frills, scales, shells and sticky feet *Although all reptiles have scaly, protective skins, tortoises and turtles like the ornate box turtle* (Terrapene ornata), *above, are the only members of the group that have shells.*

Many reptiles are adapted to specific environments: the giant leaf-tailed gecko (Uroplatus fimbriatus) *in Madagascar, above right, seems to be showing off that it has 300 teeth—more than any other land animal—to help it capture frogs and other small, slippery animals.*

Other reptiles attract mates or deter predators by flashing dewlaps, fans or frills, such as the frill-necked lizard (Chlamydosaurus kingii), *near right, assuming a defensive posture in Australia's Outback.*

Leaf-tailed geckos, like most lizards, are adept climbers, for the scales of their oversized feet are covered with microscopic adhesive bristles too tiny to be seen even in the close-up at far right.

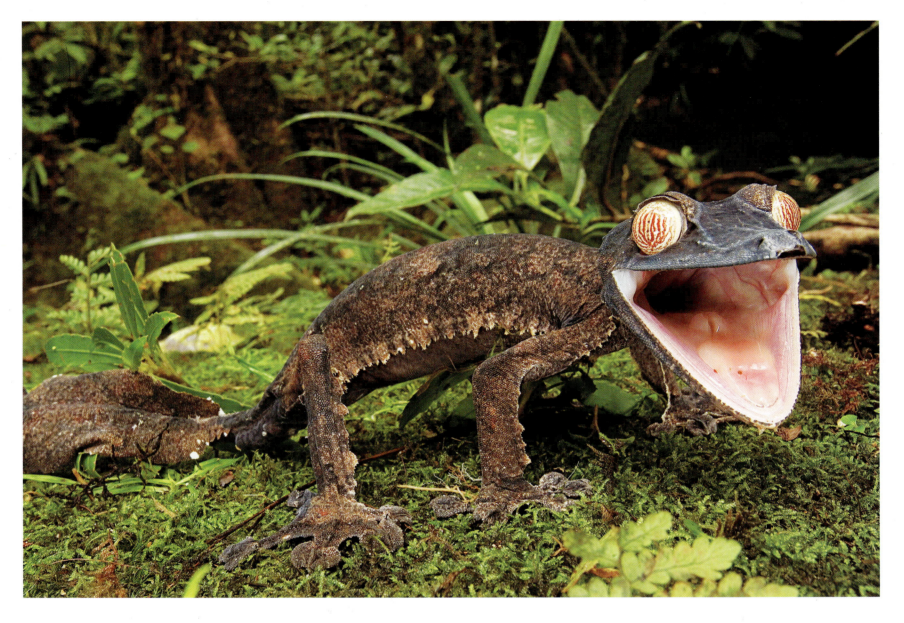

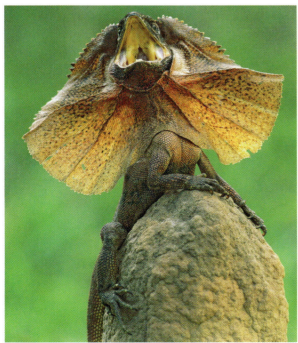

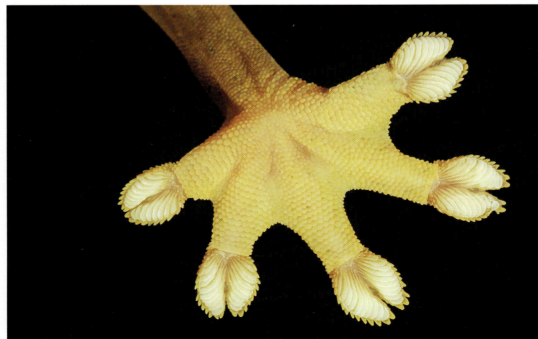

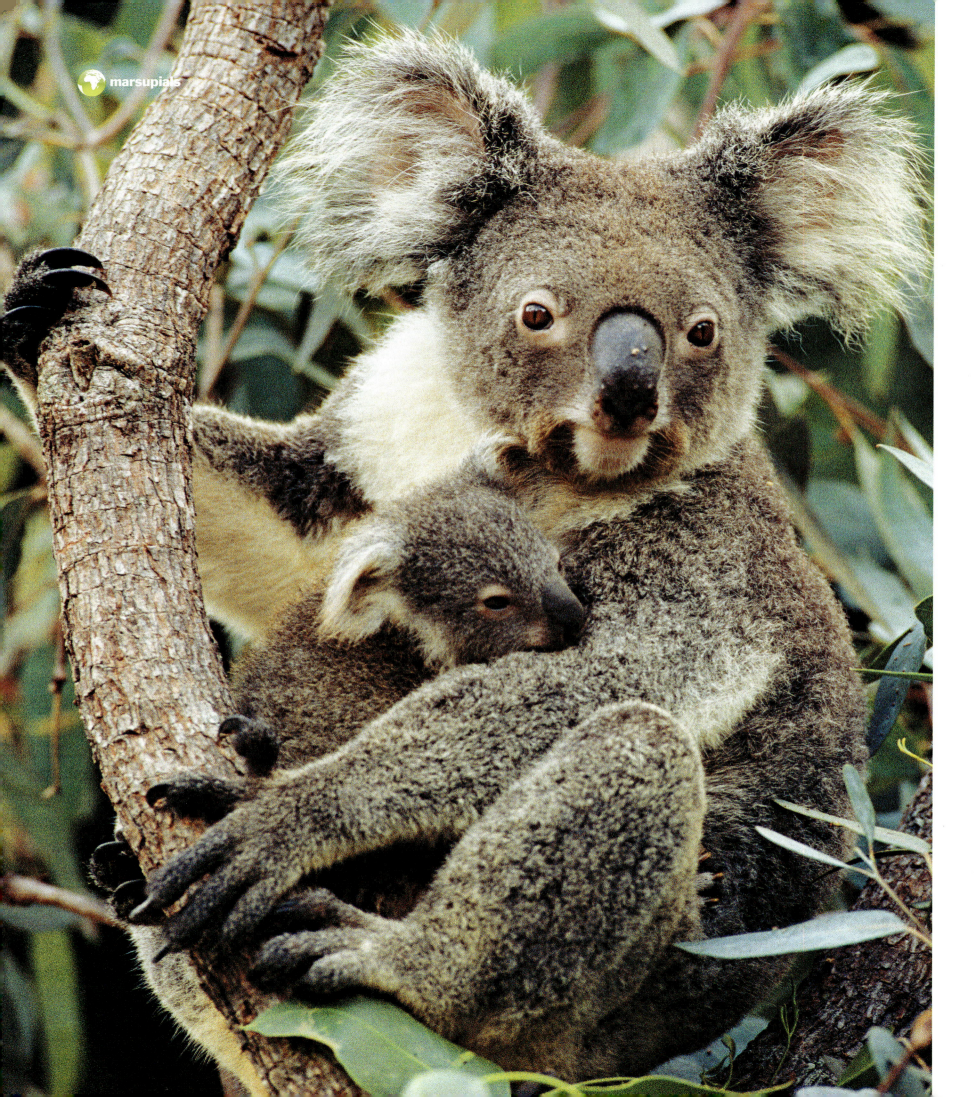

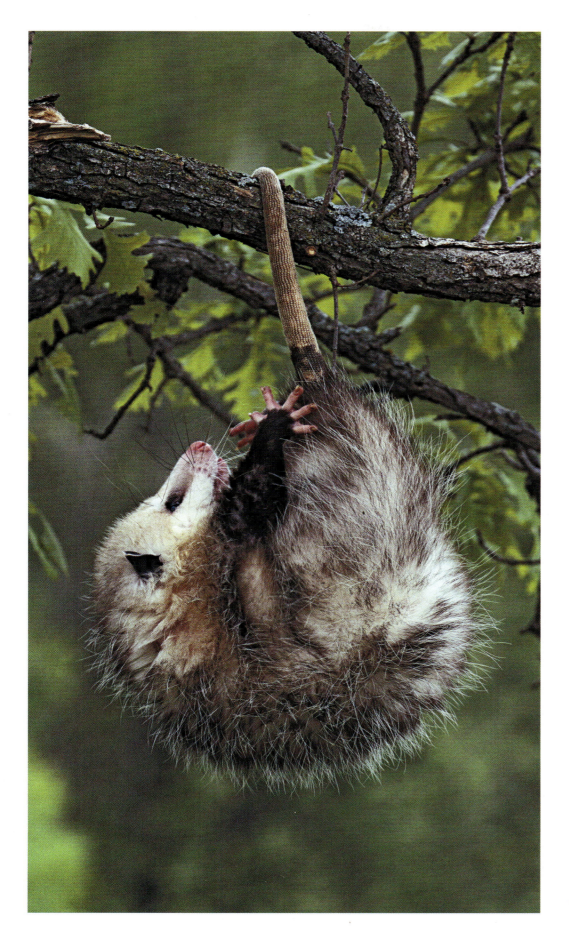

G'day, Mates!

Marsupials resemble mammals—as viewed in a fun-house mirror. Like mammals, they give birth to live offspring and nurse their young. But their reproductive process, involving the care of what is essentially an external embryo in the mother's abdominal pouch, makes them unique, as reported elsewhere in this book. Although kangaroos are the signature marsupial, the order Marsupialia is very diverse, numbering more than 200 species, including wombats, koala bears, bandicoots and Tasmanian devils. They range in size from southern dibblers a few inches long to kangaroos almost as tall as a human being. There are burrowing, grazing and hibernating marsupials, plant-eating and meat-eating marsupials. Some tree-dwelling marsupials have pouches under their arms that help them glide for more than 100 ft. (30 m), in the same manner as a flying squirrel.

Marsupials and placentals (the dominant type of mammals, to which human beings belong) are thought to have diverged more than 100 million years ago, at a time when South America, Australia and Antarctica were still a single landmass. As the continents drifted apart, most marsupials in South America and all those in Antarctica died out, the former killed off by competition with hardier placentals, the latter unable to adapt to the harsh polar environment.

In Australia, where there were fewer placentals and a milder climate, marsupials not only dominated but became giants. Fossil records indicate that kangaroos twice as tall as humans and a wombat the size of a hippopotamus once roamed the Outback, as did marsupial lions with a bite stronger than any other creature that has ever lived.

While most of these mega-marsupials died off before the last Ice Age, the majority of the world's marsupial species are still endemic to Australia. The Tasmanian tiger, a close relative to the Tasmanian devil, was the largest carnivorous marsupial in the world, but it is believed to have died out in the 1930s. A few dozen species of marsupial continue to flourish in South America, but only a single marsupial, the Virginia opossum, still survives in North America. ■

Offbeat mammals *Marsupials like the koala mother at left carry their infants in a pouch until they are fully formed, like this baby. The process takes about six months. At near left is the only North American marsupial, the Virginia opossum, famed for its clever tactic of feigning death—"playing possum"—at a predator's approach. Opossums use their partially prehensile tails as a strong extra arm*

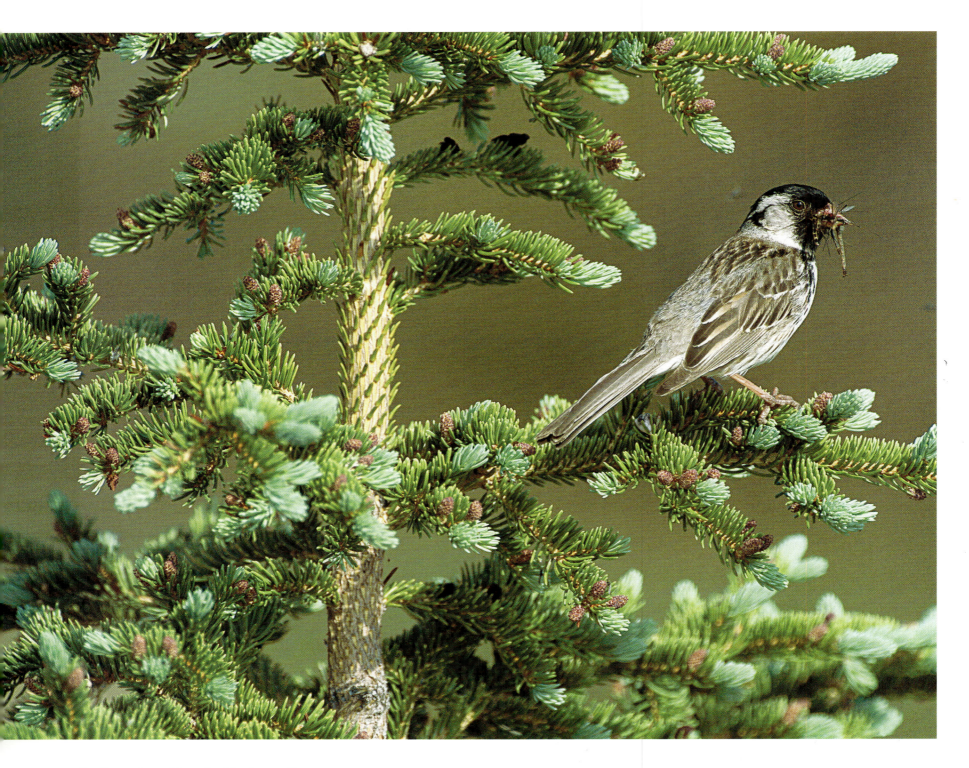

Coniferous trees *Monarchs of the plant world, trees are one of the planet's most successful life-forms: highly adaptable, widely dispersed, commanding in height and beloved for their beauty. Forests play a vital role in the respiration of the planet, taking in carbon dioxide and releasing oxygen, and they are the primary shaper of many ecosystems. Earth's "family tree" is divided into two great branches, the coniferous evergreens, which sport needles and whose seeds are cones, and the deciduous trees, which bear leaves they shed annually. Above, a Harris's sparrow* (Zonotrichia querula) *perches in an evergreen in Canada*

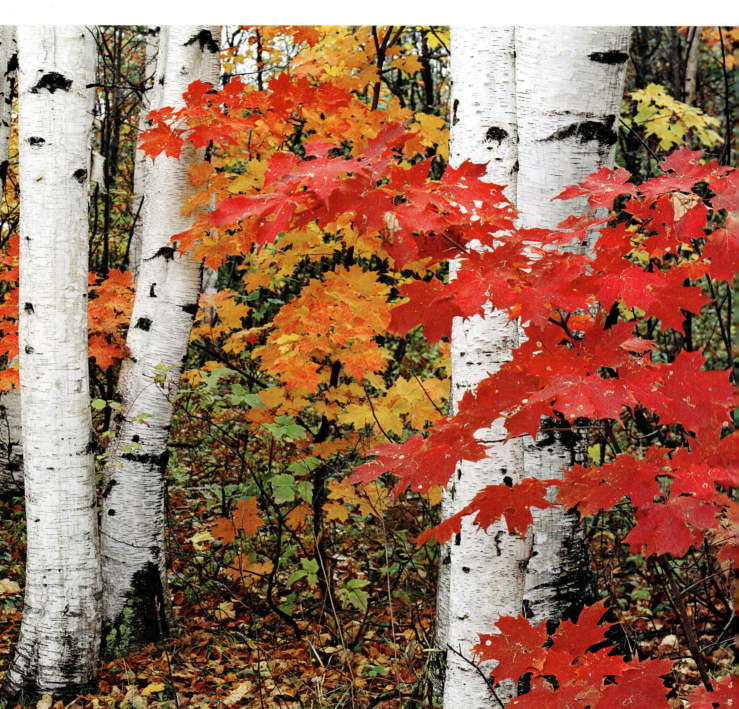

Deciduous trees *Leaf-bearing deciduous trees, such as the white birches and maples above, sporting autumn foliage in Michigan's Upper Peninsula, are the foundation plant in many of the world's great forests. As with icebergs, we see only one portion of the full bulk of these long-lived beings: a rough rule of thumb is that a tree's unseen subterranean roots are equivalent to the area it occupies above the ground. The dumbbell shape of such trees makes them a perfect vessel for transferring water between the geosphere and the atmosphere. And their annual leaf-fall is essential to the replenishment of the planet's soil layer*

 forests

70

Redwood Forest, Yosemite National Park, U.S. *Undisputed monarchs of the tree world, giant sequoias can grow as tall as 307 ft. (93 m) high— roughly the size of a 30-story skyscraper—and can be as large as 29 ft. (8.8 m) in diameter. Their great age is a match for their size: the most ancient known sequoia, measured by its rings, is 3,200 years old.*

Sequoiadendron giganteum is an evergreen that reproduces through seed cones. In the late 19th and 20th centuries, these giants were routinely felled, their timber used for such petty purposes as matchsticks. Thanks to public outrage, many of their habitats are now protected. Concerned botanists also took the massive trees to Europe and cultivated them with success.

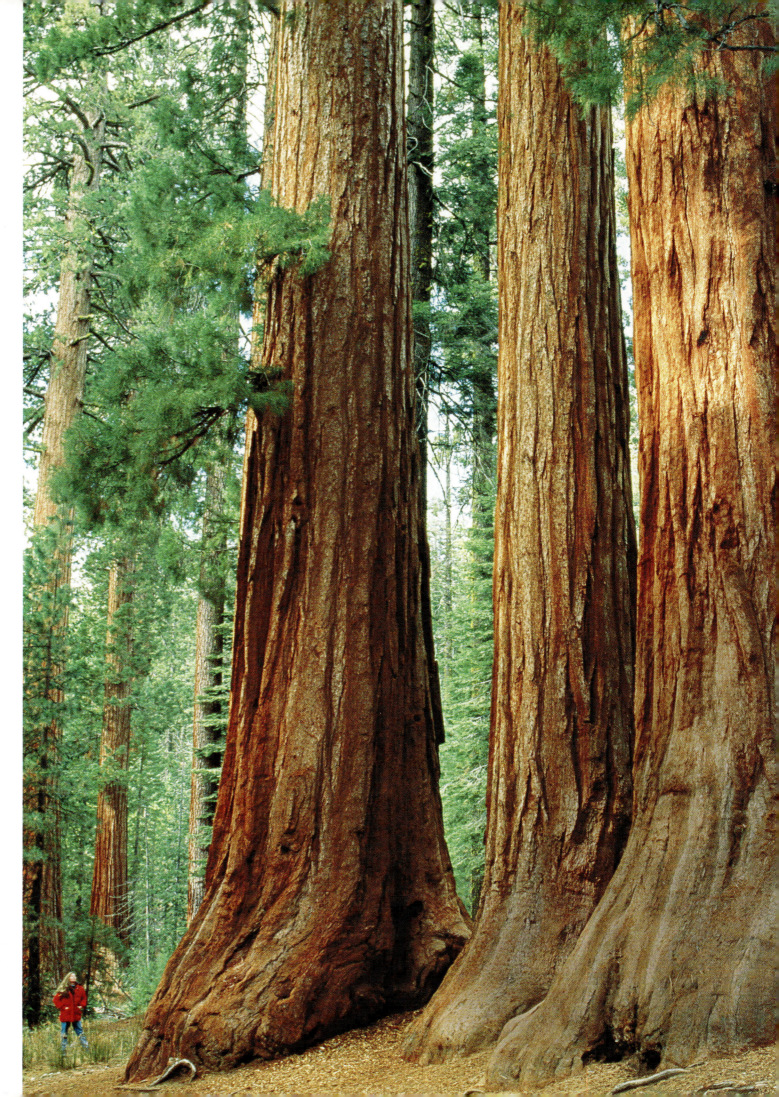

Black Forest, Germany *It is perhaps best known for its kitsch factor—cuckoo clocks, rich cakes and tales of the Brothers Grimm— but the Black Forest deserves better. One of the great surviving primeval forests of Europe, it straddles the continental divide in southwestern Germany; raindrops that fall here wind up traveling to the Atlantic Ocean via the Rhine or the Black Sea via the Danube. The forest's great stands of pine and fir were already heavily logged before Dec. 26, 1999, when 100-plus-m.p.h. winds from the huge cyclone Europeans dubbed "Lothar" devastated hundreds of acres of its green realm*

Dehesa Forest, Extremadura, Spain *This ancient oak forest covers much of western Spain and eastern Portugal, largely unchanged since the days when the Romans remarked upon its splendors after they first arrived in Iberia. Now, as then, the Dehesa is home to the famed Iberian pig—as well as the truffles it snuffles for—as well as other mushrooms, some the size of wagon wheels. The Dehesa's prevalent tree is an evergreen, the holm oak, encina to Spaniards. In 63 B.C., a Greek geographer wrote that a squirrel could climb a tree beside a beach in southern Spain and, jumping from oak branch to oak branch, travel north to the Atlantic coast without touching the ground*

71

Beech Forests, Slovak Republic *The primeval beech forests of the Carpathians were named to the U.N.'s list of World Heritage sites in 2007. Scientists say the 10 distinct sectors that make up the site represent an invaluable genetic reservoir of European beeches (Fagus sylvatica). Aside from their genetic value, the forests are eerily beautiful, seemingly the work of an arborist wing of the Art Nouveau movement. The beechnuts that fall from the trees in autumn are highly nutritious, while the beechwood itself makes fine barrels for aging beer—if the folks at Budweiser are to be believed*

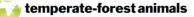
72

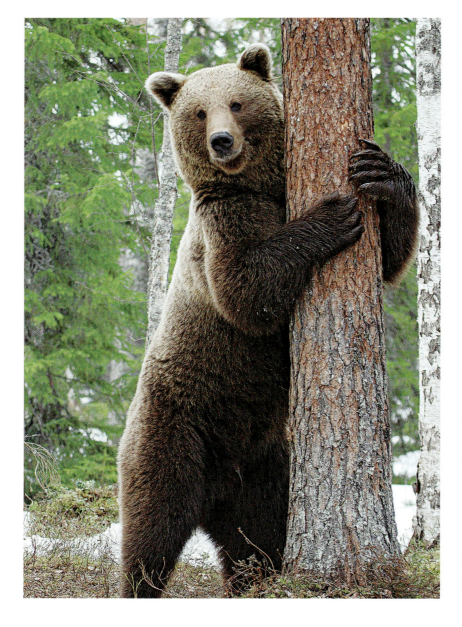

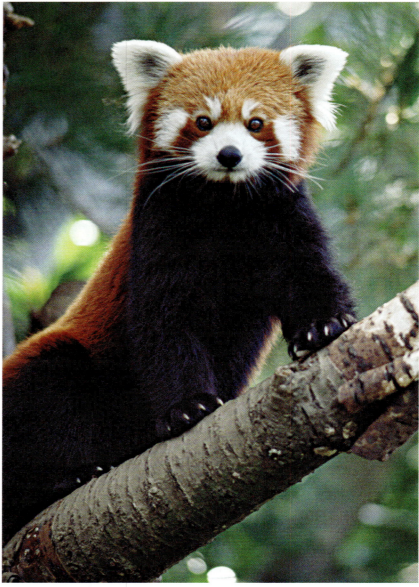

Brown bear *The planet's temperate forests are home to some of nature's more familiar animals, as well as exotic species that are highly localized. Ursus arctos is native to the northern forests of Eurasia and North America. An omnivore, it subsists on a diet of fruits, berries, vegetables and animals. Like the elephant, its large size—a big bruin can top out at 9 ft. (2.7 m) tall—makes it a dominant species in the forest, where it preys in late spring on ungulates such as newborn moose and deer*

Red panda *Far less familiar than the beloved black-and-white giant panda, the red panda, also called the lesser panda, deserves more respect. Ailurus fulgens is a bamboo-loving omnivore, a bit larger than a cat, native to the highland forests in the foothills of the Himalayas. Like the raccoon, to which it bears a facial resemblance, it is most active at dawn and dusk. And like the giant panda, the lesser panda is endangered: field biologists fear as few as 2,500 adults are still alive in the wild*

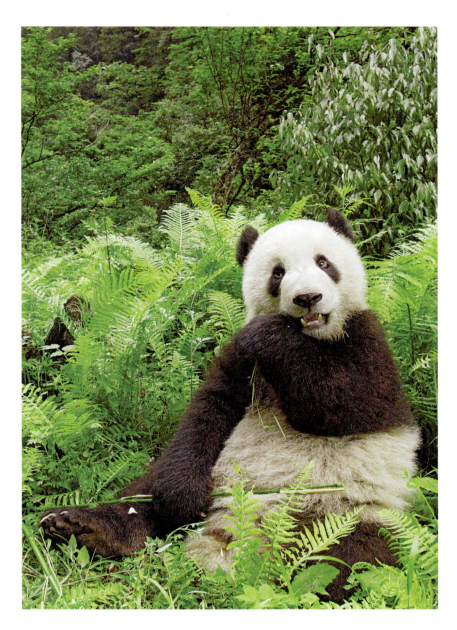

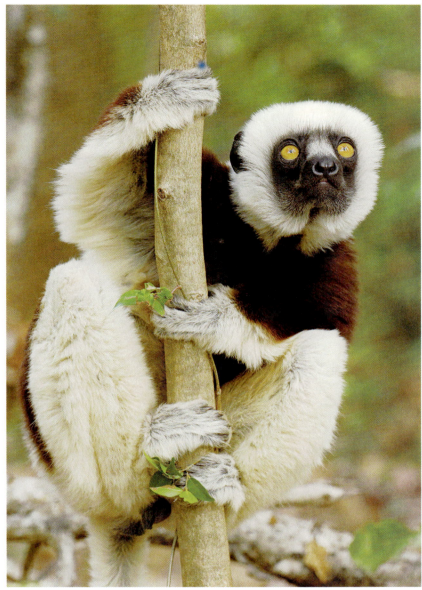

73

Giant panda *Everyone's favorite bamboo-chewer,* Ailuropoda melanoleuca *is a gentle creature whose habitat is confined to mountain forests in only three provinces of China. Males can weigh as much as 350 lbs. (159 kg); females a bit less. Scientists say there may be fewer than 3,000 of the sad-eyed bears in the wild, and they have become the poster animal for endangered species. But China boasts that there are more panda preserves than ever before, and it is hoped the species may be saved*

Coquerel's sifaka *Like Ecuador's Galápagos Islands, the big island of Madagascar, off the southeastern coast of Africa, is sufficiently isolated from the mainland that it developed a large population of unique animal species, the best known of which are lemurs, which are primates. The long-tailed herbivore above,* Propithecus coquereli, *dwells in the forest canopy and is an expert leaper and climber that walks with an upright posture on the ground; like most other lemurs, it is considered endangered*

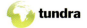

The Northern Plains

Behold the Arctic tundra in Canada's Yukon Territory in full flower during the region's all-too-brief summer season. The growing window is open for only 50 to 60 days here, and the warmest days in July peak at 55°F. Winter brings some of the harshest weather on the planet, with the average temperature hovering at a chilling −20°F. Some compare conditions here to those in a desert, for annual rainfall is a skimpy 6 to 10 in.

Unseen but dictating the appearance of the stark, treeless landscape is a layer of permafrost, subsoil that remains frozen year-round. This barrier of cold material prevents trees and larger shrubs from extending their roots into the ground, resulting in a close-cropped landscape in which low shrubs and some flowering plants pop above the mosses, sedges and lichen that make up the majority of the vegetation. The permafrost layer also keeps the scant rainfall on the surface, accumulating in smallish ponds, bogs and marshes. Wind is another invisible but essential element in this landscape, sweeping across the flat, glacier-scraped plains with no trees to hinder its progress.

Tundra makes up a large part of the earth's land surface, roughly 20%. The vast majority of it lies along the edges of the Arctic Circle, but this interesting ecosystem is also present in some high mountain regions. Alpine tundra shares the frosty snap and dwarfish vegetation of Arctic tundra but generally has soil that drains better.

Who lives here? The Yukon, one of three vast territories that make up Canada's northland, ranges over some 186,000 sq. mi., but it is inhabited by only some 31,000 people. Animals far outnumber humans, and the bestiary of the tundra is constantly shifting, for the harsh conditions here dictate survival via either hibernation or migration. ■

74

Jewel of the tundra *Left, a tiny mushroom peeps up from the thin soil layer of the tundra. Trapped in the permafrost, vegetation in the tundra typically freezes rather than decomposes after it dies, and it does not release the carbon dioxide (CO_2) taken in during photosynthesis. Tundra has thus been one of the planet's major carbon dioxide sinks. But as warmer global temperatures heat the permafrost layer, more CO_2 is now being released, exacerbating the problem in a disturbing feedback loop*

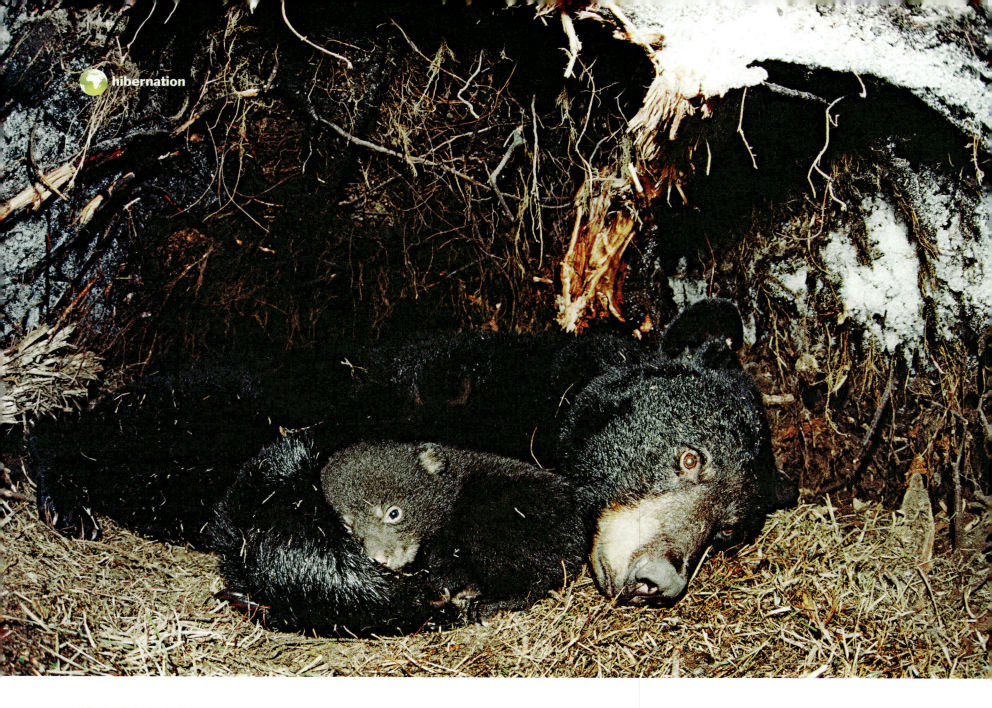

A Long Winter's Nap

Animals that live in cold climates employ three different strategies for dealing with wintertime weather and the food shortages it brings: bundle up, follow the sun or sleep through it. Shrews and weasels choose Door No. 1: the former gorge themselves before winter, taking on a layer of insulation known as "brown fat," while the latter grow thicker, warmer fur coats for winter's chill. Migratory creatures prefer the "run away" strategy, wintering where it's warmer. But for animals ill-equipped to eat so much or to travel so far, cold weather cues the big sleep.

Who's snoozing? Species of mice, skunks, raccoons, bats, frogs, turtles, snakes, snails and even some fish lapse in winter into a state of suspended animation, experiencing precipitous drops in body temperature (in many cases, close to freezing), while their heart rates slow to a few beats per minute. If removed from their shelters, many of these wild critters can be handled like toys for long periods without waking.

Bears are nature's best-known sleepyheads, yet most scientists don't classify them as true hibernators, because their body temperatures drop by only about 10° during their sleep, and they can be awakened with relative ease—if not without risk. But bears do perform a metabolic miracle that researchers have yet to understand: they stop expelling waste from their bodies and recycle the nitrogen content of urea, the usually poisonous primary component of urine, back into new protein. Bears not only lose fat during their winter sleep, as you'd expect, but surprisingly, they also increase their lean tissue and bone mass.

Some creatures hibernate in summer: lungfish bury themselves in underwater mud and sleep for several months as their river homes run dry. This process, called estivation, comes full circle when they emerge from slumber with the autumn rains. ∎

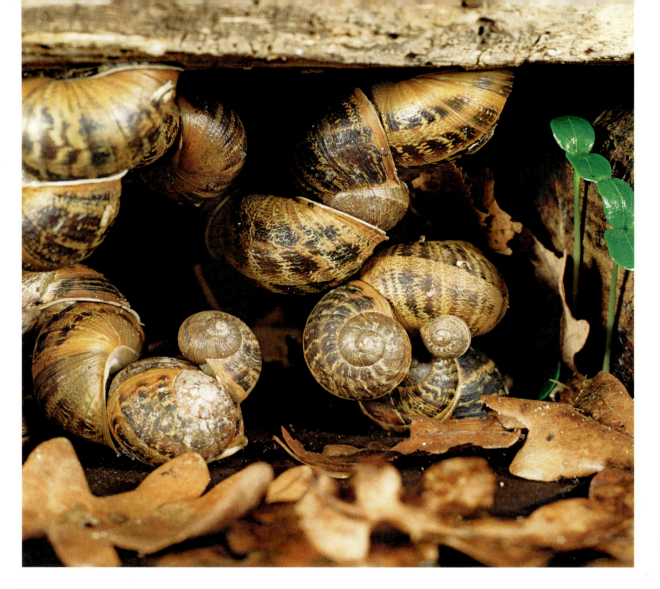

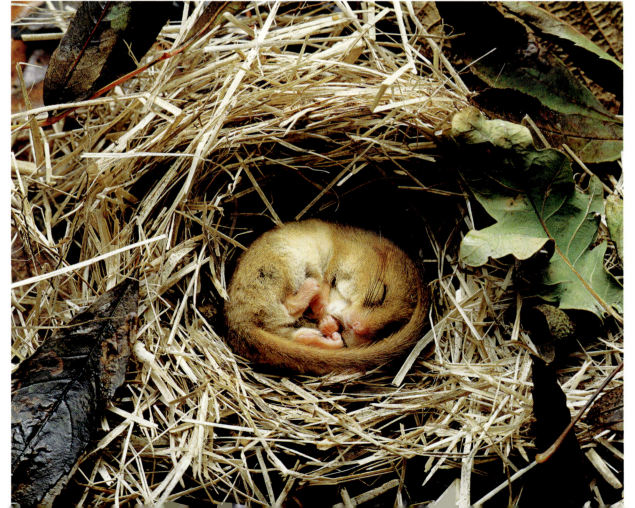

Ready … Set … Doze *At top left, a black bear sow* (Ursus americanus) *hibernates with her cub in Minnesota. Bears are light sleepers, even while hibernating, and can be dangerous if bothered. Suggestion: do not disturb.*

At top right, garden snails (Helix aspersa) *cluster for winter in their hibernaculum, the zoological name for the place an animal chooses for its seasonal sleep.*

At right, a pair of dormice (Muscardinus avellanarius) *nap; the species is so well known for its annual hibernation that it takes its name from the French verb dormir—"to sleep."*

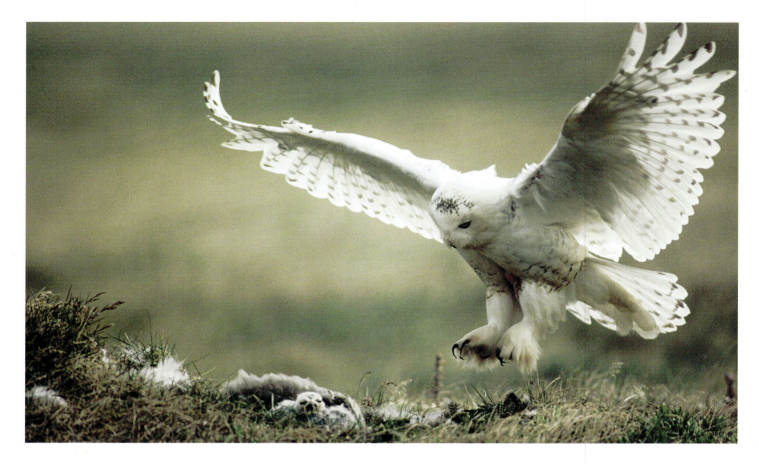

Snowy owl *Showing off the mighty wingspan and powerful legs and talons that make it a highly successful predator, a snowy owl (*Nyctea scandiaca*) comes in for a landing on its ground nest; the owlets in it will go hungry this time around. Sometimes called the Arctic owl, tundra owl or great white owl, this carnivore also preys on young ptarmigan, one of the most common gamebirds of the tundra*

78

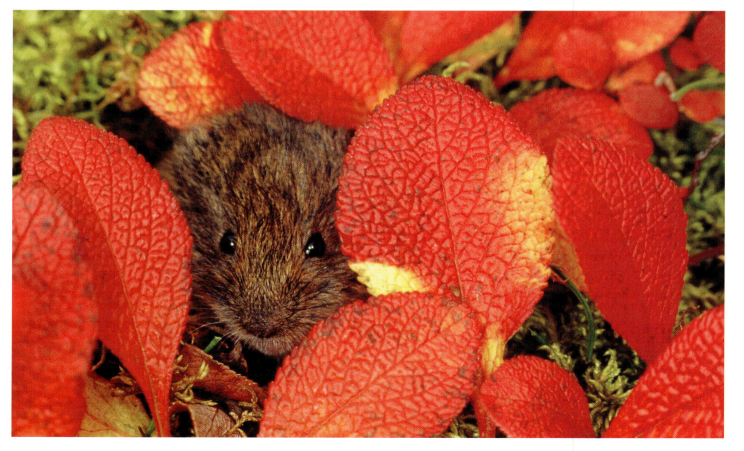

Tundra vole *He's doing his best to avoid being detected, but a sharp-eyed photographer captured this specimen of* Microtus oeconomus *hiding behind autumn-tinted bearberry leaves. Less than 7 in. (18 cm) long, this rodent is indeed as micro as its species name declares, and it is also economical, digging burrows to store roots and seeds for the long winter. Unlike some tundra dwellers, voles do not hibernate in winter*

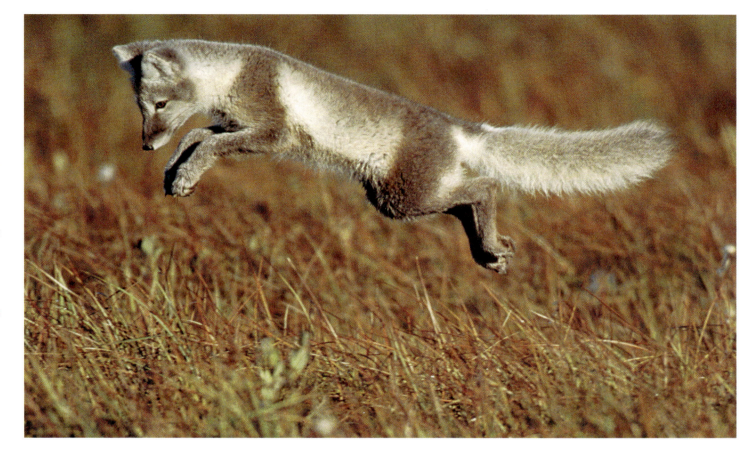

Arctic fox *Up, up and away! Demonstrating the vertical liftoff that is called "pronking" when performed by antelopes, a juvenile Arctic fox,* Vulpes lagopus, *practices his pounce amid summer grass on the tundra on the North Slope of the Brooks Range in Alaska. In addition to the usual adaptations to cold tundra weather—thick fur, extra body fat, a small size that exposes less body surface to the elements—this fox has hairy feet that help it get traction on ice. It dwells in underground dens that can be complex mazes of rooms*

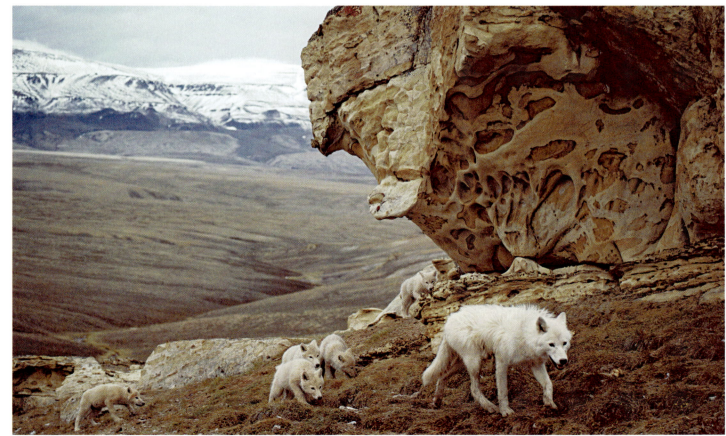

Arctic wolf *Like all wolves, members of the Arctic branch of the family,* Canis lupus arctos, *live in highly organized packs. At right, a juvenile lone male leads a group of youngsters up a mountain on Ellesmere Island in Canada. Shaped by the cold, Arctic wolves are smaller and heftier than most gray wolves; they range widely across the tundra as they hunt musk oxen, caribou and Arctic hares. Native to North America and Greenland, this cold-weather species is not found in Europe or Asia*

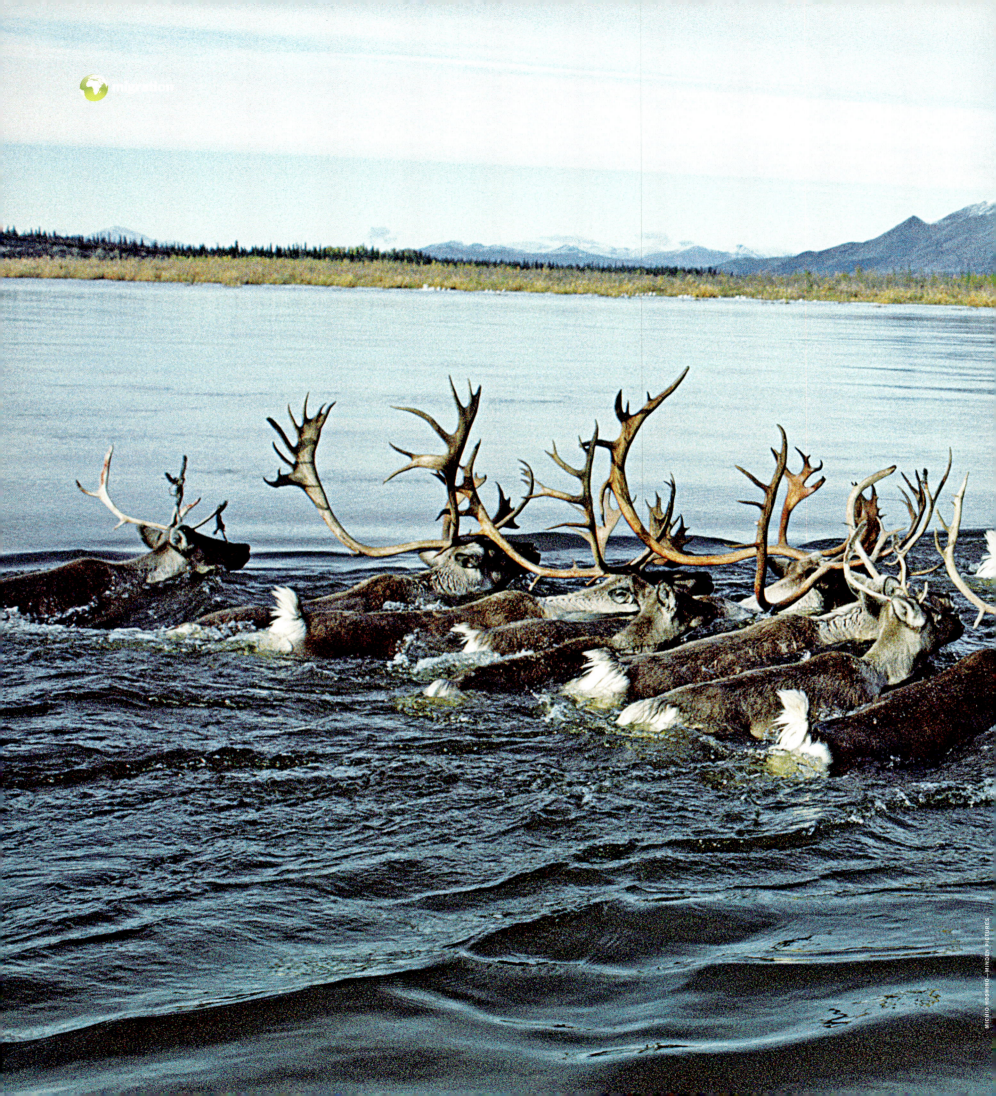

MICHIO HOSHINO–MINDEN PICTURES

Antlers aweigh *The great caribou herds that dwell on the tundra below the Arctic Circle conduct the longest land migration on the planet. Above, caribou (Rangifer tarandus) cross Alaska's Kobuk River. In some cases, caribou—which are called reindeer in Europe—travel as far as 750 miles (1,200 km) twice each year as they move between their winter and summer ranges. Their hooves adapt to the season: harder for icy winter tundra, softer for summertime grass; in addition, they serve as paddles when the caribou ford rivers. Caribou hair is hollow, offering buoyancy for their river crossings*

 galápagos animals

Alternate Bestiaries

Six million years ago, along the eastern edge of the Pacific Ocean's Ring of Fire, a string of undersea volcanoes poked above the waves, blew their tops, then lapsed into a prolonged, if restless, sleep. The dozen-plus islands that remained were almost 600 miles (960 km) from the nearest landmass and were left undiscovered by humans until 1535 A.D. In the meantime, however, thousands of other accidental tourists found the Galápagos. Lost birds alighted there and never left. Small land animals blown out to sea floated there on "rafts" of leaves and timber. Spores and seeds were borne to the islands on the breeze. As soon as they arrived, all these fauna and flora began to be shaped by their new environment. The result was (and is) a living laboratory of what happens to plants and animals that adapt in complete isolation—cut off not only from human interference, but also from the competition and predation of other species.

The islands' most famous visitor discovered in the Galápagos a new Eden: an environment where almost half the plants, nearly all the reptiles and many of the other animals were unique—found nowhere else on the planet. In 1835 Charles Darwin noticed that among more than a dozen species of finches found only on the Galápagos, each had a differently shaped beak, uniquely suited to its own food source. This observation, "seemed to me to throw some light on the origin of species," the British biologist wrote later, using the phrase that became the title of his epochal treatise on natural selection.

Generations of later scientists also benefited, like Darwin, from another unique feature of the archipelago: animals that have never been preyed upon don't have the fight-or-flight instinct that makes direct observation of wildlife so challenging elsewhere. Even now, birds, lizards and nearly every other creature on the islands are as tame and unafraid of humans as golden retrievers. Native species include the giant Galápagos tortoise, the marine iguana and lava gulls, whose feathers match the color of the island's volcanic soil—and of, course, Darwin's finches and their probing, specialized, revelatory beaks. ∎

82

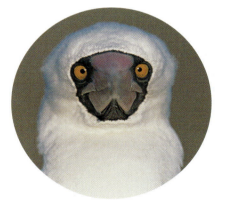

Unique *At top is the Galápagos green sea turtle. Such oceanic turtles are found in abundance across the world, but this subspecies of* Chelonia mydas, *endemic to the islands and prized for its meat, eggs and hide, is over-hunted and highly endangered. It is distinguished for its small size and relatively dark coloration.*

At center, the marine iguna, Amblyrhynchus cristatus *is the fellow on the bottom, and he's the world's only sea-going iguana. His hitch-hiking friend is a lava lizard, genus* Tropidurus, *also found only in the Galápagos, in seven different species, each unique to its location in the archipelago.*

At bottom, the sea-going Nazca booby, Sula granti, *is one of six booby species. It is found in the Galápagos and a few other locations in the eastern Pacific. The female lays two eggs, and the chick that hatches first shoves its sibling from the nest to die.*

D. PARER & E. PARER-COOK—AUSCAPE—MINDEN PICTURES; LEFT, TOP TO BOTTOM: CHRIS NEWBERT—MINDEN PICTURES; HIROYA MINAKUCHI—MINDEN PICTURES; TUI DE ROY—MINDEN PICTURES

Smoke signals *The Galápagos tortoise gave the islands their name; the word is taken from the Spanish term for "saddle," which their shells resemble. The smoking fumaroles in the background are a reminder that Ecuador's famed archipelago is still geologically active*

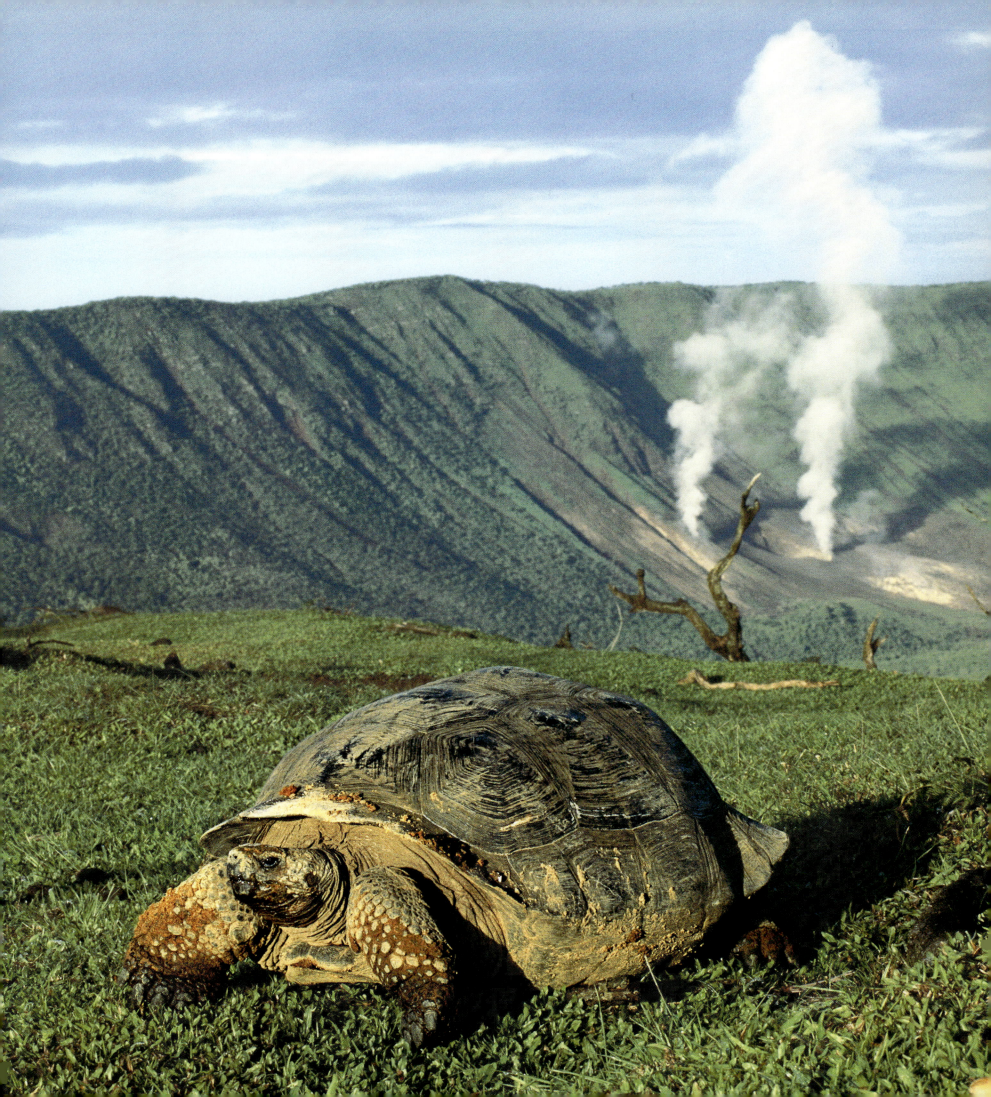

biosphere

bio·sphere *(n.)*
[Gk *bios* mode of life+ Gk *sphaira* ball]
the part of the planet in which life can exist; the world
of plants and animals; the world of life

Hiding place *This Andean marsupial treefrog (Gastrotheca riobambae) is a baby, only two weeks removed from his tadpole days. It takes refuge in the hollow of a bromeliad flower in Ecuador*

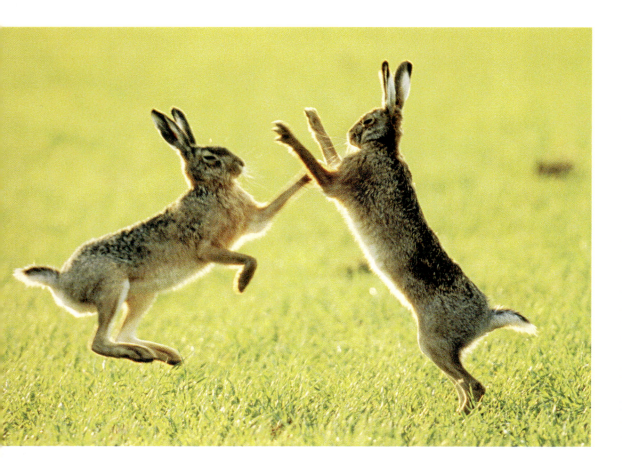

Two's Company

Human courtship rituals and mating patterns can seem bizarre at times, but *Homo sapiens* has it easy compared with many other species. Consider the anglerfish. When a male is ready to mate, he picks up a female's scent deep in the ocean. The suitor then chases his intended until he's close enough to bite, after which he hangs on so long that his body finally fuses with hers, and he is effectively absorbed into the female. In the end, only the testicles of the male remain intact; they release sperm into the female, impregnating her with the late father's child. In this sense, anglerfish mate for life—with the small caveat that life ends for the male once they have consummated their relationship.

Other species survive sex but have to jump through hoops of their own before procreating. Male horseshoe crabs don't disappear into their mates but do remain locked to females for as long as a year. Male capuchin monkeys resort to improvised percussion, using sticks to bang on trees as a mating call. Male kangaroos use their feet to give prospective mates a precoital back rub. And some varieties of beetle resort to bribery: males of the Pyrochroidae family bow before females with whom they want to mate, showing a deep cleft in the forehead. This indentation contains a small dose of cantharidin, the aphrodisiac humans call "Spanish fly." The female tastes this chemical, which is valuable as a repellent against ants and other predators, and only then allows the male to copulate with her. During intercourse, he transfers a larger quantity of cantharidin to the female, which she conveys to her eggs, making them safer.

Many female mammals are fertile and mate only at designated periods of their estrous, or reproductive, cycle. Willing females often have a repertoire of signals all their own. When a lady alligator selects a mate, she swims toward him, places her snout beneath his chin and closes her eyes, seeming to luxuriate in the vibrations created by his mating calls. Then and only then does she consent to sate her gator. ∎

Shall we dance? *At top, a pair of European hares* (Lepus europaeus) *engage in a ritual show of jumping that precedes mating. Below, for many species, mating takes place only when the female is in estrus; here a male giraffe sniffs to detect a telltale scent.*

At right, two red-crowned cranes (Grus japonensis) *raise their voices during a courtship dance in Hokkaido, Japan. The cranes are highly endangered; as few as 1,500 may survive in the wild.*

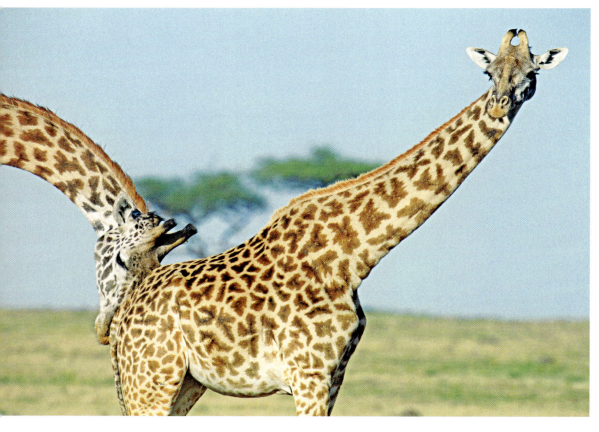

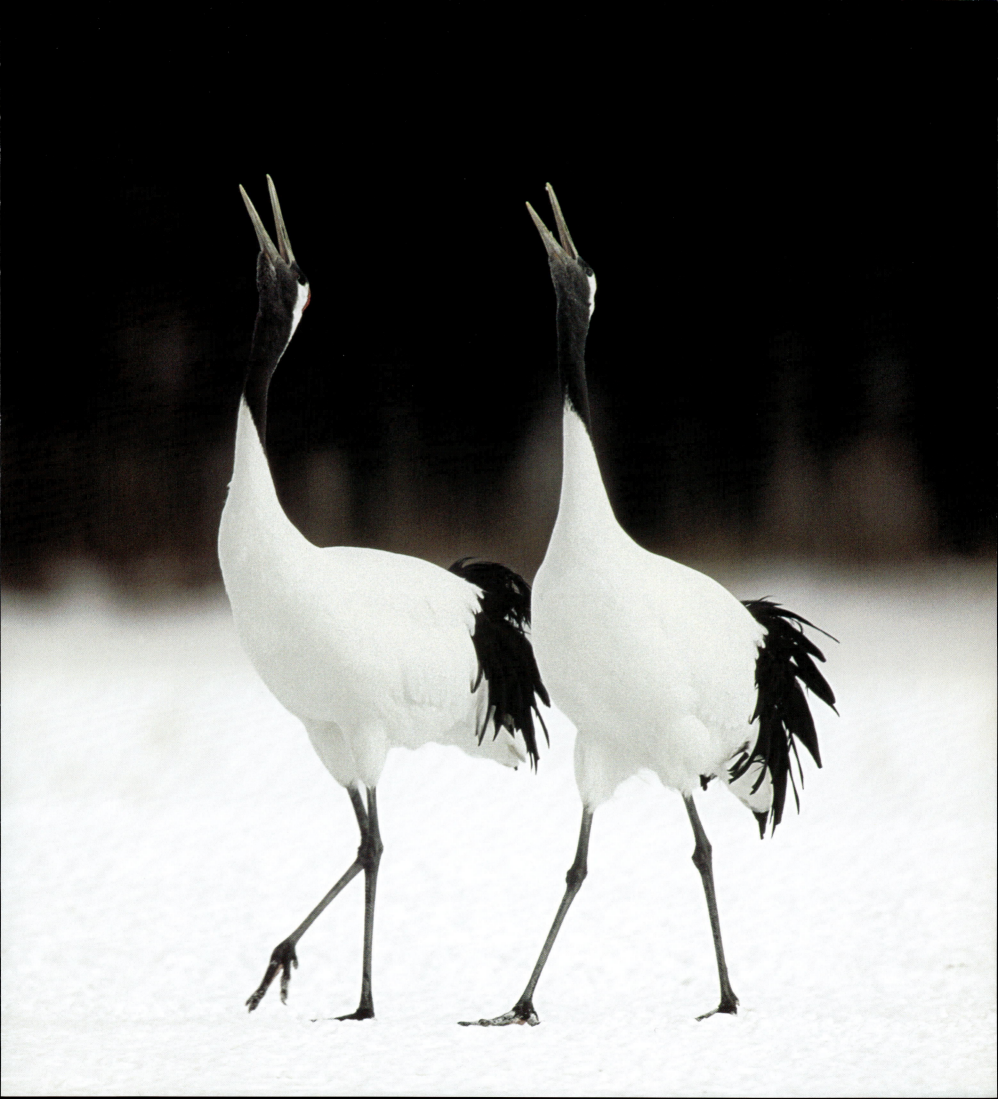

88

Desperately Seeking …

Think of it as animal advertising: just as lonely humans place personal ads, wild creatures gripped by the urge to merge find countless ways to exhibit their interest and desirability. The poster boy for courting displays is the male peacock that struts and fans his colorful tail feathers when in search of a mate, but his behavior is far from unique. The chests of male gelada baboons turn a fiery shade of red during courtship. Frigatebirds inflate a large red bladder, the gular sac, beneath their chins, while some species of bellbird can stiffen three wattles that usually hang loosely from their heads, creating the appearance of tricorn spikes extending from the face, a sort of horizontal Mohawk. Several breeds of lizard not only puff up their throats like goiters but also raise their crests. Many birds, such as male ducks, molt and take on new, brighter plumage when mating season arrives.

But what of animals not born with the anatomical equipment to promote themselves? Male bowerbirds build complex structures from twigs, leaves and every other building material they can find, fill them with all the brightly colored objects they can scavenge, then present the bower to the female, who tours it before deciding whether to breed. Interestingly, the most ornate of these bridal chambers are built by the bowerbird species that has the dullest plumage and whose males are thus the least naturally equipped to draw the eye of a mate. Breeds with brighter feathers also build bowers, but they are far less intricate.

Charles Darwin once wrote, "The sight of a feather in a peacock's tail … makes me sick," and little wonder: under his theory of natural selection, such lavish allocations of effort and biological resources can seem pointless. After all, a brighter coat or a talent for architecture doesn't help an animal find food or fight off competitors. This prompted Darwin to devise a second theory, which he called "sexual selection." It postulates that any trait that increases an individual's chance of mating is also reinforced, and thus is more apt to be passed on to subsequent generations. ■

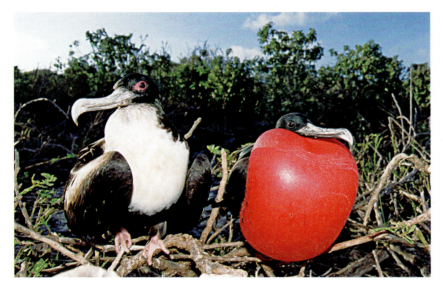

89

Take a chance on me? *On the left page, a male brown gardener bowerbird,* Amblyornis inornatus, *adds a dash of blue color to the elaborate structure he has built and decorated to woo a mate in New Guinea.*

On this page, clockwise from top left, a male frigatebird, Fregata minor, *inflates the red gular sac beneath his chin, seeking to attract the female next to him. These large birds are native to the tropics; their wingspan can reach 7.5 ft. (2.3 m). Once called man-of-war birds, frigatebirds received a nautical nomenclatural upgrade in the 19th century.*

The male hooded seal at top right is showing off his inflatable nasal membrane. The first word of his scientific name, Cystophora cristata, *means "bladder bearer" in Greek. The hooded seal is found only in the Arctic and northern Canada.*

Above, a water lily reed frog, Hyperolius pusillus, *puffs up his resonant bladders in order to issue a loud mating call. In this case, the frog's physical transformation is a courting rite based on sound rather than appearance*

Above left, one would think the bright red face and the brilliant white ring around his neck might be enough to attract a mate, but this male Phasianus colchicus *puts on quite a show of flapping his wings. Night fever!*

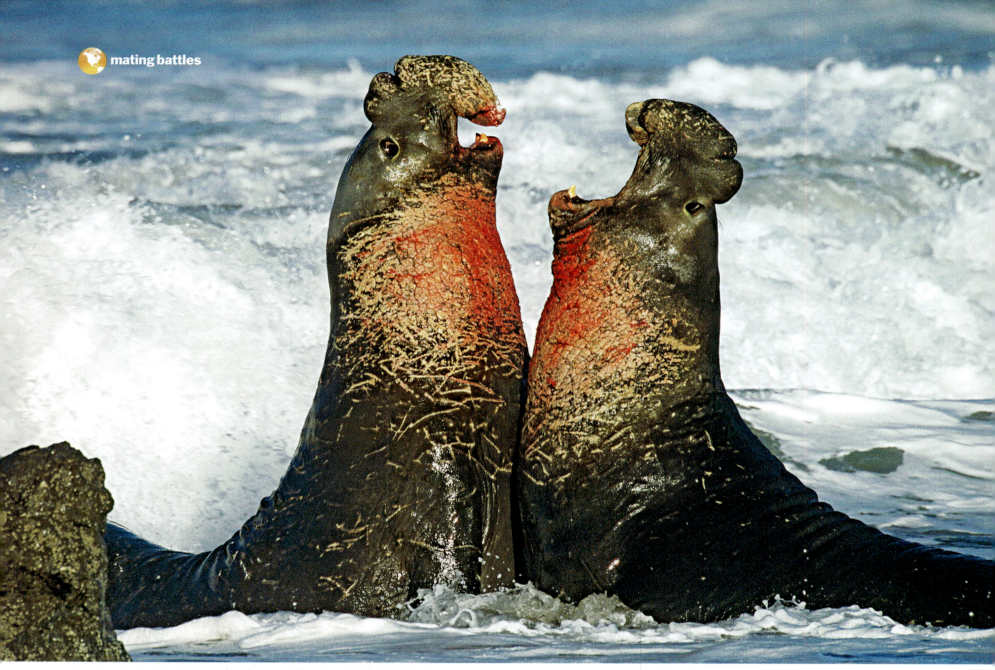

Northern Elephant Seals *Two male seals square off—and sound off—in California*

Dustups for Dominance

Nature's great law of natural selection awards survival to the fittest specimens of a given species. We're used to thinking of natural selection as a process that occurs gradually over millions of years, as the offspring of better-adapted animals gradually outnumber those of the ill-adapted. But in fact, natural selection also takes place generation by generation among many species, as males engage in battles for dominance—and the right to mate with the most desirable females.

Generally speaking, male mating battles are seen among the more advanced animals, including many mammal species. In such groups, there is often one male that takes a leadership role: this alpha male is the only male in the group that is allowed to mate, and he will mate with every female in the group until he is ousted from his position by a stronger male.

In other cases, the alpha male bonds with an alpha female, and they are the primary mating pair. This is the case in most wolf packs, which are highly organized social units in which a variety of roles, most directly related to the activity of hunting in a pack, are clearly established. In some cases, several pairs in a pack of wolves may mate and breed, but more attention in the form of food, rearing and protection will be awarded to the offspring of the alpha pair.

Male wolves that lose a battle for dominance often choose to leave the pack rather than take an inferior position; these "lone wolves" then wander the countryside seeking a mate to help them begin a new pack structure. In some animal species, including apes, lone males band together in a social unit known as a bachelor group.

Male mating rituals are as diverse as the animal kingdom itself, and not all of them involve fighting. Some contests involve displays of grace, with males competing to show their prowess at leaping or running. But many more are duels in which the combatants resemble gladiators, wielding the weapons of their species: bull moose battle with antlers; seals with bellowing blasts from their vocal cords; rams with tough spiraling horns. Nature's challenge: Get ready to rumble, and may the best man win! ■

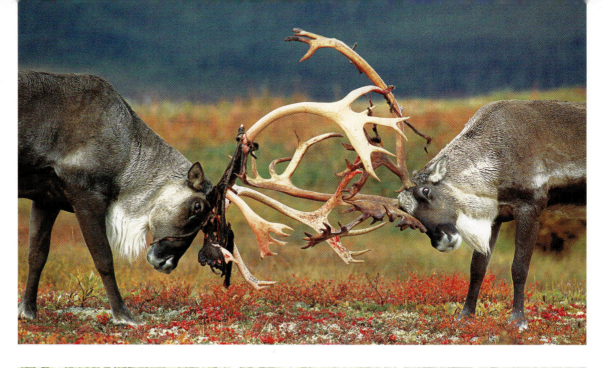

Caribou *Males lock antlers at Denali National Park and Preserve in Alaska; blood can be seen on the antlers of the combatant at left*

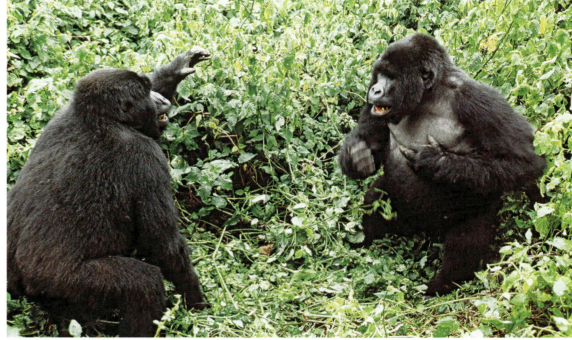

Gorillas *Two male mountain gorillas strike aggressive poses in Virunga National Park in the Democratic Republic of Congo*

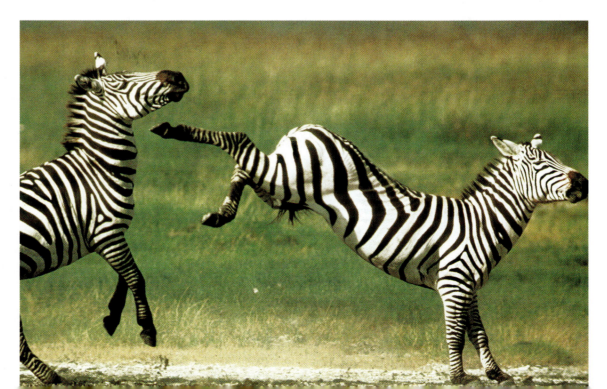

Zebras *Males kick up their heels on Africa's great grasslands, the Serengeti*

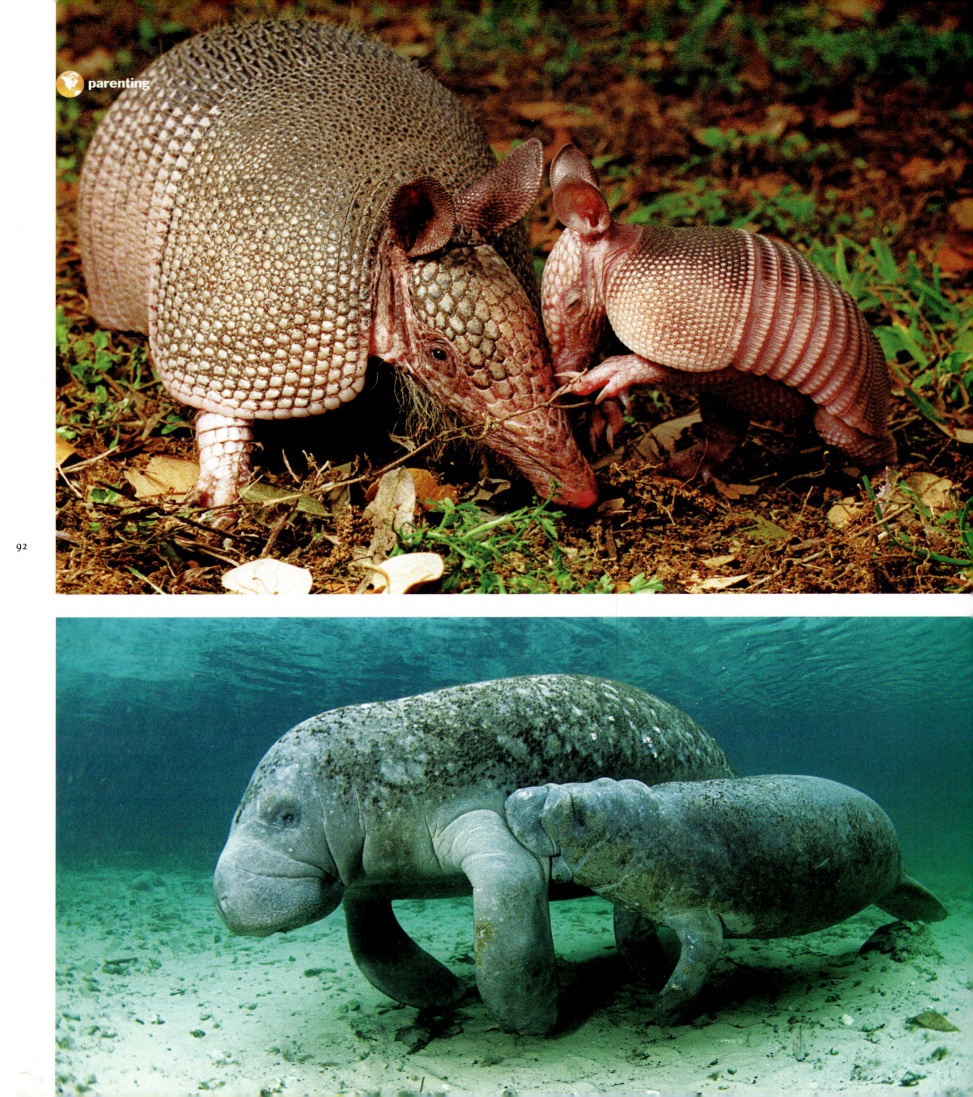

Family Ties

Birds do it. Bees do it. Even educated fleas do it. And after they've done it: well, there are a lot of little birds, bees and fleas to be raised. Parenting in nature assumes a wide variety of forms. Filmgoers around the world thrilled to the sacrificial ordeal endured by adult emperor penguins as they weathered the brutal Antarctic winter to protect their eggs in the hit 2006 documentary *March of the Penguins*. Yet for every heartwarming example of animals that mate for life and share in the nurturing of their young to independence, nature also seems to serve up a dystopian counterpart: animal parents that show little interest in their children and never create a meaningful bond with them.

In species in which fertilization takes place externally without sexual activity, as in many fish, there is little display of parenting behavior. In contrast, viviparous animals—those that give birth to live young—are likely to be deeply involved in the care and feeding of their offspring. However, the degree of parental involvement generally depends on the state of development of the newborn: mammals like giraffes and horses give birth to infants that are capable of standing and walking within an hour, whereas those that give birth to less fully developed children spend much more time caring for their young. Mammals, of course, are distinguished in the animal kingdom by the presence of female mammary glands and nutrition via nursing, which forges a strong link between parent and child.

Ovoviviparous animals, such as sharks and many reptiles, incubate their eggs within their bodies, then give birth to live young when the eggs hatch internally. Oviparous animals, including birds, lay fertilized eggs, then incubate them, generally with their body warmth, to begin development. Most birds carefully feed and nurture their young until they are independent enough to leave the nest; the tasks are so demanding that birds often enter into monogamous relationships, at least until the chicks are fledged, to see them through.

Lest we grow too misty-eyed over the extent to which animals can seem to mirror humans in their devotion to their young: biologists have observed infanticide, the killing of young by their parents, in many species. Oftentimes this takes the form of cannibalistic infanticide, in which parents kill and eat their offspring; the practice has been observed in chimpanzees, prarie dogs and pigs, to name only a few. To which we can only say, if feebly: Don't do it. ∎

93

Family portraits *Four photographs capture animal mothers nurturing their children. Clockwise, from top left: like humans, armadillos are placental mammals; their young reach maturity in only three to six months.*

A hummingbird mother places food in a chick's mouth. Unlike most bird species, hummingbird males are not involved in nesting.

Wolf pups are born blind and deaf, and they remain in the den until about 2 months old. This mom looks a bit fatigued from her labors.

Manatees, aquatic mammals, are pregnant for 12 months, and calves often are not fully weaned for 18 months. Here, a calf is nursing underwater.

Outback lookout
This young eastern gray kangaroo joey in Australia is almost old enough to leave the pouch

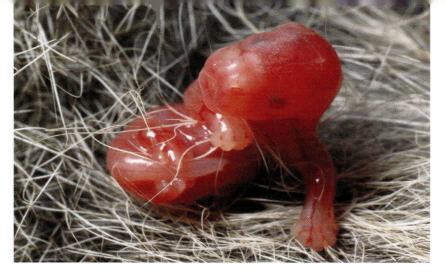

Newborn *This tiny wallaby is about to take a perilous journey: across its mother's body to her nurturing pouch*

Womb with a View

Marsupial babies are the ultimate pouch potatoes. Born very prematurely by human standards, the offspring of kangaroos, wombats and other marsupials have undeveloped hearts, lungs and kidneys that are not able to sustain life. These offspring are also stunningly small: some newborn kangaroos (a.k.a. joeys) are the size of bees, even though they will eventually be as tall as an adult human. The joey's only parts that are even close to maturity at birth are its chest muscles and forelimbs, which enable the tiny, blind child to crawl from the birth canal to a pouch (called a marsupium) on its mother's belly. Once inside, the baby affixes itself to a nipple, which expands to lock the newborn in place. Also sheltering and holding the child in position are muscles inside the pouch that help it form a kind of external womb.

This unusual nurturing strategy has many advantages for marsupials, which are adapted to harsh environments. If food becomes scarce, the mother stops producing milk and allows the baby to die. This doesn't hurt the mother's chances of reproduction, for many marsupial females keep several embryos on standby and will begin to develop another as soon as one dies. Infanticide also increases the mother's chances of survival: nature gives placental mammals like humans little choice other than to carry a baby to term, even if there's not enough food to support both mother and child.

A baby kangaroo usually pokes its head outside the mother's pouch around four months after it first crawled in. At five months, it takes its first, tentative steps on the ground, but it will continue living part time within the pouch (and nursing) until it is about a year old. After that, kangaroo moms will chase away a child that tries to climb back into the comforts of the pouch: it's time to grow up. ∎

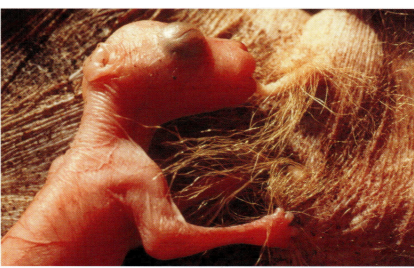

Attached *A red kangaroo joey nurses within its mother's pouch*

95

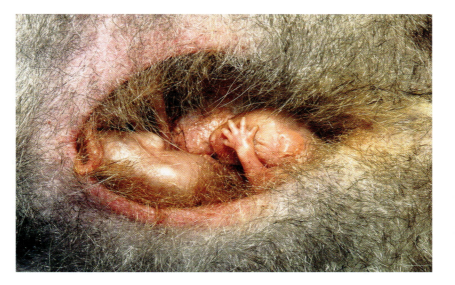

Resting *A Virginia opossum sleeps in the pouch; opossums nurse for 3 months before leaving the pouch, kangaroos for much longer*

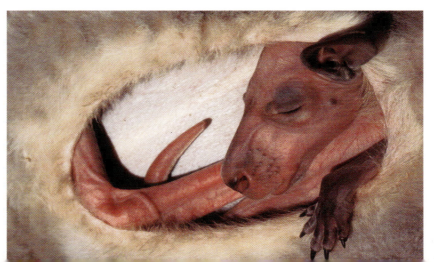

Snoozing *A red kangaroo joey, about 130 days old, takes a nap in the pouch. At age 5 months or so, it will emerge for the first time*

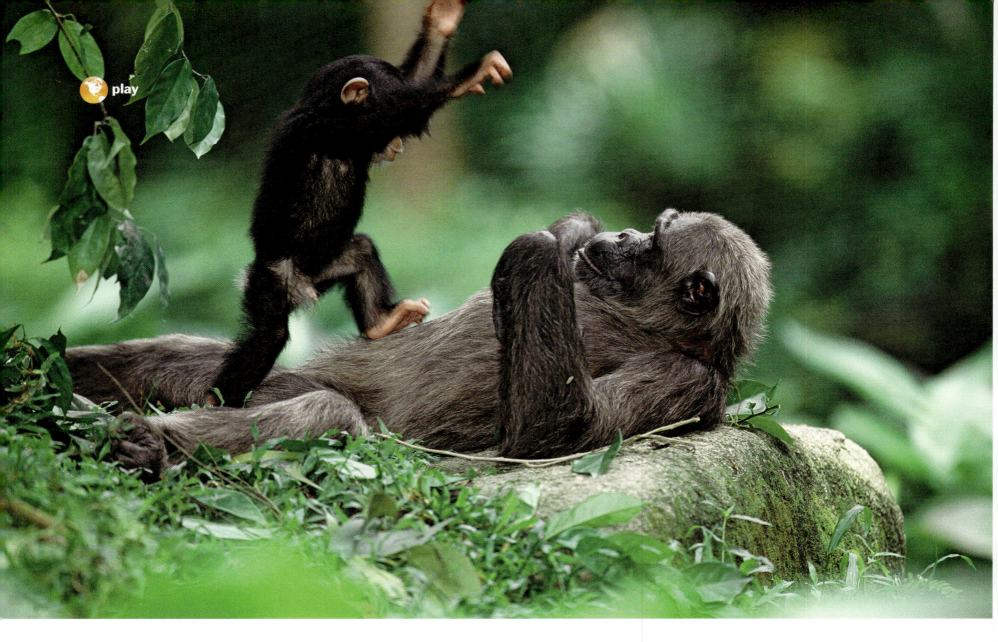

Never a Dull Moment

"Happiness is never better exhibited," Charles Darwin wrote in *The Descent of Man,* "than by young animals, such as puppies, kittens, lambs, and company, when playing together, like our own children." The similarity is clear, yet animal behaviorists, or ethologists, still can't say why animals play.

Much play behavior in animals is a form of dress rehearsal for adult needs like hunting, fighting for mates or escaping from predators. Such pantomime is seen most often in social species in which parents protect and feed their young. That includes most mammals and many species of birds. Yet even cockroaches have been observed chasing one another in a manner that some researchers believe might be play.

Most reptiles (with the exception of turtles) appear not to play at all. One theory posits that because they are cold-blooded and have lower metabolic rates, reptiles simply don't have any energy to spare. Indeed, the burn rate from play is considerable: some animals devote as much as 40% of their time and 3% of their total energy to horsing around. Call us unscientific, but perhaps they enjoy all that recess for the same reason that human kids do: It's fun, Mom! ■

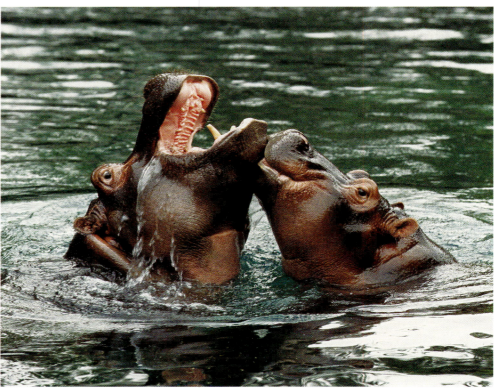

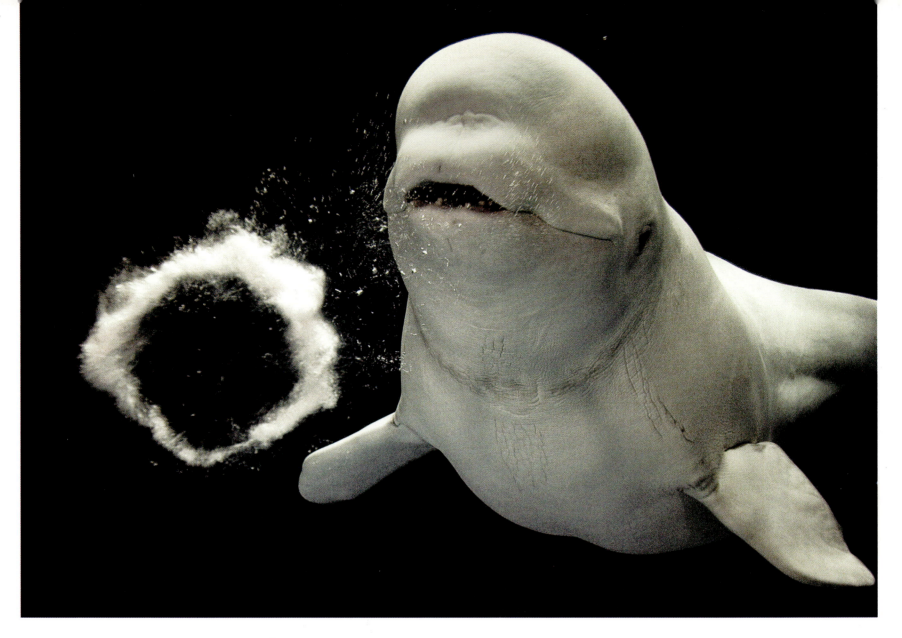

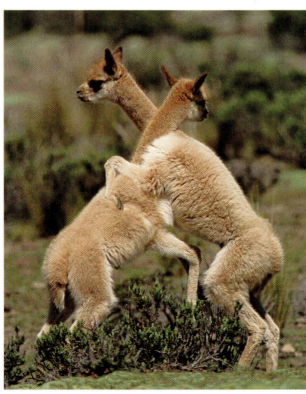

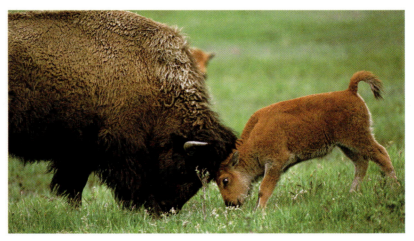

Where seldom is heard a discouraging word *At the top of the left page, chimpanzee* (Pan troglodytes) *adults have been documented playing with their young in humanlike ways, making silly faces, tickling and making a sound that may be the primate equivalent of laughter.*

Below them are mother and child East African river hippos (Hippopotamus amphibious kiboko). *These big mammals chase each other and spar in mock combat. They also, believe it or not, are capable of performing underwater backflips.*

On this page, the beluga whale (Delphinapterus leucas) *at top is blowing a toroidal ring, which scientists believe is an act of pure play. At left, young vicuñas* (Vicugna vicugna) *in the Peruvian Andes simulate fighting like adult males vying for victuals. In the same manner, an America buffalo cow* (Bison bison) *squares off and butts heads with her calf, above.*

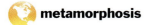
98

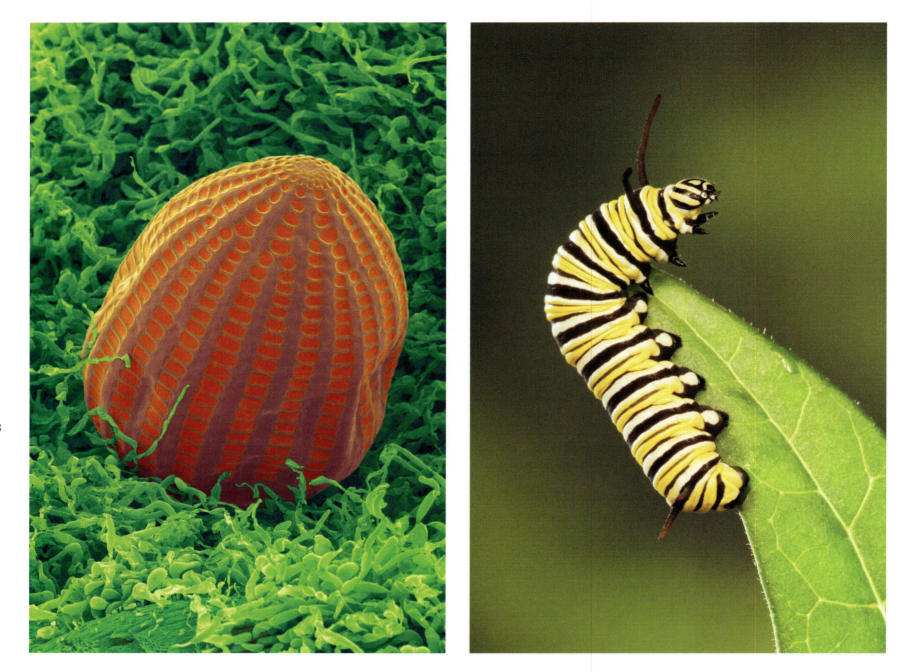

Ch-ch-ch-changes

Nature is a grand illusionist, but the process by which a single creature's body is transformed into a radically different incarnation surpasses mere trickery: metamorphosis is more akin to a miracle. The change from tadpole to frog, or caterpillar to butterfly, not only requires that old limbs be discarded while new appendages sprout, but it also means that most of the original creature's internal organs and nervous system disappear, to be replaced by new equipment for moving, breathing, digesting food and carrying out many other essential tasks. More often than

not, these tools are adapted to an entirely different environment and diet than were their predecessor's. The bad news: the transformation frequently makes the critter very tempting to an entirely new set of predators.

Metamorphosis is a stunning feat of genetic engineering. A butterfly's DNA contains the blueprint for both the the humble caterpillar of immaturity and the glorious winged adult it becomes. More remarkable, all these genes are switched on and off at precisely the right moment. The timing appears to be related to

physical cues that the animal takes from its environment, especially light and temperature, which change in tandem with the seasons. Thus, as summer draws near, a tadpole's tail begins to disappear, while legs start emerging and gills begin mutating into lungs. Its digestive tract is reconfigured to thrive on a carnivorous rather than vegetarian diet. Within weeks the fishlike creature is gone, replaced by a mature amphibian that hops instead of swims, breathes air rather than respires in water and eats insects instead of leaves.

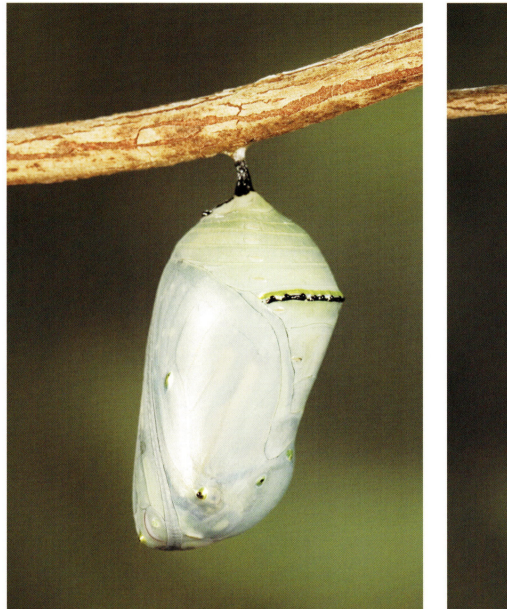

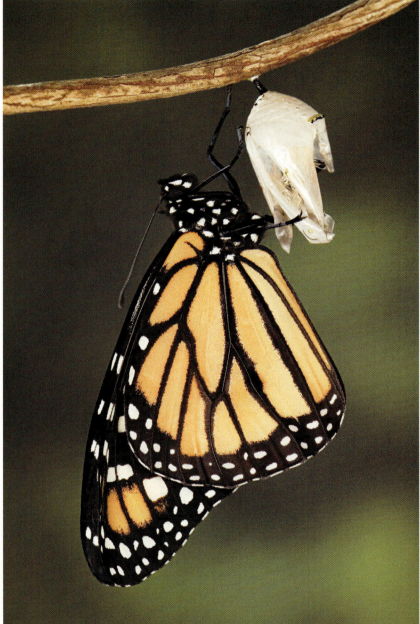

99

Scientists have long wondered whether a creature's memories can survive the process of metamorphosis. In March 2008 that fascinating question was partially answered, in the affirmative, by findings published in the journal *PLoS ONE*. Researchers led by biologist Martha Weiss of Georgetown University trained tobacco hornworm caterpillars to fear the strong odor of nail-polish remover by exposing subjects to it while administering a mild electric shock. They found that caterpillars that received this conditioning early on did not transfer the memory of the odor after they were transformed into adult moths—but those that were shocked later in the caterpillar stage did retain the reflex and fled from the smell. The scientists hope these findings may help them learn how to reorganize human mental circuitry to better preserve our brain functions following an otherwise debilitating stroke. ∎

Makeover *Monarch butterflies begin life as an egg, far left, that hatches into a caterpillar, which spins a silk cocoon, or chrysalis, third picture, in which it begins its transformation. The process concludes with the emergence of the adult winged insect*

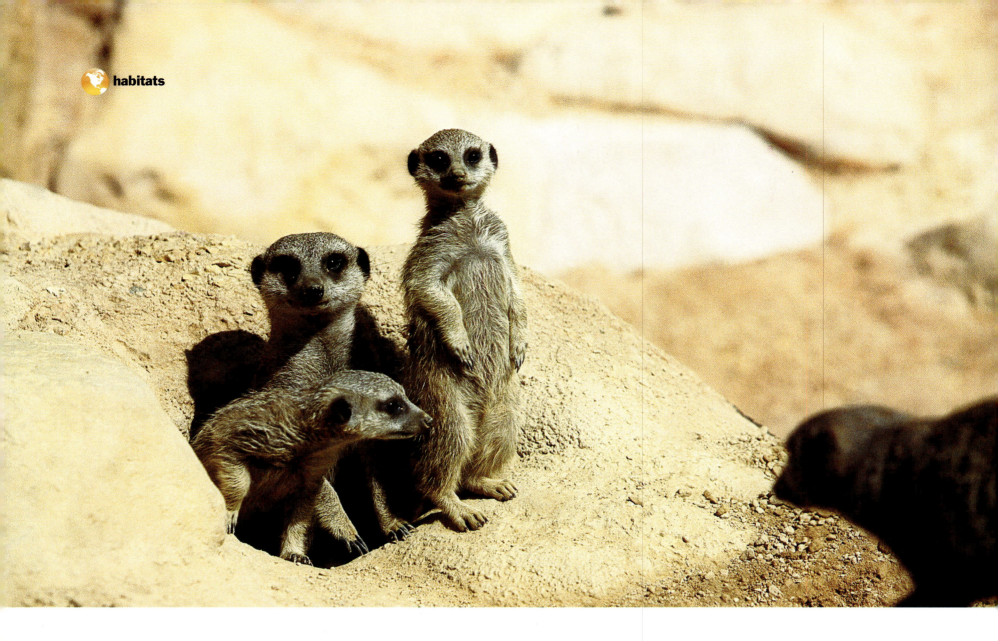

Meerkat manors and anthill ateliers

Humans are far from the only animals that alter their environment by building homes for themselves. Spider-webs, anthills, beehives and beaver dams all attest to the itch for engineering that seems hard-wired into the DNA of hundreds of species of animals. Even shrimp create their own habitats by burrowing into underwater rocks. Animal architects satisfy the same needs as human designers do: to protect young, attract mates, avoid predators, store food and provide shelter from the elements.

Nature's engineers may lack human intelligence and tools, but their creations are wonderfully diverse. At the bottoms of rivers and streams, the larvae of caddis flies capture passing silt, vegetation and even pebbles in a web of silk, then use them to encase themselves in a suit of armor that protects them from hungry fish and filters in water-borne nutrients. Other animals create dwellings of lavish intricacy. Multiple generations of badgers will add new rooms to their setts, sometimes bringing the total number of chambers to many dozens, and the elaborate burrows dug by some rats can have hundreds of entrances and exits. Paging Martha Stew-rat! ∎

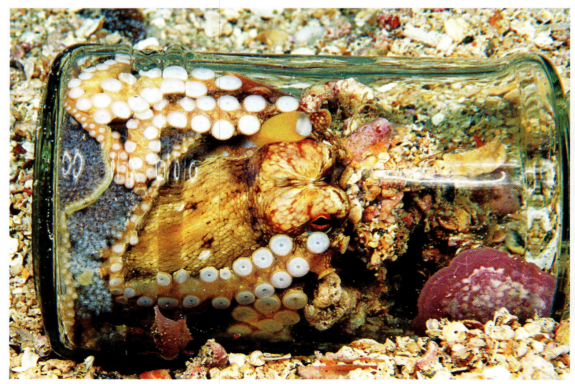

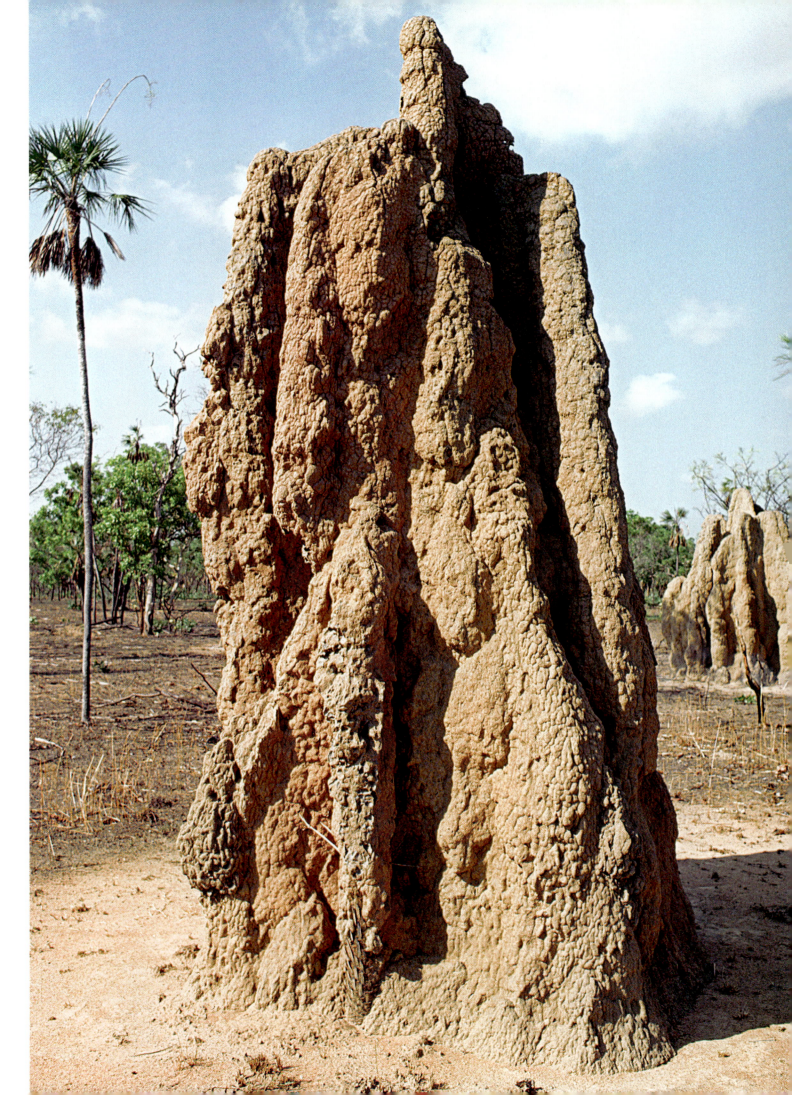

This old house *Meerkats, top left, are among the dozens of mammals that create homes by burrowing; others include groundhogs, moles and rabbits.*

Anthills like the skyscraper at right in Australia's Northern Territory can reach impressive heights. Some fossilized anthills have been dated as millions of years old.

The octopus at bottom left has taken shelter with her eggs inside a glass jar beneath 50 ft. of water in Papua, New Guinea

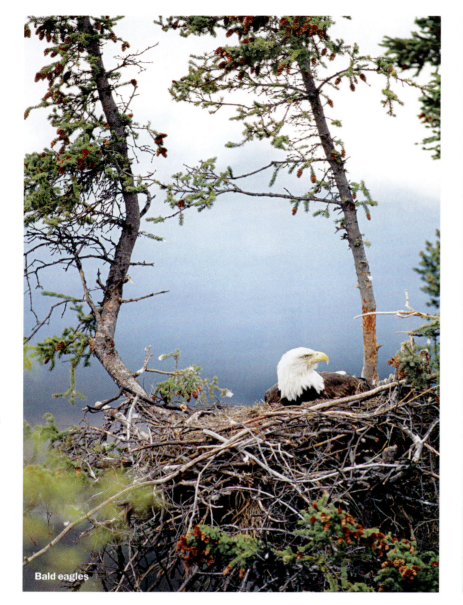

Bald eagles

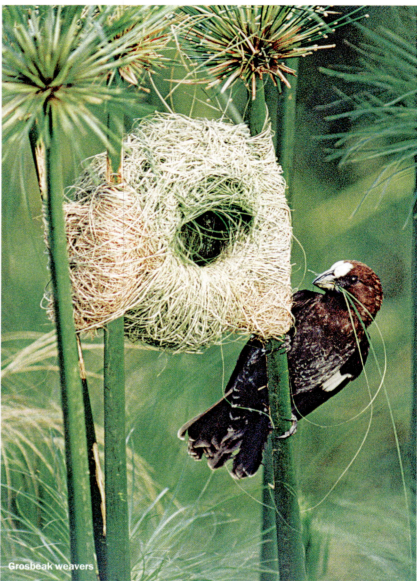

Grosbeak weavers

102

Avian Architects

After human beings, birds may be nature's most sophisticated architects. They build nests that hang in the air, float on water and descend into the ground, as well as form the familiar "cup" design. To do so, they weave complicated knots, use sophisticated geometry, employ advanced chemistry and create elaborate camouflages. And they use a diverse range of materials: sticks, mud, branches, moss, leaves and even scraps of tossed-off human goods. So it's tempting, but misleading, to think of bird nests as the avian equivalent of human houses, the result of conscious planning and design.

In fact, bird nests are not true "homes." They usually serve only two temporary purposes, to protect eggs and raise youngsters, and they are then abandoned. Nor does thought seem to be involved: experiments show that birds raised in captivity without ever seeing a nest will build precisely the kind their own species constructs in the wild when the nesting instinct calls.

Even so, bird engineering displays stunning range and complexity. A pair of bald eagles, one of the few species that return to the same nest each year, will begin their aerie-building project by laying sticks in a triangular formation, then will continue to add more layers above it, taking care to rotate the triangle for added strength. The resulting structure can be more than 12 ft. (3.5 m) deep and weigh more than 2 tons.

The resourcefulness of these nest-building species is remarkable. European starlings scavenge particular plants, like wild carrot and yarrow, whose chemical content checks the growth of parasites within the nest. And at least one species, the great crested flycatcher, adorns its nest with skin shed by a snake, to frighten off predators that savor birds but fear snakes.

There are avian rebels as well. Cowbirds don't build nests at all; their parenting strategy calls for practicing abandonment and deceit: females stash their eggs in the nests of other species and let the adoptive parents hatch and raise their young. Slackers! ■

FROM LEFT: MICHAEL QUINTON—MINDEN PICTURES; MITSUAKI IWAGO—MINDEN PICTURES

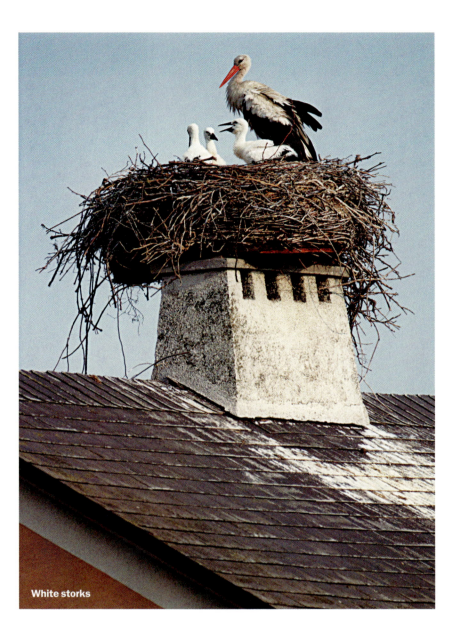

White storks

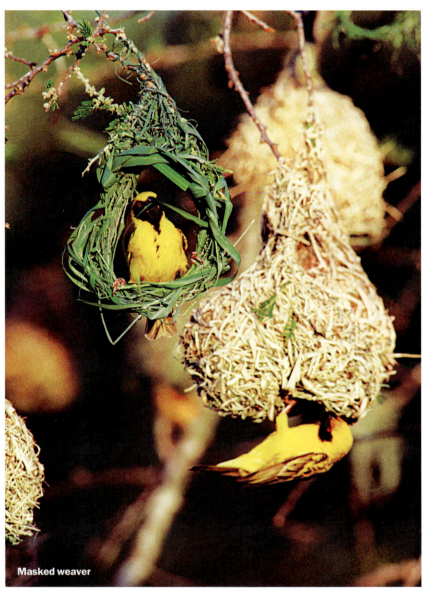

Masked weaver

Wide world of nests *Bald eagles* (Hali-
aeetus leucocephalus), *shown at far left
above in Alaska, return to the same nest
each season.*

Grosbeak weavers (Amblyospiza
albifrons), *shown in a swamp on St.
Lucia, are part of the passerine order, birds
that build highly elaborate nests.*

White storks (Ciconia ciconia), *shown
nesting on a rooftop in Austria, prefer
to roost on man-made structures, like
chimneys and barns.*

The lesser masked weaver (Ploceus
intermedius), *shown here in South
Africa, protects its young by building a
hanging nest, often above water, with
entrance holes near the bottom.*

Cliff swallows (Hirundo pyrrhonota),
*form communal nests from mud pellets
cemented on cliffs or beneath overhangs.*

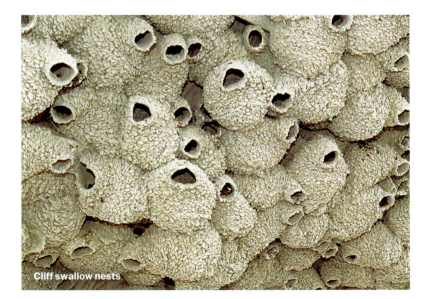

Cliff swallow nests

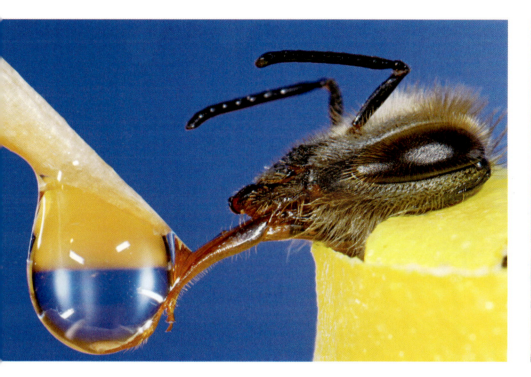

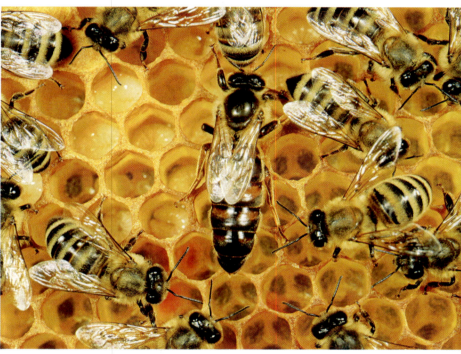

Queen City

Only half of what most of us think we know about honeybees is true: yes, these busy insects of the order Hymenoptera are highly specialized, with different members of their colony, the hive, focused exclusively on niche jobs like cleaning, building new rooms within the structure, regulating temperature and so on. But there is a surprising amount of freedom in bee-dom: most bees don't spend their entire lives devoted to only one of these jobs. Rather, they will rotate throughout their lives from one task to another.

The two exceptions to this rule are the queen, whose only job is to lay eggs, and the drones, males whose only job is to mate with Her Majesty. Each hive has only one queen and perhaps a few hundred drones, and for their entire lives these small minorities will be confined to their assigned roles. The rest of the hive's bees, as many as 50,000 workers— all of them females whose sexuality is deliberately undeveloped—share more than a dozen tasks, one of which is to remain at the entrance to the hive and beat their wings, so that its unique scent will be fanned outward, helping guide other members home. Scientists describe such group-oriented creatures as eusocial—that is, beneficially communal. ■

The rule of law *Honeybees form the second most complex social organizations on the planet—after humans. Female honeybees climb a career ladder that progresses from tasks like housekeeping and feeding young to searching outside the hive for nectar and returning to process it to guarding the hive itself. In the process, they literally work themselves to death—buzzing around at up to 25 m.p.h., visiting as many as 10,000 flowers each day, carrying heavy loads of pollen and nectar back to the hive. At the end of their 40-to-50-day life spans, they either keel over from exhaustion or, unable to work anymore, are pushed out of the hive to starve or are stung to death by younger, more vigorous members.*

The same harsh rule applies to drones and even the queen herself: all are killed when they can no longer contribute to communal life. Little wonder the Roman poet Virgil marveled at bee society, noting that they "pass their life under the might of the law."

At right, honeybees (Apis melifera) *work together to form a chain as they repair the hive. Above left, a close-up of a bee's tongue as it laps up a sugar solution; above right, the large bee in the center of the photo is the queen.*

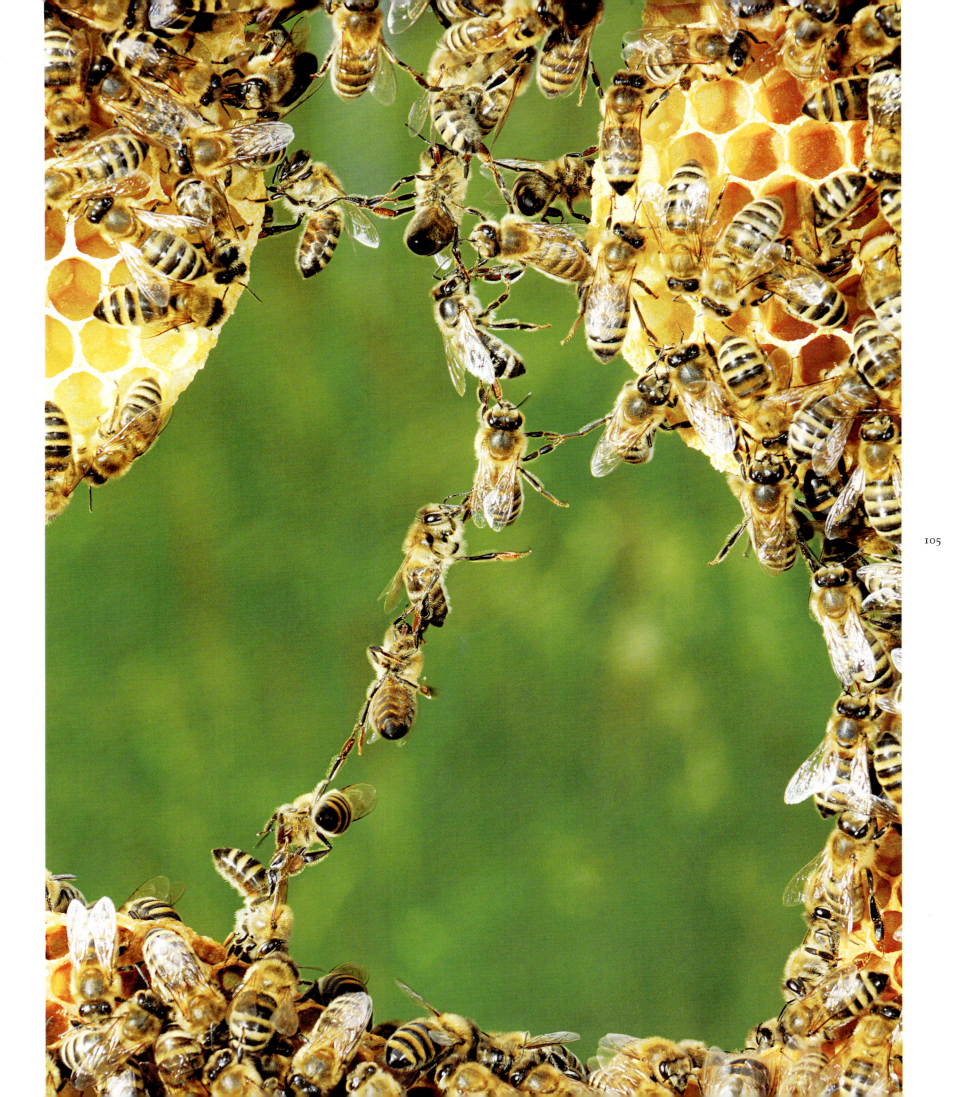

Priming the Pump

Call it colonialism, insect division. The globe swarms with more than 12,000 species of ants, whose colonies are found everywhere except Antarctica, Iceland, Greenland and a few South Pacific islands. And call it socialism: ant colonies survive only through the mutual assistance these intensely social insects provide to one another. A case in point is the honey ant: some species of this group have evolved a specialized class of worker ant that stores vast amounts of food in its abdomen. But these treasures are not for personal use. Called "repletes," the ants suspend themselves from the ceiling of an underground nest, where they hang like light bulbs for weeks and months at a time. Early in their careers, repletes allow other members of the colony to approach

and deposit food in their mouths. Later, after their abdominal cavities have swollen to the size of grapes, they permit their fellow colonists to make withdrawals from this communal food bank. No ant can share in a replete's larder, however, until it has identified itself with an elaborate series of coded antennae taps, certifying that it is a member of the same colony. In some species, the designated repletes are even more specialized, dividing themselves into separate niches to store nectar, insect juices and water.

Almost all ants play highly specialized roles within their colonies. Not only are they divided into broad castes like soldiers, hunter-gatherers and workers, but some species also break shared tasks down into minute, assembly-line jobs: leaf-

cutter ants have distinct castes for processing foliage once it has been brought inside the nest. In other species, some workers are full-time custodians that carry debris to a "garbage dump" outside. A 2007 study from Warsaw's Jagiellonian University even suggests that ants can sense how much longer they have to live and then adjust their behavior accordingly: younger ants (whose loss would be a blow to the colony) are confined to safer tasks, while older ants (which will die soon, in any case) take on riskier jobs.

"Go to the ant," King Solomon advises in the Old Testament. "Consider her ways and be wise." It's a rare monarch who lends his support to such a profoundly communistic society. ∎

YANN ARTHUS-BERTRAND—CORBIS; RIGHT: NORBERT WU—MINDEN PICTURES

Bright orange—for now *The Great Barrier Reef is alive not only with the beautifully tinted corals that have built it but also with fantastically colored fish like the coral trout above, a type of grouper that can change its colors to foil predators. Habitats for a wide variety of fish and shellfish, coral reefs are the keystones of oceanic ecosystems that are a primary food source for tens of millions of people who live along the world's coastlines. At left is an overview of the shallow coral reefs that make up Australia's enormous natural wonder*

tions—requiring sunlight, clear water warmed to 64° to 88°F (18° to 31°C) and a minimum of severe wave action—corals are confined to tropical and subtropical areas of the globe.

Reefs assume a wide variety of forms. Fringe reefs are those that form a ring attached to the shore of a tropical island, sometimes with a lagoon between the reef and shore. Barrier reefs grow parallel to the shores of continents, with a

deep lagoon between reef and shore. Australia's mighty reef forms a beautiful necklace around the northeast coast of the continent, a coral archipelago made up of almost 3,000 distinct reefs and some 900 islands in the Coral Sea.

Like smaller reefs all across the planet, the Great Barrier Reef is threatened by climate change: warmer ocean waters lead to a process called coral bleaching in which the algae coral

use for nutrition die off, leaving behind colorless, dead corals. Major bleaching events struck this reef in 1998, 2002 and 2006; more can be expected. Scientists say the coral reefs to Australia's west in the Indian Ocean are even more seriously endangered owing to warming seas; indeed, the ongoing rapid decline of coral reefs around the planet is one of the most unsettling signs of global climate change. ■

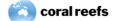
Creatures of the Reef

Measured by volume, coral reefs don't amount to much: they take up only 1% of the planet's ocean floor. By almost every other yardstick, however, they are vitally important. Home to some 25% of all underwater species, coral reefs are a delicate and wondrously beautiful ecosystem in which thousands of different life-forms cooperate for mutual benefit. The symbiotic creatures that create such reefs—the coral polyp and the tiny algae called zooxanthellae that take refuge inside them and, in return, pass nutrients to their host—fertilize plant life around the reef, attracting tiny fish that graze on seaweed and other aquatic flora. These, in turn, lure larger fish that prey on them. The result is an iridescent underwater city, teeming with life and activity. Here urban sprawl is welcome: as one generation of coral dies, its offspring expand the 'hood by building new shells on top of their parents' skeletons.

Sometimes called the rain forests of the sea, coral reefs are to the oceans what forests are to continents: sanctuary and breeding ground for fish and plant species that will disappear without them. Parrotfish, spiny lobsters, shrimp, urchins, sea snakes and billowy squid are among the colorful species that rely on these underwater colonies. Like rain forests, coral reefs are also natural pharmacies, from which a wide variety of beneficial drugs have been derived.

Coral reefs play an outsized role in the life of another species with which they share the planet: their nooks and crannies are home to fish and shellfish that are important sources of food and livelihood for millions of human beings. In short, if these undersea living wonders die off, many humans may perish along with them. ■

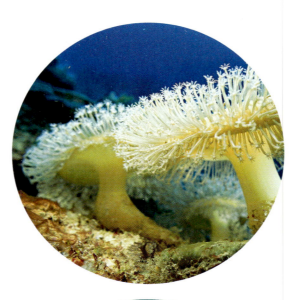

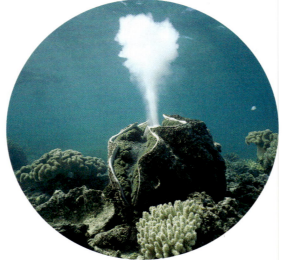

Sponges, clams and corals *Like all sponges, the large orange* Latrunculia magnifica *at right, photographed in the Red Sea, is a primitive animal that filters nutrients from the sea for food.*

Not all corals have hard exoskeletons: at top above are free-standing mushroom leather corals, with polyps extended in feeding mode.

At bottom, a giant clam, Tridacna gigas, *expels a cloud of eggs. This largest bivalve mollusk can be more than 3 ft. (1 m) across and weigh more than 400 lbs. (181 kg). Like most corals, giant clams are host to algae that provide nourishment; they also filter nutrients from the sea. Sadly, ripping yarns that paint such undersea behemoths as capable of eating humans are, in Mark Twain's term, "stretchers."*

180

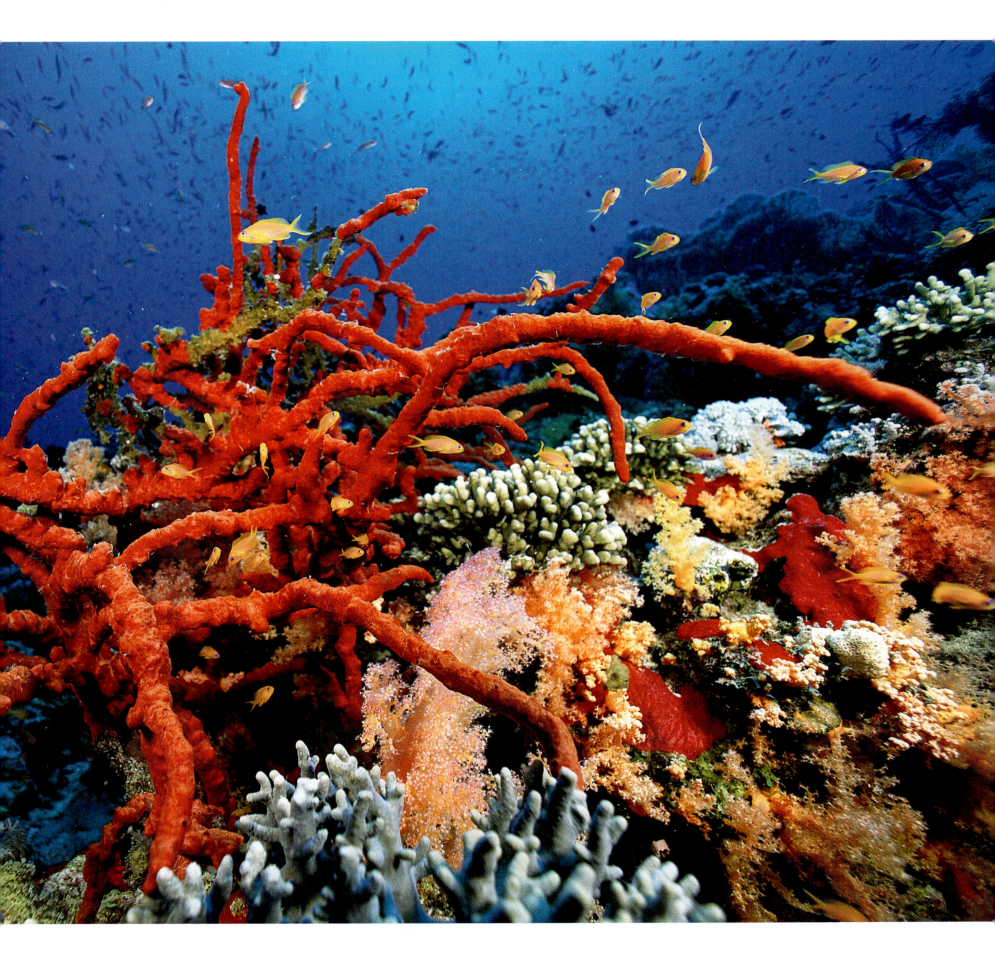

Hermit crab *These 10-legged crustaceans, members of the super-family Paguroidea, are not true crabs, but they are similar to cave-dwelling hermits, for they live inside the castoff shells of such gastropods as marine snails and retreat inside them when danger is near. A hermit crab will call a number of different-sized shells home as it grows larger*

182

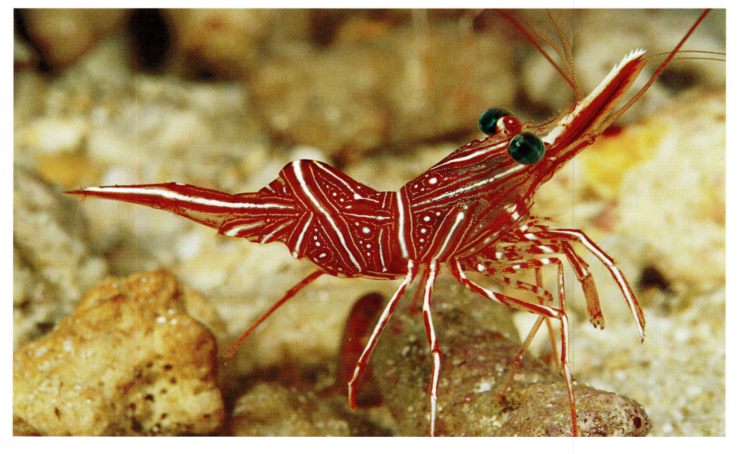

Hinge-beak shrimp *This striped fellow, Rhynchocinetidae durbanensis, has the key traits of the arthropod phylum, which includes insects, arachnids, crustaceans and such myriapods as centipedes: a segmented body encased in a hard exoskeleton. Most crustaceans are aquatic and have two pairs of antennae and compound eyes that rest on stalks*

Ghost crab *The large eyes mounted on stalks serve* Ocypode quadrata *well; they give it 360° vision with which to hunt insect prey. But it is blind overhead, so it prefers to burrow into the sand to escape becoming birdfood. This amphibious crustacean leaves its shore burrow at night to take on oxygen as water washes over its gills; it also spawns in the ocean. While it may look fierce, it's only a few inches wide*

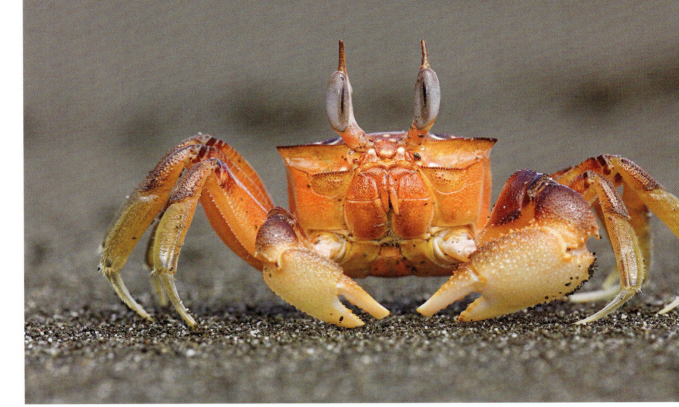

183

Bullseye reef lobster *Why the name? Note the target on the right side of* Enoplometopus holthuisi. *Lobsters are the largest crustaceans and are distinguished for their long, adept claws—pincers and crushers—which they use to crack open the shells of their favorite foods: mussels, clams, starfish and crabs*

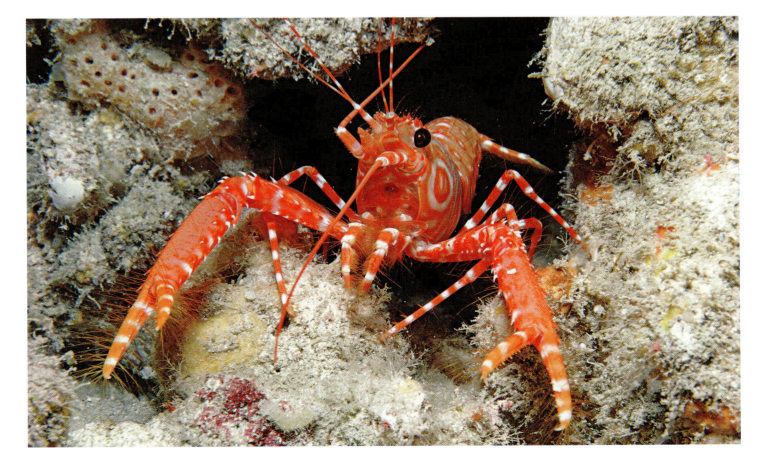

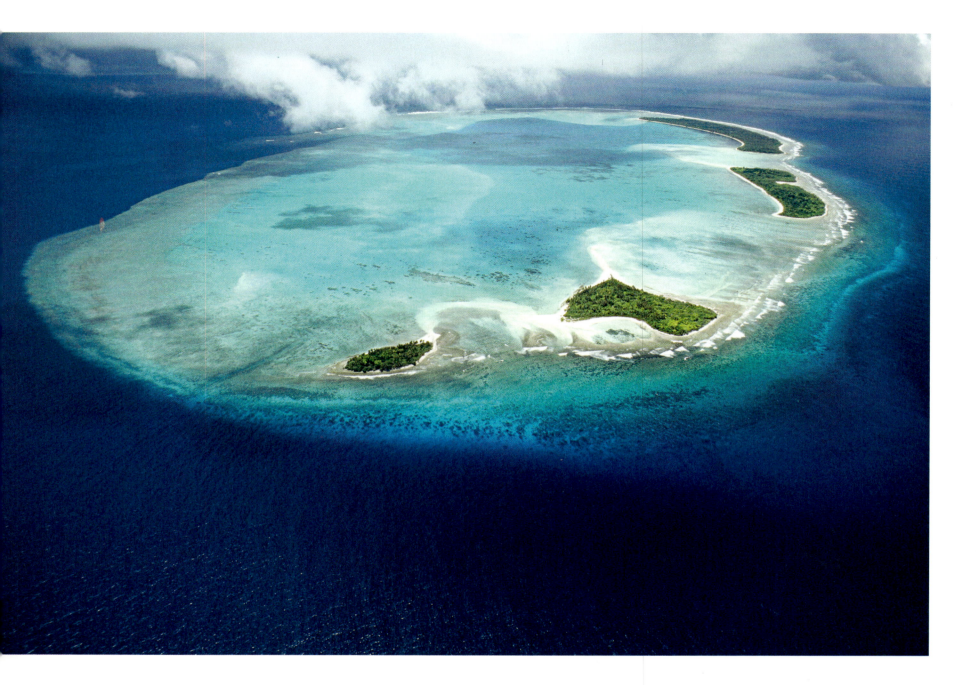

Atoll, Palau, South Pacific

Atolls are oceanic treasures, hiding in plain sight. The term was coined by South Pacific islanders for these unique circular or elliptically shaped reefs that grace the island archipelagoes in their region. Atolls posed a scientific mystery that required more than 100 years to solve. The problem: they are composed of coral reefs whose older sections extend well under the surface, whereas corals, by their nature, can only live in shallow waters, where the tiny creatures that build them can receive the sunlight they need to live. The Sherlock Holmes of the atoll was British biologist Charles Darwin.

During his voyage aboard the H.M.S. *Beagle* in the 1830s, he studied atolls and reached a surprising conclusion: they are built on the remnants of extinct volcanoes, and the corals are latecomers in the process that forms them.

Darwin noted that atolls exist in three stages of development. In its first stage, an atoll is a fringe reef forming around the slopes of a volcano. Next, an atoll forms a barrier reef that encircles the volcano, much of whose substance is submerged below the waves, deeper than coral reefs can live. In its third stage the volcano is entirely submerged, and a ring of coral reef forms around a central lagoon.

Darwin posited that atolls form as volcanoes slowly subside into the ocean. The hypothesis fit the stages—except for its bewildering argument that volcanoes could somehow sink beneath the waves. It wasn't until the theory of plate tectonics was accepted, more than 100 years after Darwin's voyage, that scientists realized that extinct volcanoes could indeed subside into the sea, as they cool and contract, or as the giant tectonic plates that compose the planet's crust slowly move and shift locations. Elementary! ∎

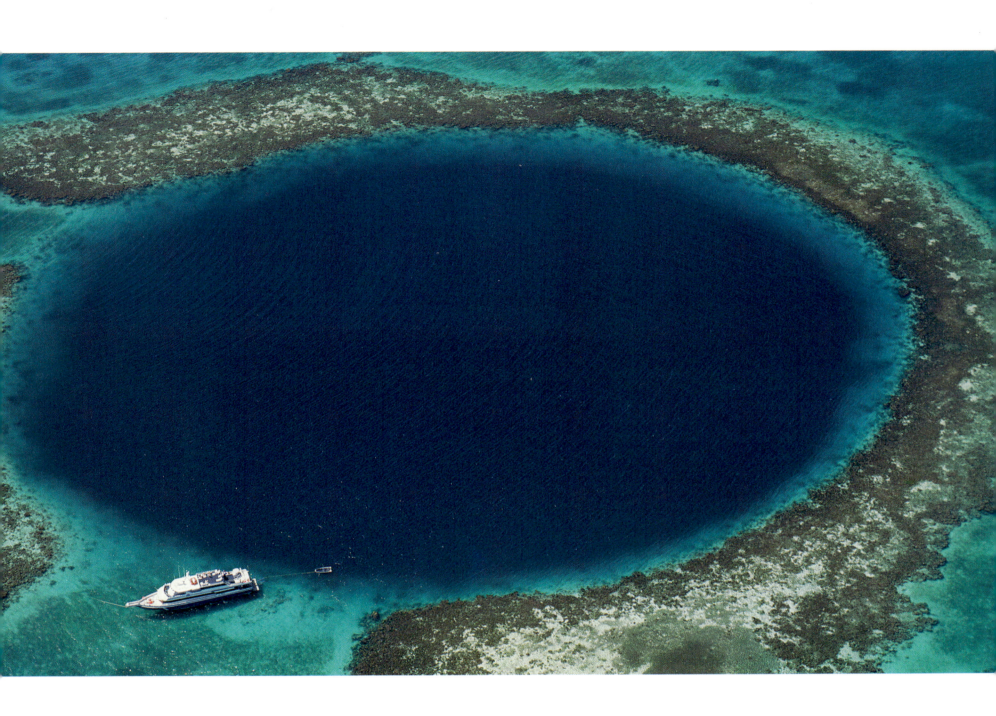

Great Blue Hole, Lighthouse Reef, Belize

An atoll is a coral reef forming a circle or ellipse that surrounds the remnants of a submerged, extinct volcano. But not all the graceful rings in the ocean are atolls. Consider one of the loveliest sights in the Caribbean Sea, the Great Blue Hole off Lighthouse Reef, east of Belize. This deep-blue circle, almost entirely surrounded by a reef, seems to offer a portal to the oceanic underworld. Indeed, it is has been measured to be 410 ft. (125 m) deep, even though the waters in its vicinity are very shallow, like many of the coastal shelves off the isles of the Caribbean.

What's going on? The Great Blue Hole is an example of a phenomenon that occurs in both the hydrosphere and the pedosphere: it is a sinkhole. Like sinkholes on land—the kind common in regions of karst topography that seem to appear without warning, bent on swallowing homes—it was initially formed as a void in a limestone cave system. During the last Ice Age, which ended about 10,000 years ago, the Great Blue Hole and the area around it were above land. But when melting ice filled the planet's oceans with water, the cave system was submerged. Sometime later, in a process that echoed those that formed the cavelike cenotes not far away in Mexico, the roof of the cavern collapsed, and the vast space filled with water: the Great Blue Hole.

Some 1,000 ft. (305 m) wide, this ring of bright water has become one of the most sought-after sites in the world for scuba divers; indeed, the inventor of the scuba apparatus that made undersea exploration a popular sport, Jacques-Yves Cousteau, was one of the first to probe its splendors. ∎

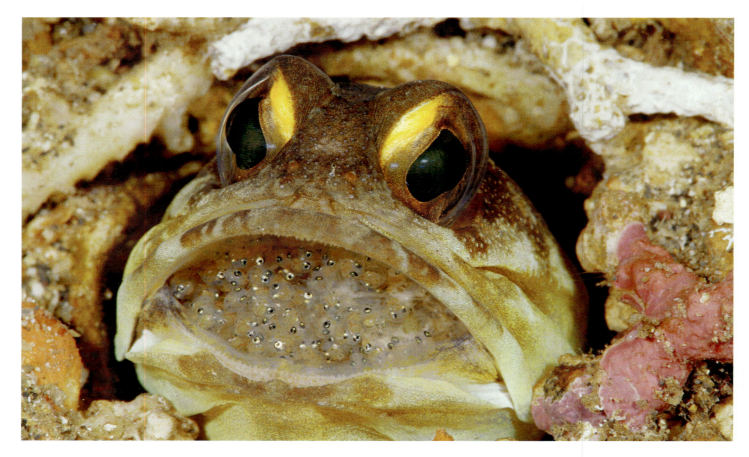

Jawfish eggs *A male jawfish of genus* Opistognathus *holds fertilized eggs in his mouth, protecting them from predators. Animals that incubate eggs in this fashion are classified as mouthbrooders; most such animals are fish, though some frogs also do so. It is often the male who takes on this duty. Jawfish live in burrows on the seabed that they excavate with their strong jaws*

186

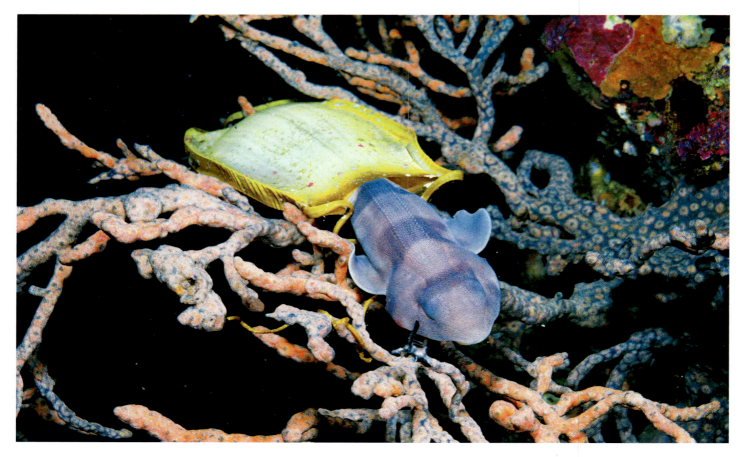

Swell shark baby *The egg case of this just-hatched blotchy swell shark* (Cephaloscyllium umbratile) *is a flat rectangular shape. The baby shark is about 5 to 6 in. (13 to 15 cm) long; it has a double row of spiny denticles on its back to help break open the case. This newborn is blue, but it will take on a splotchy brown color as it matures. Swell sharks, like pufferfish, are named for their ability to inflate their bodies to deceive predators*

Horn shark egg case
*The natural world abounds in lovely geometrical forms, such as this hard, spiral-shaped egg case of a horn shark (*Heterodontus francisci*). Such cases are screwed into crevices in undersea rocks; each holds a single shark, which will hatch in six to nine months. Horn sharks are slow-moving and a bit sluggish—for sharks, that is*

187

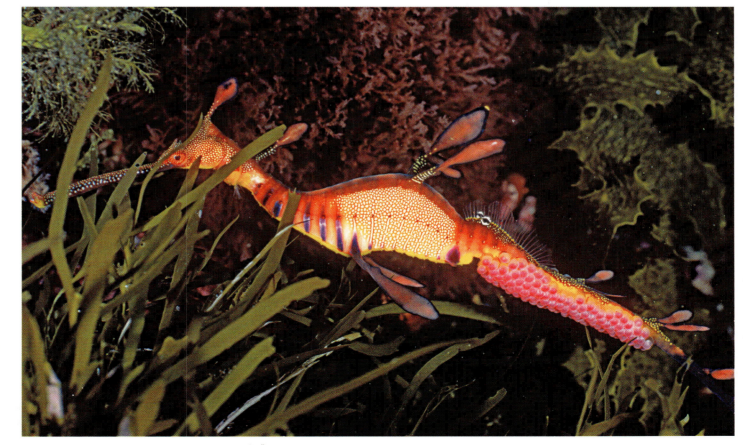

Seadragon eggs *As is the case with a number of fish and amphibian species, the male common seadragon (*Phyllopteryx taeniolatus*) is charged with carrying the fertilized eggs. The female deposits the ruby-colored eggs on the ventral area of the male's tail, called a brood patch. When the eggs hatch, the young seadragons remain inside a yolk sac that nourishes them for several days*

camouflage

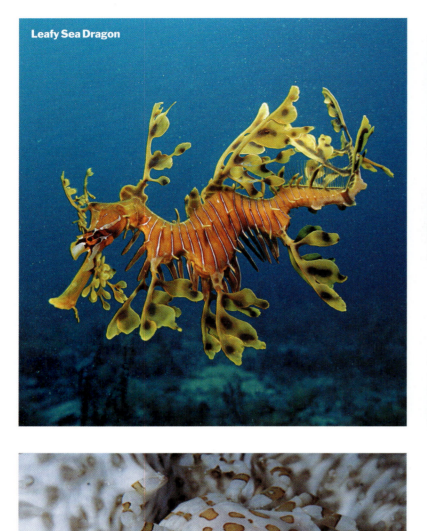

Leafy Sea Dragon

Harlequin Crab

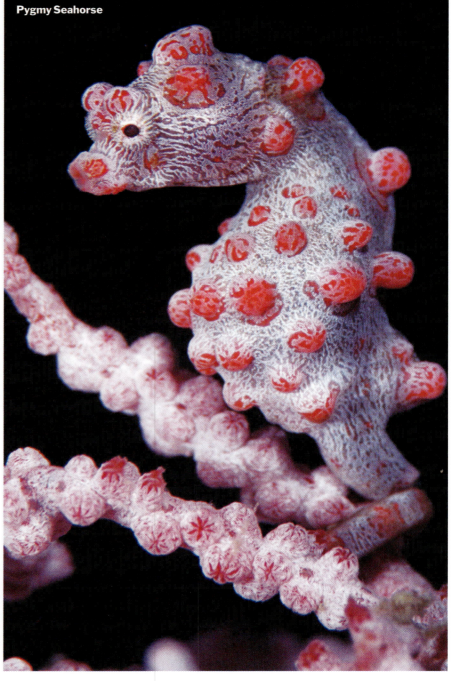

Pygmy Seahorse

188

Marine Masquerades

While it's commonplace for human beings to project their behavior onto animals, it's a mistake to employ anthropomorphism too broadly in approaching the animal kingdom. It's tempting to assume that the marine creatures shown here have chosen to disguise themselves in order to hunt better—or, in most cases, better evade their hunters. But alligators don't decide what skin color is in vogue this season: that hue has been decided over vast timespans by the process of natural selection, which favors animals whose outward appearance makes them more likely to survive in their environment.

The results can be breathtaking, as fish indigenous to coral reefs come to resemble the reefs themselves, and the American alligator's tough hide bears the same greenish tint as the marshy ponds of the Everglades it swims in. The leafy sea dragon is one of nature's most fascinating eye-foolers: it sports a number of extra appendages that look like leaves but serve no function other than to make the creature blend in amid the seaweed of its natural habitat. Some of the adaptations are extreme: the eyes and mouth of the sand stargazer are located on top of its head, so that this bottom-feeding predator lies prone in the seabed, eyes on the prize. ∎

CLOCKWISE FROM TOP LEFT: MARK SPENCER—AUSCAPE—MINDEN PICTURES; CONSTANTINE PETRINOS—NPL—MINDEN PICTURES; HIROYA MINAKUCHI—MINDEN PICTURES

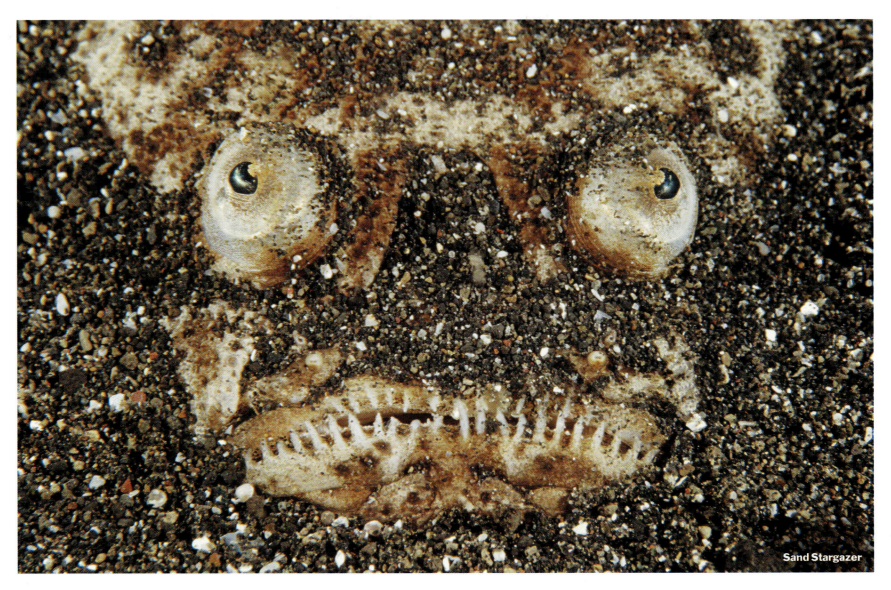

Sand Stargazer

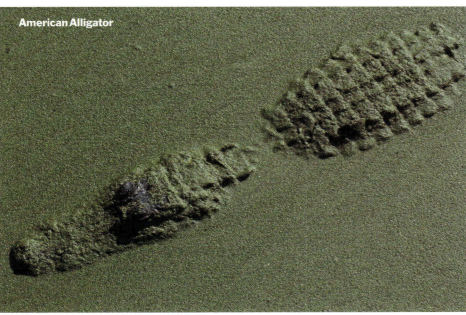

American Alligator

Painted Frogfish

cry•sphere

cry·o·sphere *(n.)*
[Gk *kryo* cold, icy + Gk *sphaira* ball]
the portions of the earth's surface where water is found in
solid form, as in polar zones; the frozen world

Frozen realm *A small plane flies over a glacier in Wrangell–St. Elias National Park in Alaska*

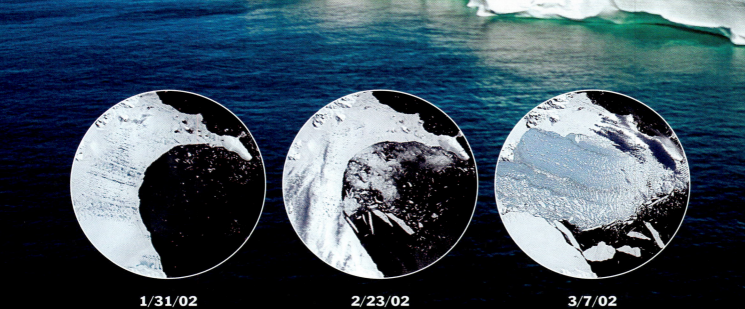

1/31/02 2/23/02 3/7/02

Breakup of the Larsen B Ice Shelf *Over a three-month period in 2002, the 600-ft. (183 m)-thick Larsen B Ice Shelf in Antarctica, which had been stable for more than 12,000 years, broke free of the glacier that formed it. Above at left, the shelf is dotted by dark-bluish melt ponds, indicating that collapse is imminent. In the middle photo, the shelf begins to crack free of land. In the third*

picture, the former shelf splinters into thousands of iceberg slivers. The large area of light-blue ice in the 3/7 image may look solid, but it is composed of very closely packed icebergs and shards of ice that no longer are part of a coherent mass. The largest such collapse since the last Ice Age dumped 500 billion tons of ice into the ocean. The breakaway section was about the size of Luxembourg.

Ice tray *The Ross Ice Shelf, left, is the largest such formation in Antarctica and is about the size of France. As with an iceberg, most of its mass lies below the water line*

Life on the Edge

Perched atop frigid polar seas, ice shelves may look solid, but they are essentially objects in transition, part of the natural cycle of a polar glacier. These vast formations take shape when an expanding inland glacier drives its leading edge off of the land and out over the ocean, where it floats on the waters beneath it. This cantilevered platform of ice generally remains tethered to its parent glacier for years or decades (although some hang on for scores of centuries) before its length and weight cause it to break free, split into fragments and bob away on the waves. Denizens of the cryosphere, ice shelves exist in only three places: Greenland, Canada and Antarctica. The massive planes range in thickness from 150 to 1,200 ft. (46 to 366 m).

Ironically, the two facts many people think they know about ice shelves are wrong. First, the awe-inspiring 2002 breakup of the 1,200-sq.-mi. Larsen B Ice Shelf in Antarctica was not a direct result of global warming. Even some scientists initially got this wrong, but an exhaustive 2008 study by Neil Glasser of Aberystwyth University in Scotland and Ted Scambos of the University of Colorado, published in the *Journal of Glaciology,* made a convincing case that climate change was only a contributing factor in the event. The fault lines that led to the collapse, they determined, were the result of decades-old crevasses created by long-term glaciological processes.

Second, many people fear that the breakup and eventual melting of ice shelves will raise global ocean levels. They will not, for shelf ice is already floating in the water. Indeed, since frozen water takes up more space than the liquid kind, disintegrating ice shelves actually lower sea levels ever so slightly, when the calved icebergs travel to warmer waters and melt. But the disintegration of an ice shelf does contribute indirectly to rising sea levels by removing the barrier to the glacier behind it. In such cases, the migration of ice from land to water—which does raise sea levels—can speed up by as much as eight times once the path has been cleared. ∎

193

Torpedoes in Tuxedos

Brilliantly adapted to their harsh polar environment, penguins are among the planet's most fascinating animals: they breed like birds, swim like fish, socialize like humans, dress like dandies and share the joie de vivre of the playful otter family. Like all birds, they boast feathers and lay eggs, but these flightless creatures spend as much as 75% of their lives in the water. So the forelimbs that would function as wings for other birds have been transformed into flippers, while their feathers are so tightly packed (as many as 75 quills per square inch) that they resemble leathery skin. Their coats are "countershaded" to conceal them from ocean predators: jet-black backs blend in with the watery depths when seen from above, while white bellies disappear into the bright surface of the ocean when seen from below. And their bodies have evolved into the hydrodynamic torpedo shape seen in water animals from beavers to whales.

Like beavers, penguins move clumsily on land, but these superb swimmers dart through the water at up to 15 m.p.h. (24 km/h). Some species of penguin may swim as far as 3,000 miles (5,000 km) between feeding grounds and nesting areas, on voyages that last for many months. Monitoring devices reveal that emperor penguins—at 4 ft. (1.2 m) tall, the largest species—sometimes dive as deep as 1,700 ft. (518 m) and can stay underwater for up to 11 minutes.

All penguins live south of the equator, ranging from the Antarctic to as far north as the Galápagos Islands. Highly social creatures, they engage in elaborate rituals, such as bill-jousting and flipper-boxing, as they fight over mates. They have even developed a form of currency with the pebbles they use to build nests. Females will sometimes steal pebbles from one another's piles, and males of some species bow and present their mates with a pebble before breeding. Mates also bond by touching necks and slapping one another's backs. When pebbles are scarce, some females "sell" sex in exchange for the stones needed to build a nest. After chicks are born, all the parents from a colony will sometimes engage in a celebratory display in which they thump their chests with their flippers while leaning their heads back and crowing loudly. Monitoring devices have not yet detected the presence of cigars. ■

194

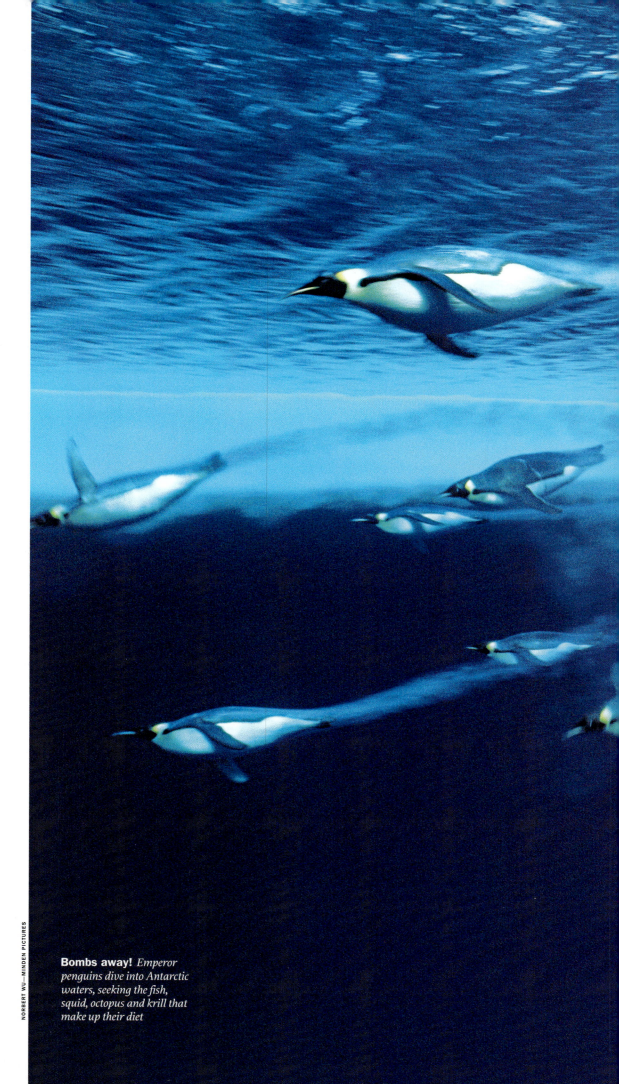

NORBERT WU—MINDEN PICTURES

Bombs away! *Emperor penguins dive into Antarctic waters, seeking the fish, squid, octopus and krill that make up their diet*

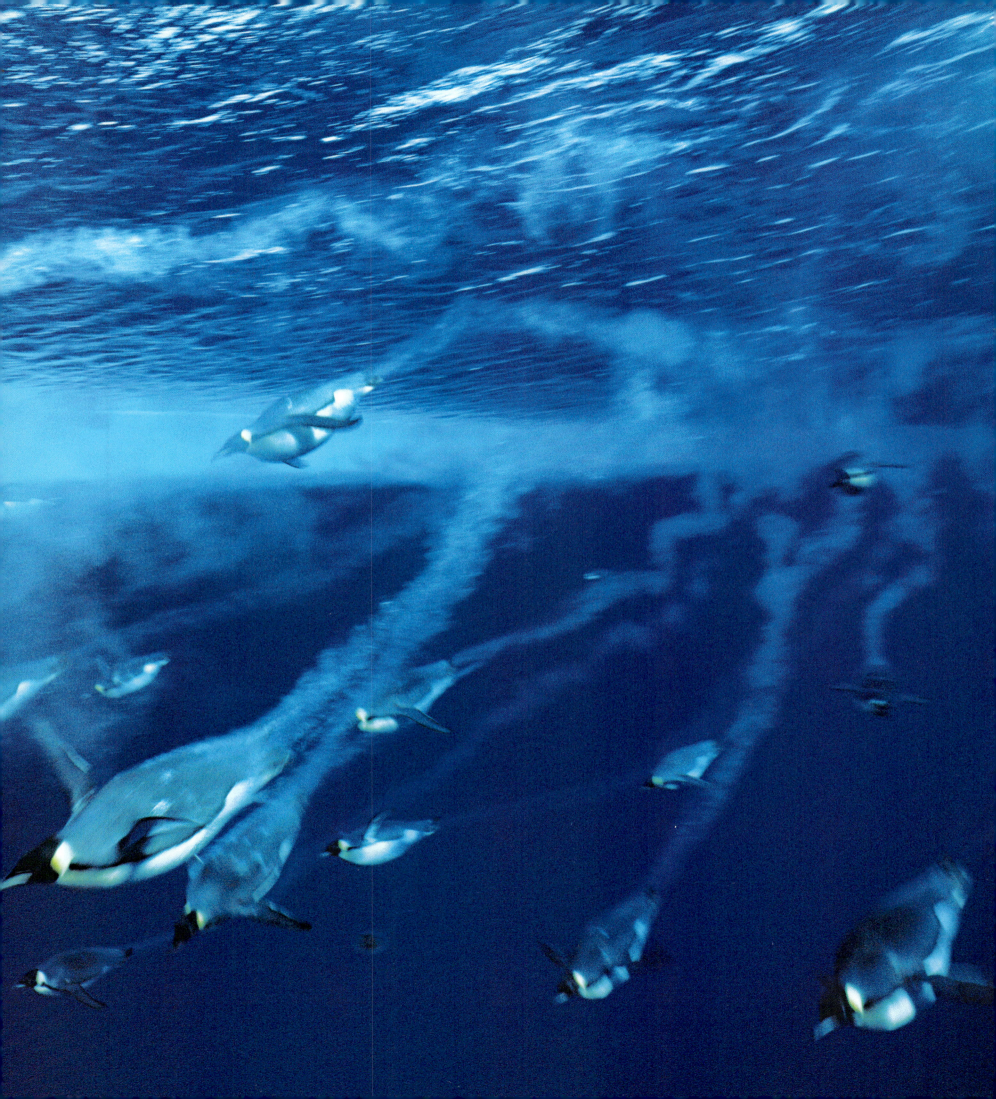

Safe and sound *Emperor penguins mate for life and share a complex parenting cycle. The mother lays a large egg, then leaves it in the father's care over the long Antarctic winter. The female returns when the chick hatches and watches over it alone, while the male departs. Later the father returns and both parents share in nurturing the chick*

196

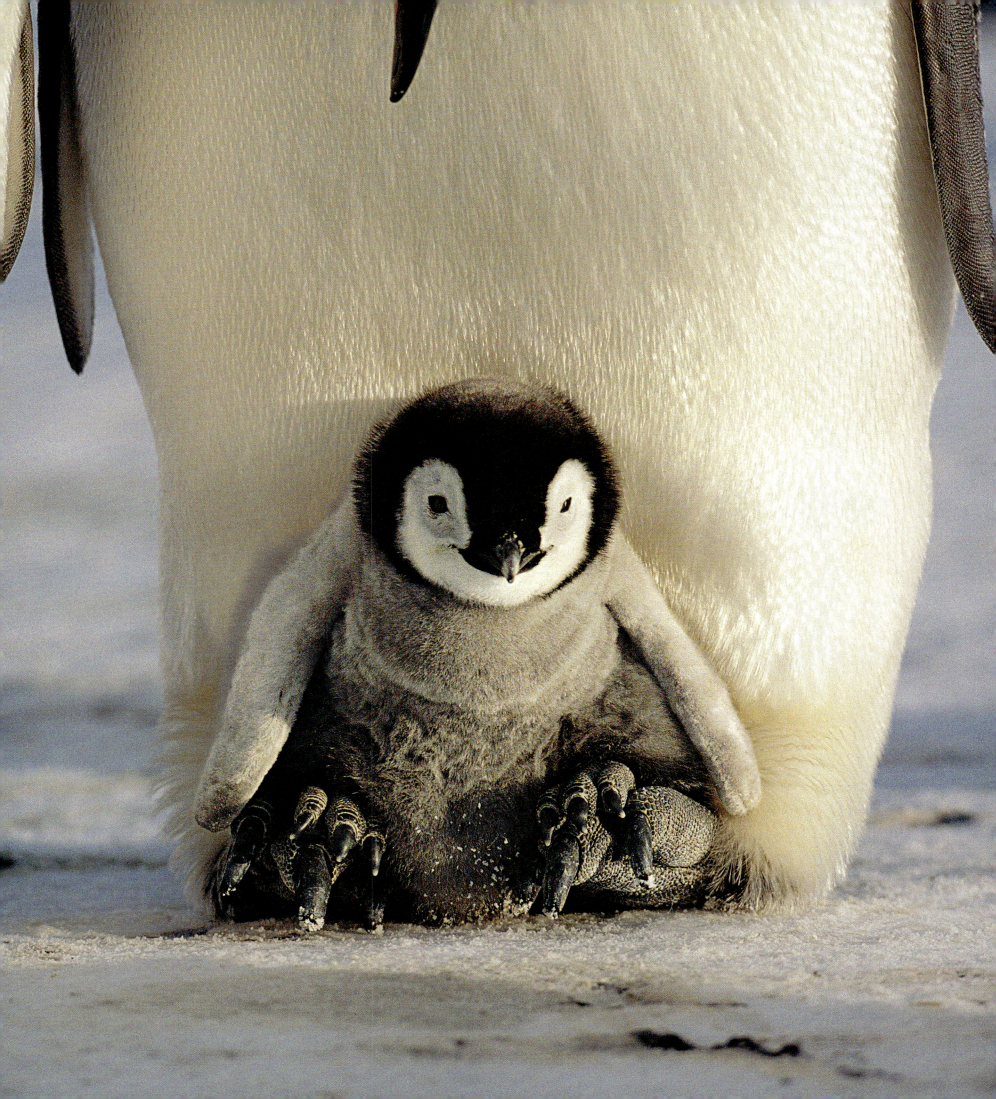

 glaciers

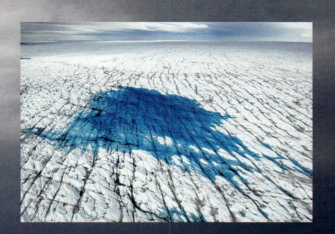

From ice to water *Glaciers around the world are in headlong retreat, and the pace of this melt-off is no longer, well, "glacial." The photograph above shows areas of light-blue meltwater where the surface of a glacier in Greenland is melting. Below, a glacier in western Greenland is retreating up a valley, leaving a bare patch of ground in its wake.*

In some cases, the meltwater can form into flowing streams, as shown in the main picture on these pages, also taken in Greenland. Meltwater also penetrates cracks that run deep within the ice, eventually making its way to the ground, where it acts as a lubricant, causing glaciers to slide more quickly toward the sea.

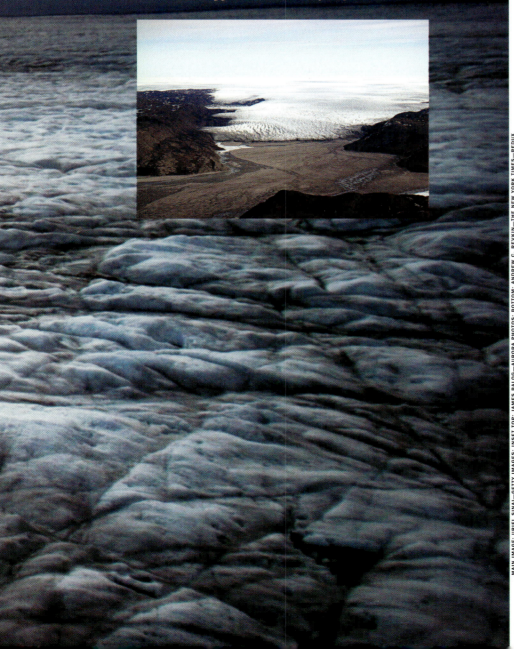

Melting Away?

Are we living through the twilight era of the planet's great glaciers? The answer appears to be a resounding, alarming yes. A March 2008 study by the World Glacier Monitoring Service analyzed 100 inland glaciers across nine mountain ranges and found that the rate of global glacial shrinkage quintupled between 1980 and 2006. Why is this alarming? Because glaciers, despite their static appearance, are in fact moving rivers of ice. They act as crucial reservoirs that store rain and snow, then steadily release freshwater to rivers and streams, in small enough doses to prevent flooding but in large enough volume to quench the thirst of the surrounding landscape. Widespread glacial melting could reverse this balance, causing ruinous floods, followed by long droughts.

The problem is not limited to the comparatively small Alpine glaciers that roost atop mountains, far from the poles. A separate 2008 study (by the Institute of Arctic and Alpine Research) identified a second problem: faster melting also causes the large "continental" glaciers of Greenland and Antarctica, which store most of the world's freshwater, to slide more rapidly toward the ocean, where they calve into icebergs, float away and melt, raising sea levels worldwide. The acceleration in the annual rate of ice loss in Antarctica alone may dump tens of billions of additional tons of frozen water into the oceans each year, a looming threat to millions of people living at sea level on the world's coastlines.

An ongoing long-term study by the National Snow and Ice Data Center, which compares the current size of the world's 3,000 major glaciers with that in historic photos, also indicates that the blanket of ice that covers 10% of the earth's surface is rapidly shrinking. Many scientists now believe that the Arctic Circle will be ice-free, at least during the polar summer, starting sometime around the year 2030. ∎

199

200

Get up, stand up! *Like many mammals, polar bear males do battle for the right to mate with females. The bears can weigh as much as 1,500 lbs. (680 kg) apiece, but they rear up, stand erect, hiss, snort, growl and trade blows as they vie for supremacy*

MICHIO HOSHINO—MINDEN PICTURES

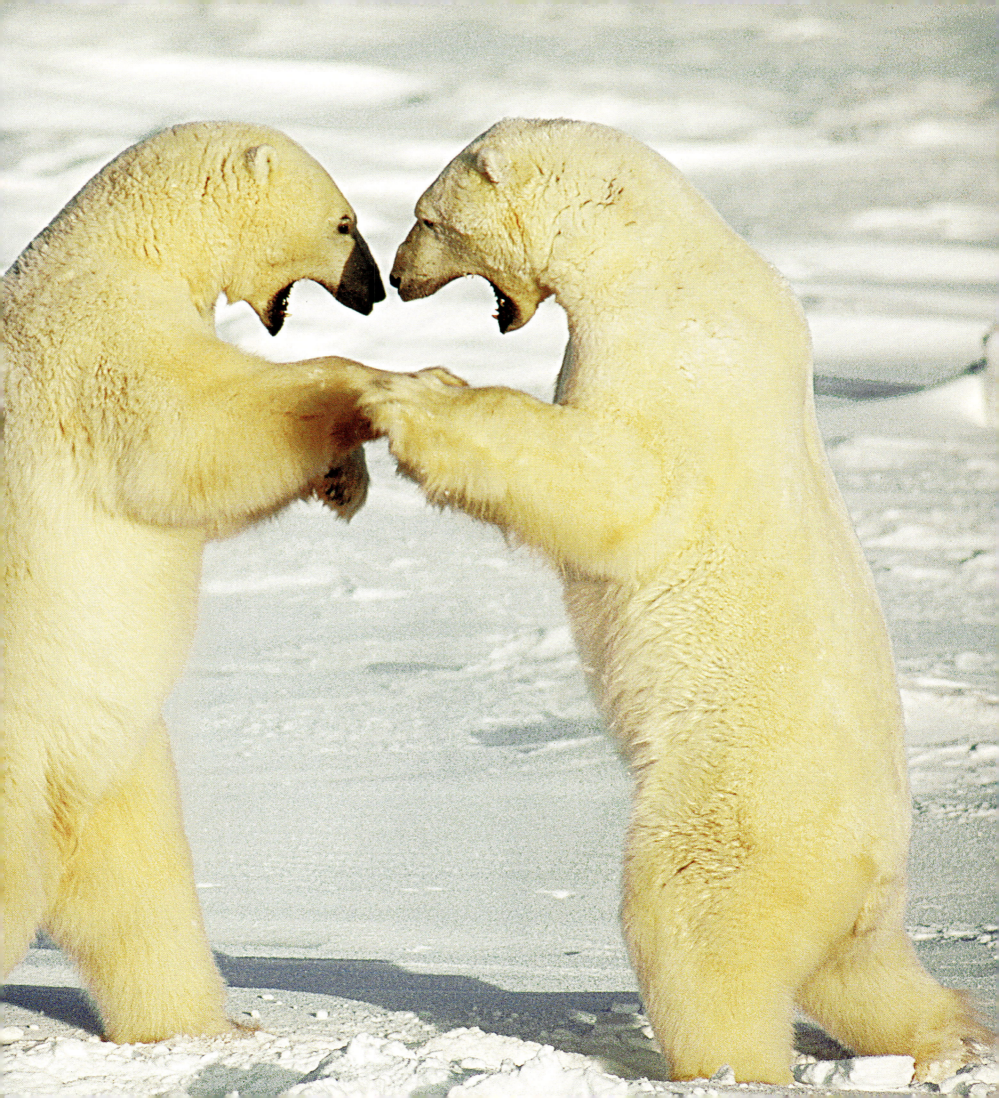

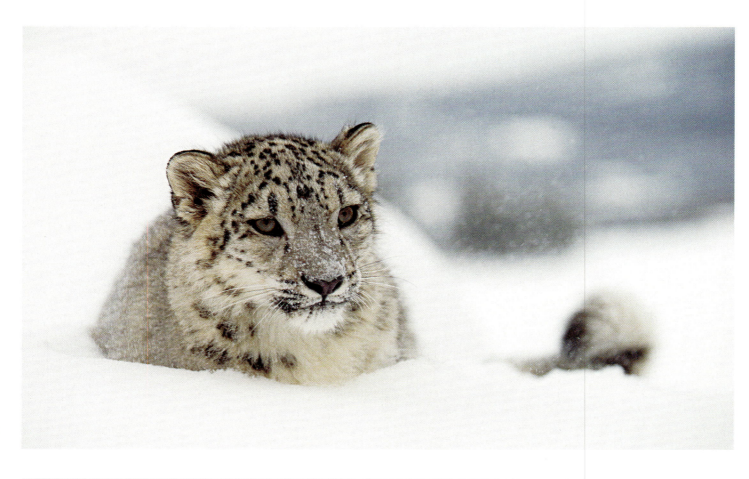

202

Snow Leopard *We may think of leopards as animals of the jungles and plains, but heavy-furred Panthera uncia is native to the mountains of central Asia. A bit smaller than other species of leopard, it is admired for its lovely coat of white fur dappled with spots. Unlike most of the other big cats, the snow leopard cannot roar*

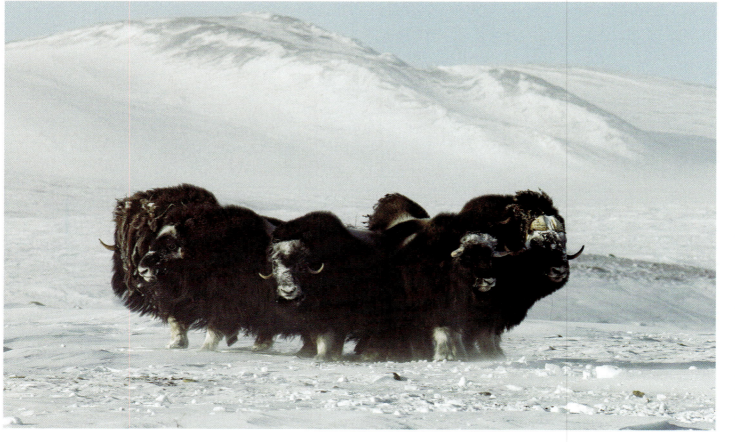

Musk Ox *There's a reason Ovibos moschatus is known as the musk ox; males give off a strong odor in rutting season, when they also butt heads to determine mating rights. These long-horned bovines with shaggy winter coats were hunted almost to extinction and now are found only in northern Canada and the Arctic Circle. At left, elders of a herd group together, encircling the young, as a human draws near*

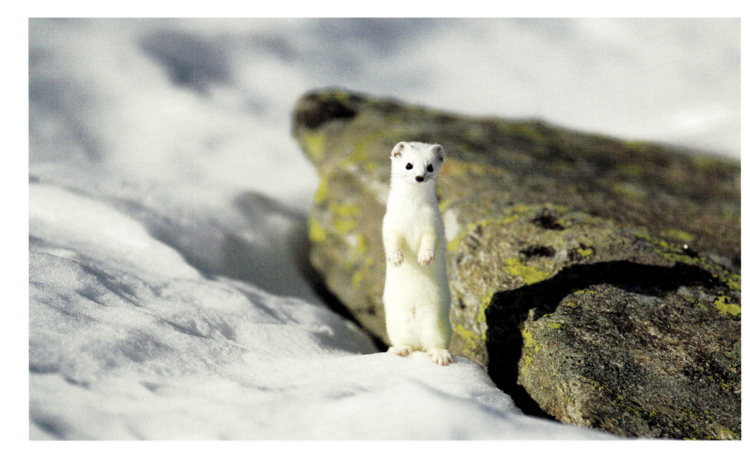

Ermine *The small mammal is prized by humans for its blinding-white winter coat, seen here on a specimen in the Alps. Ermines* (Mustela erminea) *are close relatives of ferrets, weasels and minks; they are all members of the family Mustelidae, small carnivorous mammals that have short legs and long bodies*

203

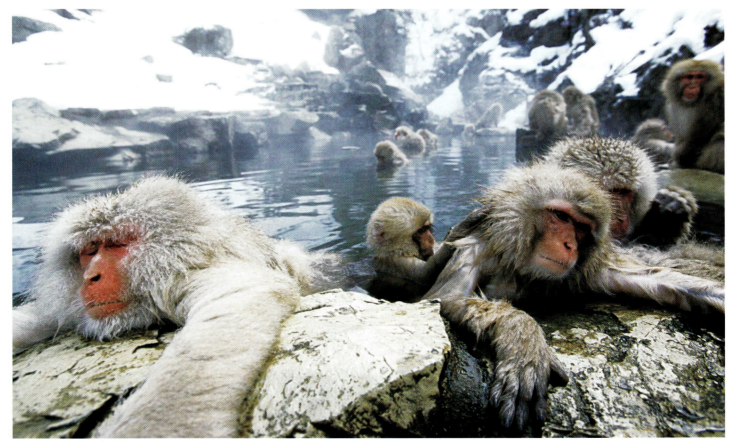

Snow Monkey *High in the mountains of Japan's Honshu Island, these Japanese macaques, or snow monkeys* (Macaca fuscata), *are blissing out in the Jigokudani hot spring in Nagano, site of the 1998 Winter Olympic games. The monkeys can withstand extreme winter cold, but they are also at home in temperate forests*

 icebergs

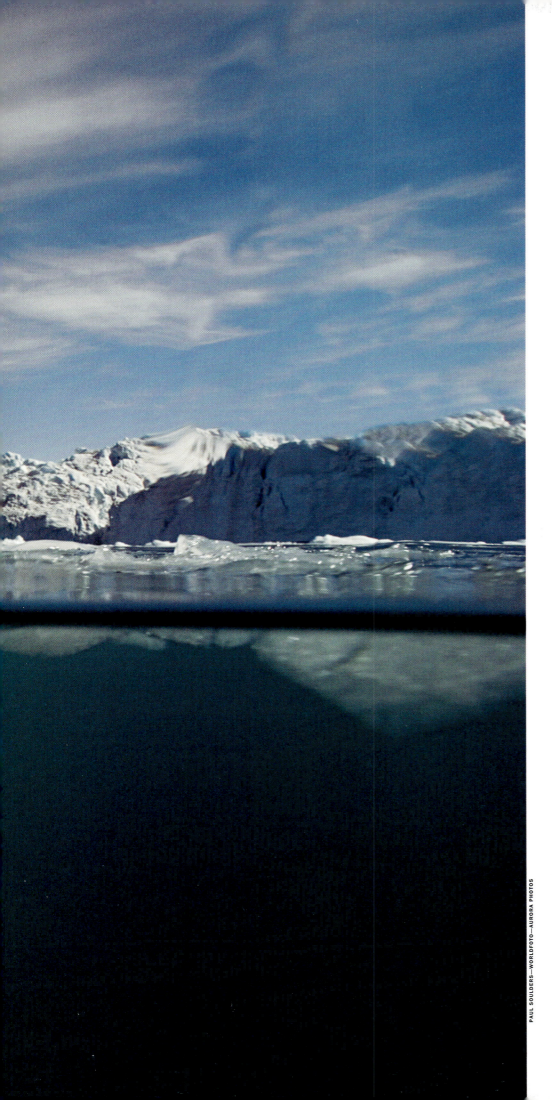

More than meets the eye *A newly-calved iceberg takes to the open sea off Ilulissat, Greenland*

Things Unseen

We've all heard that much of an iceberg's mass is concealed beneath the water. But seeing is believing, and this photo taken off the western coast of Greenland is a convincer. There are only two iceberg factories on Earth, Greenland and Antarctica, but they are prolific: most years, thousands of the beautiful, dangerous objects calve from glaciers and cast off to sea. Icebergs float for the same reason that ice cubes do: frozen water weighs exactly as much as the same amount of the liquid kind, but takes up more space. This means that ice is necessarily lighter than the water it displaces, and the ratio of an iceberg's overall size to the portion that is visible above the surface (about 8 to 1) corresponds precisely to the difference between the volume of water in its liquid and solid phases.

Icebergs that calve from the Greenland glacier are believed to have been frozen about 15,000 years ago, but Antarctica's can be up to 10 times older. Greenland's icebergs are usually shaped like mountains, while Antarctica most often creates flat, "tabular" bergs. One recently discovered attribute of icebergs is that they "sing"—not in a manner that's audible to human ears but nonetheless real. In 2005, scientists monitoring earthquakes in Antarctica picked up low-frequency signals that seemed to move around with large icebergs. When the recording of these signals was sped up, they resembled everything from bees buzzing to the string section of an orchestra tuning up. The most widely accepted explanation for this effect is that icebergs develop a pervasive network of tiny cracks, through which water rushes at high speed, under intense pressure, causing the berg to vibrate and emit a sonic hum.

But the songs of icebergs may soon become golden oldies: the International Ice Patrol, which surveys the North Atlantic to prevent *Titanic*-style disasters, has often recorded as many as 2,000 bergs each year migrating south from the Arctic Circle. But in 2006, for the first time ever, they found not a single one. ∎

205

Tusk-ans *The unicorns of the sea, narwhals (Monodon monoceros) are members of the order Cetacea, along with whales, dolphins and porpoises. Unlike baleen whales, which filter small prey from the water, narwhals are toothed whales that feed on small fish. Male narwhals grow a distinctive single tusk, though some female narwhals have one. Males appear to "fence" with their tusks at times, an activity that was once viewed as a mating duel but may simply be a means of cleaning the spears.*

Narwhals are found only in the Arctic. Above, the aquatic mammals gather in an ice break to breathe. At right, the tusks grow in a clockwise spiral and can reach almost 10 ft. (3 m) in length; narwhals themselves are 23 to 26 ft. (7 to 8 m) in length.

Halls of Ice

Caverns of ice may resemble caverns of rock, but these frozen essays in vacancy are, like the substance they are made of, unstable and evanescent. While stone caves may take eons to form, cathedral-sized galleries of ice can be carved within glaciers by meltwater in years or even months. And unlike rooms gouged from solid rock, glacier caves can disappear even faster than they were formed. Because glaciers are always sliding across the rock beneath them, visitors in these caves can hear the frozen walls that shelter them groaning and splitting. Stone caverns rarely collapse, but ice caves are always vulnerable to cave-in. Veteran glacier spelunkers, or glaciospeleologists, as they call themselves, tell of striking walls inside an ice cave with a hammer to anchor a rope, only to watch a crack hundreds of feet long appear with lightning-fast speed.

The fate of the world's most extensive and famous network of such caves is a testament to their fragility. The glacier atop Mount Rainier in Washington State was once honeycombed with miles of passageways that opened onto magnificent crystalline chambers. By the early 1970s, however, many of these rooms had collapsed, and the network of tunnels connecting them had begun to shrink. By 1991, the entire frozen labyrinth had vanished. As climate change shrinks glaciers worldwide, ice caves are becoming rarer. But new ones are still being formed: the emerging glacier atop the Mount St. Helens volcano is home to a fledgling network of ice caves and tunnels.

The glacier cave shown here is just one of the unusual geological phenomena that distinguish Iceland, a tiny nation blessed with a disproportionate share of natural wonders. Straddling the Mid-Atlantic Ridge on the rift between the North American and Eurasian tectonic plates, this country, slightly smaller than the state of Kentucky, has more than 40 volcanoes (a quarter of which have erupted in the past century), seven major glaciers, 20,000 waterfalls and thousands of hot springs and geysers (the word is derived from Icelandic). Yet since most of its people live near the coastline, much of Iceland's interior has yet to be fully explored, and many of its geological oddities are yet to be fully documented. ∎

208

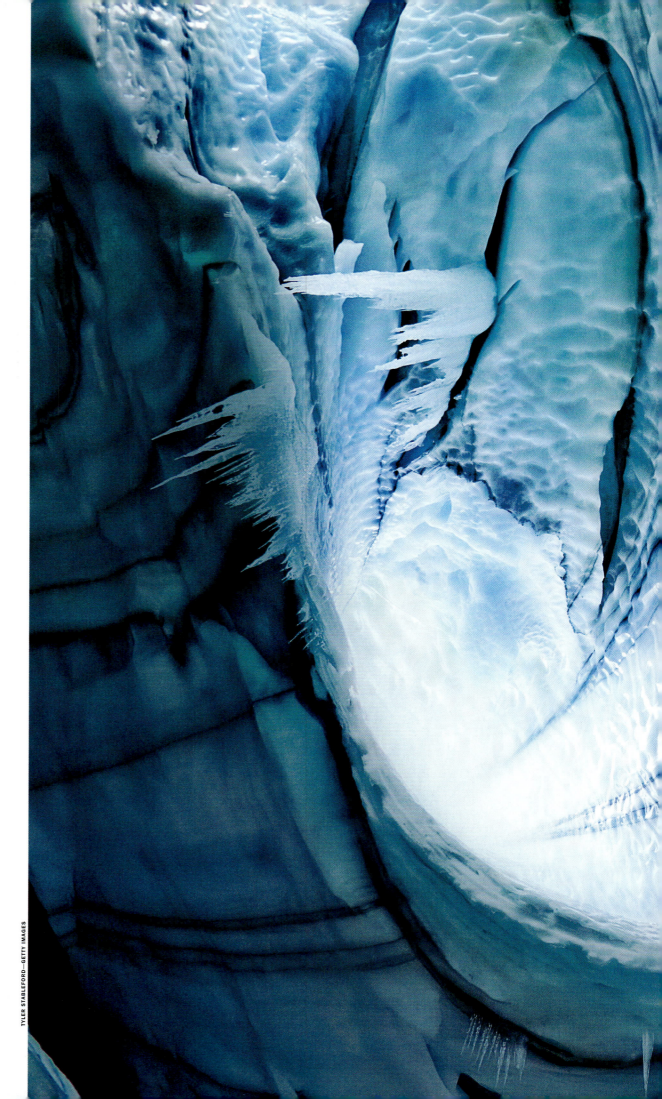

TYLER STABLEFORD—GETTY IMAGES

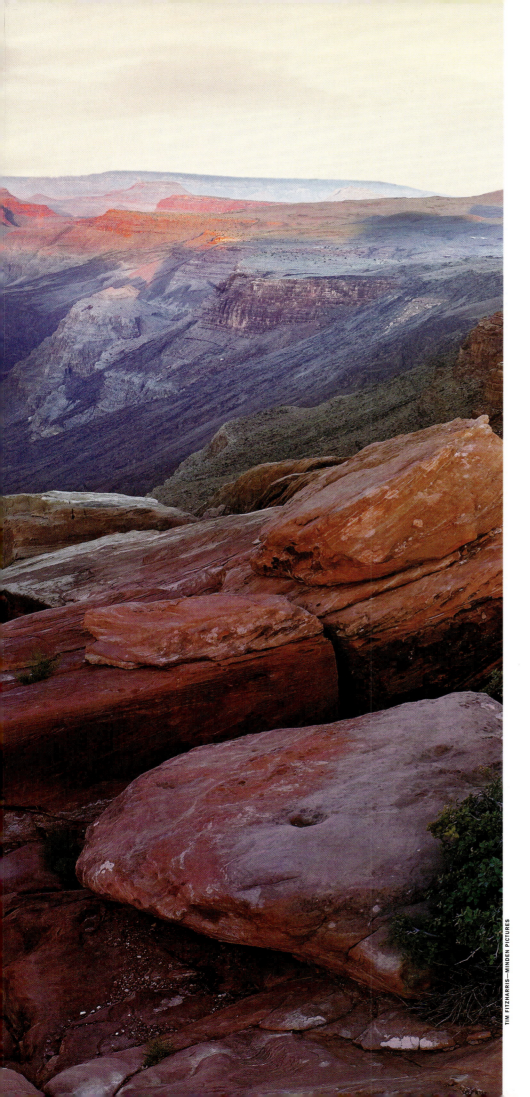

Time and the river *The Colorado River flows through the Grand Canyon, as seen from Toroweep Overlook*

A River Runs Through It

The most important factor in the creation of the planet's great canyons is always invisible yet everywhere apparent: time. Canyons are the glorious residue of the operation of an irresistible force, flowing water, against an erodible object, stone, over vast eras of time. The forces that formed the scene at left can be stated as a simple equation: *Colorado River + gravity + rock x 17 million years = Grand Canyon.*

The process by which rivers carve through rock, drawn by gravity to seek sea level, is called downcutting. Ironically, the Grand Canyon in Arizona was created by a process of uplifting as well as downcutting. Like the rest of the surrounding region, this area is rising, thanks to tectonics, as the North American Plate, pushed by the Pacific Plate, slowly elevates the level of the Colorado Plateau. (The Rocky Mountains are another spectacular result of this process.) This uplifting process raises the velocity of the river, increasing its downcutting power and carving the riverbed ever deeper within the walls of the canyon. The astonishing result: in some places the river is more than 1 mile below the top of the surrounding cliffs.

If the Grand Canyon is a work in progress, so is our understanding of it. When this book was begun in 2007, geologists estimated the canyon to be about 6 million years old. But on March 7, 2008, *Science* magazine published a study by a team of scientists from the University of New Mexico that found the canyon is closer to 17 million years old. Team leader Victor Polyak said the findings, made possible by newly improved radioactive dating techniques, surprised the research team. The study also found that the Grand Canyon formed as two separate gorges, with erosion occurring more slowly in the western section than in the eastern section. The two gorges came together to form the single canyon familiar to us around 6 million years ago, the geologists said, near the feature known as the Kaibab Arch. ■

241

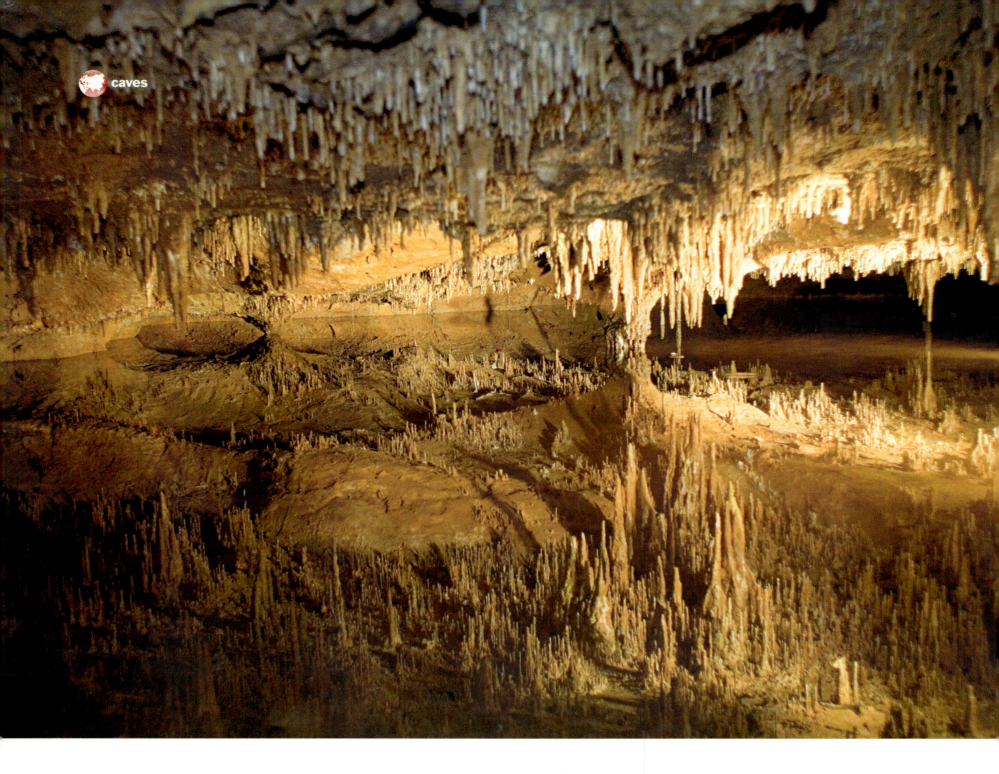

Wonder Down Under

Portals to the underworld, caves are ready-made geology labs, where processes generally unseen are exposed, vast eons of history are recorded, and nature adorns, rather than abhors, a vacuum. Most caves are created by the undergound erosion of lime-stone due to the effects of a slightly acidic solution of water over vast stretches of time; they are called solutional caves. In their early stages of development, such caves are created by trickling groundwater, which gradually forces cracks and fissures in the limestone. The process is often accelerated as the new voids beneath the ground connect with rivers and springs, in some cases forming long tubes and vast subterranean chambers. In some older solutional

caves, the water table that shaped the void has fallen, leaving the space dry. A different type of cave is formed through volcanic activity, when "bubbles" of space are preserved intact as molten lava hardens; they are called primary caves.

The glories of this netherworld are stalactites and stalagmites, formed by the slow trickling of ground-water saturated with calcium carbonate. Stalactites are the needles that hang from the ceiling; stalagmites "grow" from the floor as drops of calcium carbonate accumulate. Amid these eerie, beautiful formations, early peoples gathered in the firelight, for these quiet chambers are also the wombs of human society. ■

Going down? *At right is one of the large dry tubes, left behind by an ancient river that has now dried up, inside Gunung Mulu in Sarawak, a cave system known for its enormous chambers. Above, subterranean trompe l'oeil: stalactites reflected in a pool at Luray Caverns in Virginia appear to be stalagmites emerging from the ground*

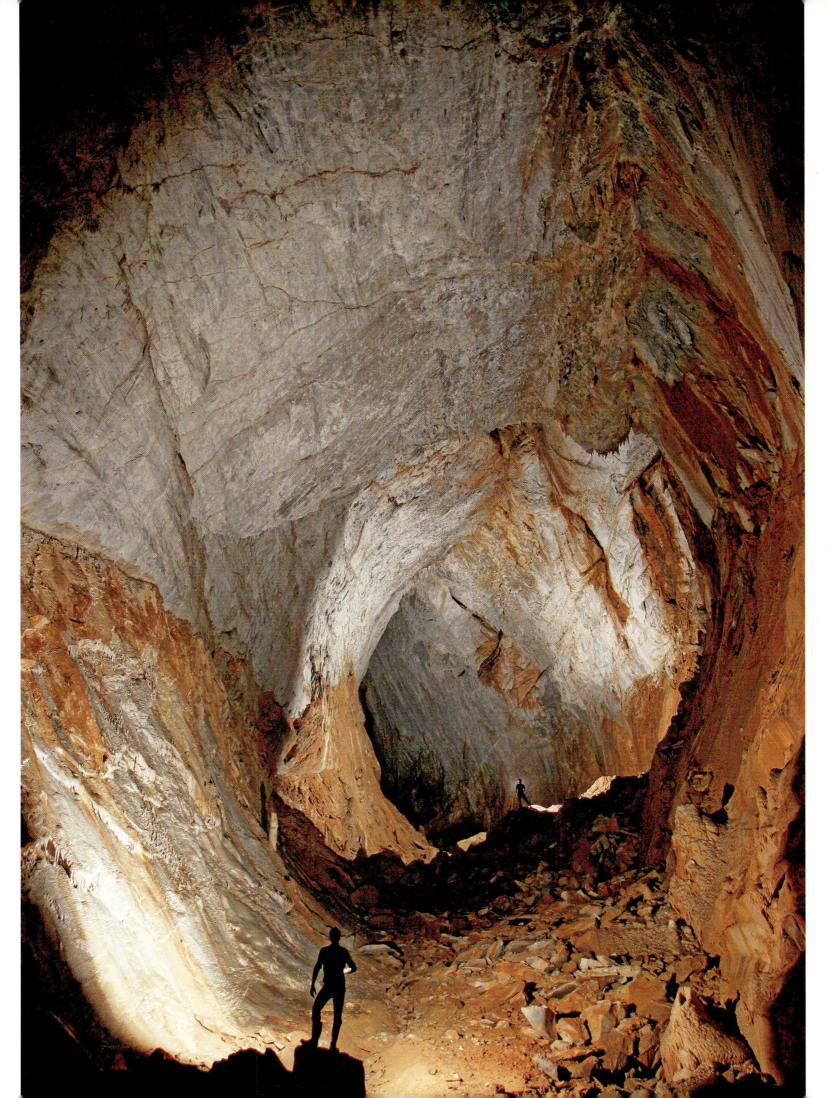

Hanging around *The large knob on the nose of this ghost bat (Macroderma giga) in a cave in northern Australia is called a nose-leaf: it is used in echolocation, a sort of sonar in which bats send out a series of clicking signals, then interpret their echoes to locate potential prey*

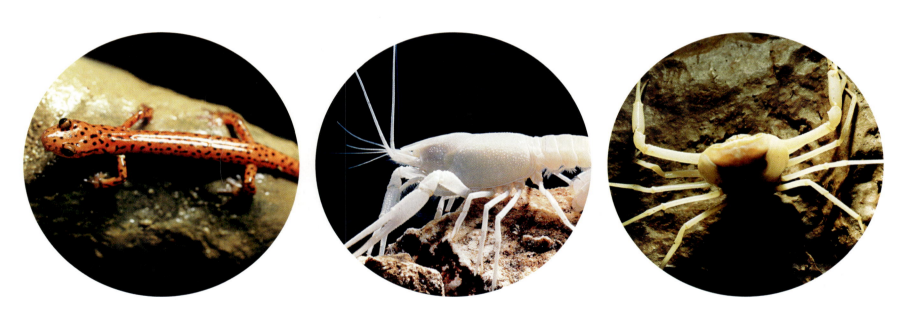

Creatures of a Dark World

Caves are studies in severity, set apart among Earth's ecosystems by the absence of the natural riches that shape life on the planet's surface: there is little weather here, and the lack of sunlight rules out plants that flourish through photosynthesis. But if this subterranean world is long on minerals and short on vegetables, it is surprisingly rich in animals. Like other extreme zones—the poles, the deep sea, the desert—the stern necessities of the cave environment breed creatures so specifically adapted to them that they cannot exist elsewhere.

The absence of light exerts a profound impact on cave life. Many of the creatures here are blind, for eyes serve no purpose in a dark world. And since there is no light to illuminate colors, many cave-adapted creatures, like the crab and crayfish shown above, are albinos. The lack of vegetation radically limits the diversity of species here: most cave animals are found in caverns where there is some fresh running water, providing a source of nourishment for fish, crabs, crayfish and other cavern-dwellers. And then there are the day-trippers: many creatures, such as wolves and bears, keep a foot in both worlds, maintaining dens in caves but frequently venturing outdoors to find sustenance.

The signature cave animal, the bat, is among these subterranean commuters. The winged mammals of the order Chiroptera are one of the planet's most diverse animals, with more than 900 distinct species. Bats are highly skilled predators, whose use of echo-location to find prey is one of nature's most efficient hunting adaptations. Highly sociable, bats roost by the thousands in caves across the world, though many species of bats also dwell in trees and cliffs. ∎

Troglobite or troglophile? *Scientists call animals that dwell only in caves troglobites; their adaptations are troglomorphics. Among the most common of these adaptations is the absence of pigment, as seen in the crayfish, center, and crab, right, above.*

The salamander at top left has plenty of pigment, but it is blind, as is the blind cave characin fish, a species of the Mexican tetra. Such animals are nourished by small creatures and vegetable matter found in freshwater streams and sometimes by bat guano. Bats and other animals that shuttle between caves and the surface world, like the cave salamander, are called troglophiles.

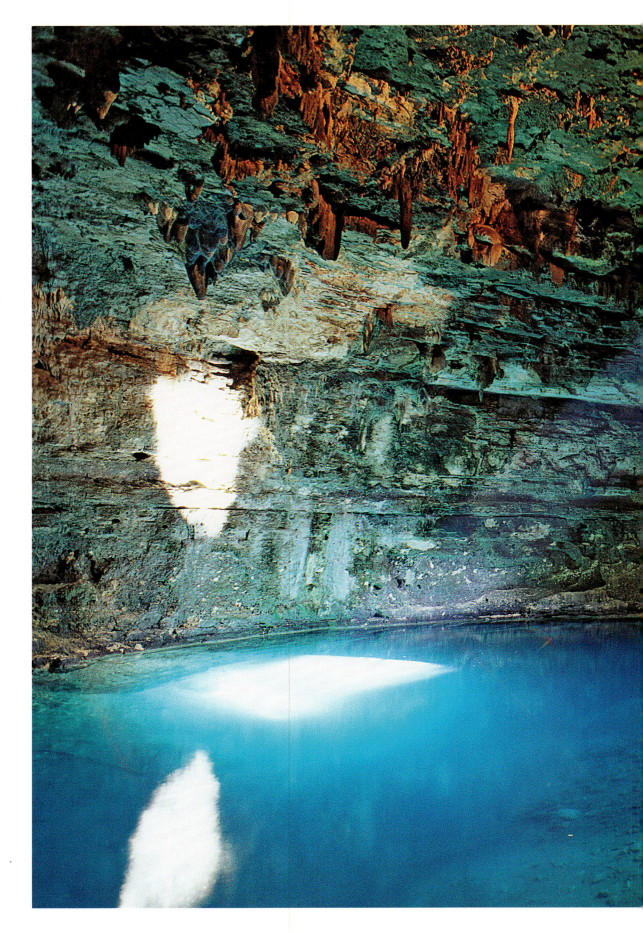

One Room, Skylight View

Cenotes are among nature's more whimsical creations. These underground hideaways are part cave, part lake, part swimming hole—and entirely beguiling. In truth, though, a cenote is essentially a glorified sinkhole, one that resembles a cave, contains a pond or lake of groundwater and often opens to the surface above. The planet's greatest trove of them lies in Mexico, particularly on the Yucatán Peninsula, but cenotes are also found on some Caribbean islands and in Australia. The term *cenote* is derived from the Maya and refers to a site where groundwater can be found. Indeed, since the Yucatán has relatively few lakes and rivers, Maya settlements were often built near cenotes, which offered supplies of freshwater. The Maya capital of Chichén Itzá was built around an extensive network of them.

Cenotes form in areas of karst topography, when rock below the surface dissolves, creating a void covered by a thin layer of rock, soil and vegetation and filled with rainwater infiltrating through the ground. (Many cenotes are closed systems that are not fed by underground rivers or springs.) When the thin roof covering the underground void collapses, it becomes open to the surface, allowing rainwater to fall directly into the cavern. In later stages, cenotes can become filled with sediment and eroded soil and rock, until the waterline is covered and the cavern becomes a ravine. But geology lessons can't convey the sheer beauty of these entrancing, hushed spaces, alive with the trickle of water, shot through with shafts of sunlight dappling the long vines that dangle from the surface above and sometimes echoing with the oohs and ahhs of delighted human intruders. ■

Looking up *A visitor contemplates the view from the bottom of a cenote near Valladolid, Mexico*

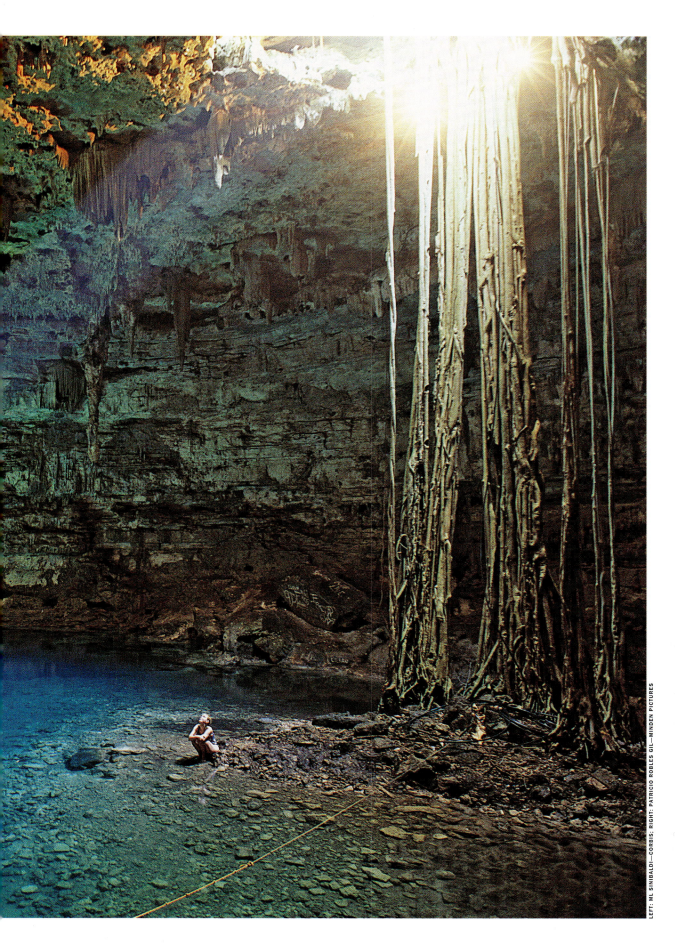

The stages of a cenote *There are several distinct stages in the life of a cenote. The aerial photograph below, taken outside Tamaulipas, Mexico, shows three sinkholes that may someday become cenotes. The two lower sinkholes have collapsed below the surrounding landscape; it is possible that only a thin layer of surface soil is acting as the ceiling of a more extensive vertical void directly beneath them, but it's also possible that the sinkholes have reached their maximum depth and will never become true underground cenotes. The shallow sinkhole at the top has already filled with water.*

The extensive system of cenotes at Chichén Itzá was first explored by American Edward Herbert Thompson. In 1904 he began excavating the Sacred Cenote, a primary site of Maya religious worship, and found a number of ritual objects as well as human skeletons, suggesting that the cenote was used for human sacrifice. Today cave divers continue to explore the underground passages and byways of a large system of interconnected cenotes along the east coast of the Yucatán Peninsula in the state of Quintana Roo.

247

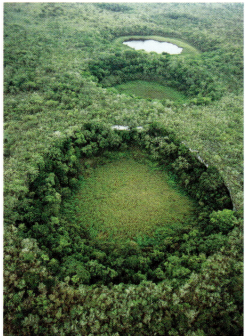

index

index

250

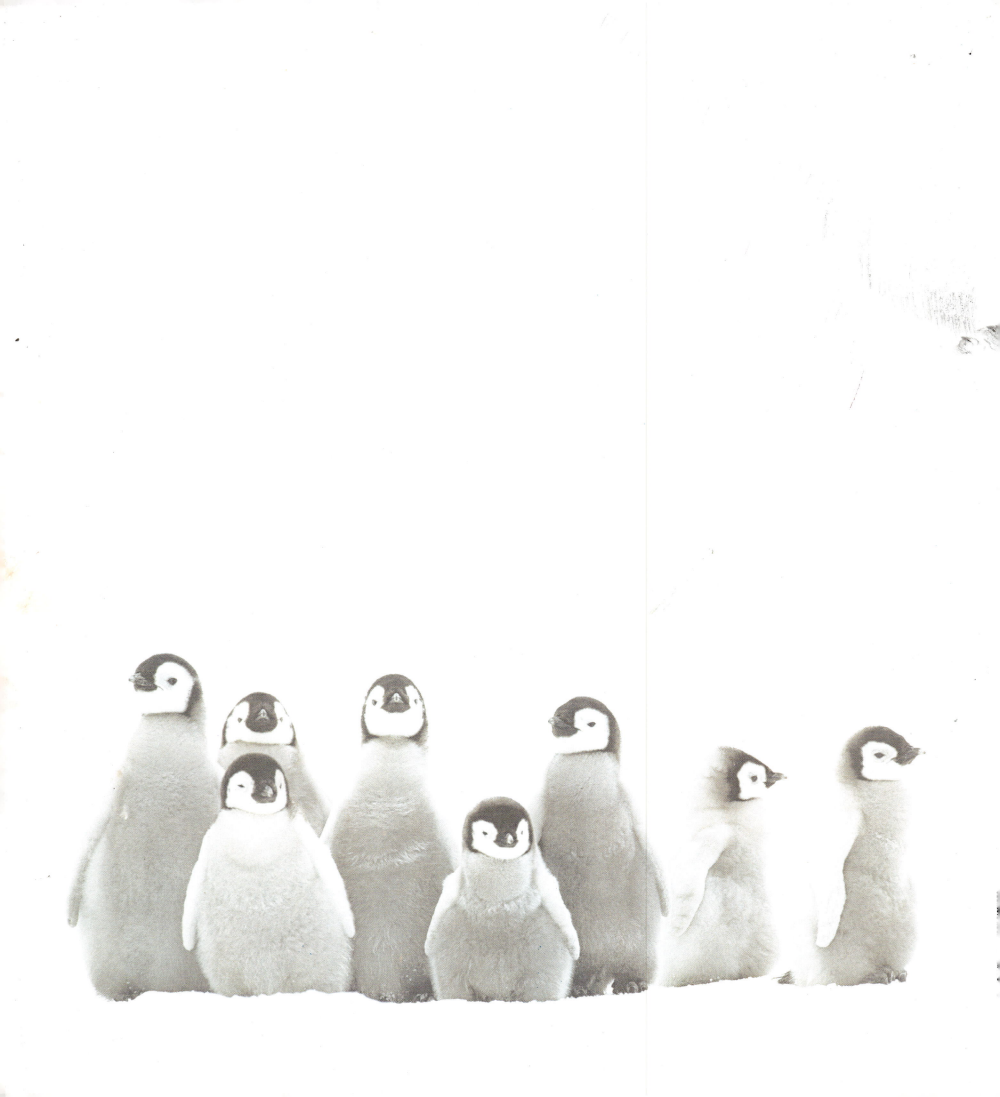